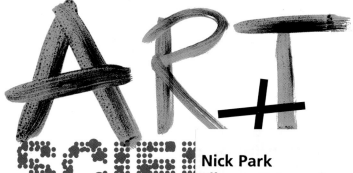

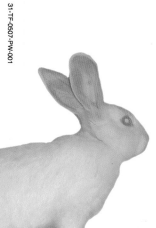

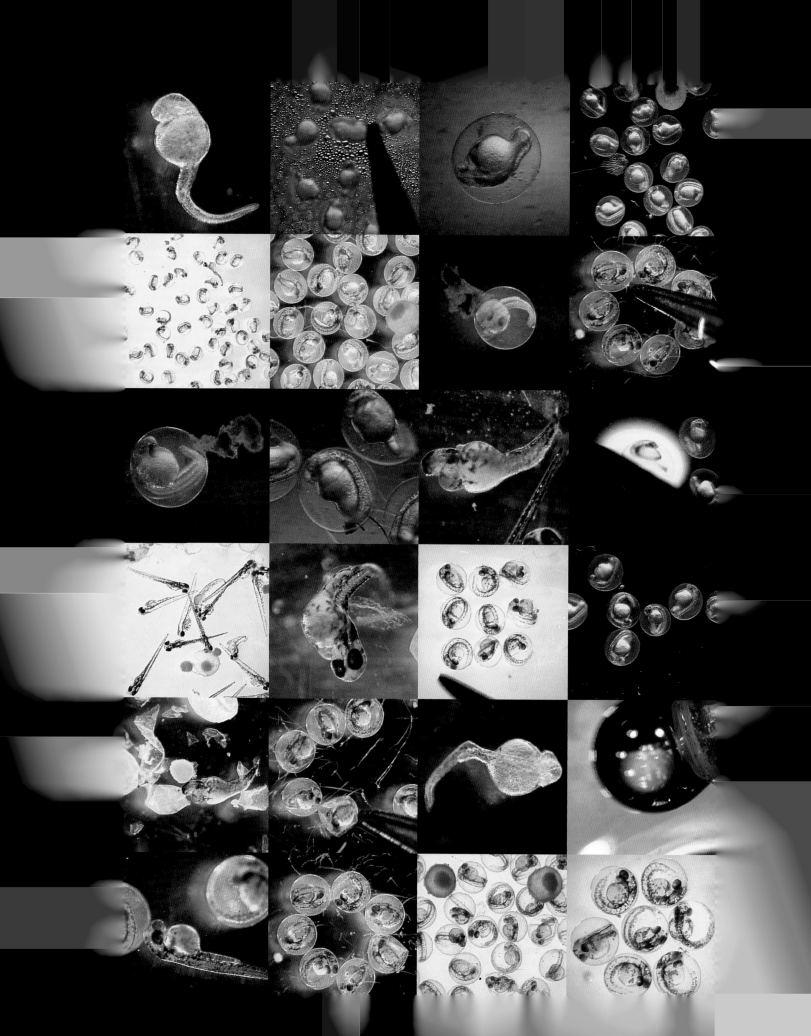

Stephen Wilson

ART + SCIENCE NOW

with over 270 colour illustrations

Thames & Hudson

On the half-title page: **Eduardo Kac,** *GFP Bunny,* **2000,** transgenic artwork, Alba the fluorescent rabbit. Kac persuaded researchers in France to create a genetically modified rabbit by introducing GFP genes from a jellyfish. Alba's new genetic element made its fur glow when exposed to a specific UV light. The researchers, concerned about using bioengineering for an art project, refused to release the rabbit to Kac; this created a widespread public debate, which Kac considered a major part of the project.

Frontispiece: **Kathleen Rogers,** *Tremor,* **2006–7** Matrix of stills from a video showing different stages of zebrafish development during an experiment in systematic genetic mutation. Rogers's project documentation exposes a research dilemma: 'making and unmaking the gene requires a pathological trespass into the mystery it seeks to reveal. In the microscopic study of fetal growth in living mutations, physical contact and looking create tremors and palpitations that are tactile and reactive and invariably fatal.'

This page: **Cornelia Hesse-Honegger** Watercolour painting of mutated leaf bugs from the Trang Bom district of South Vietnam, where the chemical defoliant Agent Orange was used. Both leaf bugs have one deformed feeler. The painting is part of the artist's decade-long project to make photographic and painting studies of mutated bugs living in environments of pollution and high radiation.

First published in the United Kingdom in 2010 by
Thames & Hudson Ltd, 181A High Holborn,
London WC1V 7QX

First paperback edition 2012

British Library Cataloguing-in-Publication Data
A catalogue record for this book is available from the British Library
ISBN 978-0-500-28995-2

Printed and bound in China by Hing Yip Printing Co. Ltd

Unless otherwise indicated, all quotes in the captions are taken from the creators' online project descriptions of the works illustrated.

The author's companion website to the book provides links to artists, works and other relevant resources: http://userwww.sfsu.edu/~infoarts/links/wilson.thames.html. See also the Thames & Hudson website.

To find out about all our publications, please visit **www.thamesandhudson.com**. There you can subscribe to our e-newsletter, browse or download our current catalogue, and buy any titles that are in print.

The author wishes to thank all those who have made this book possible. The artists and scientists who surged across disciplinary borders in creating the work represented here. The team at Thames & Hudson, who helped to shape a book that could engage audiences who might not normally encounter this field of work. Research assistants Jessica Walker, who coordinated image acquisition and communication with artist contributors, and Cassandra Sechler, who fact-checked and indexed. And my wife, Catherine Witzling, who edited early drafts and helped me ride the ups and downs of the production process, and my daughter Sophia, who assembled the index, contributed photography and provided honest reactions to drafts of the book.

contents

ART, SCIENCE + TECHNOLOGY

Art and science, the twin engines of creativity in any dynamic culture, are commonly thought of as being as different as day and night. This is a critical error. The partitioning of curiosity, inquiry and knowledge into specialized compartments is a recipe for cultural stagnation. For example, biology does not belong only to biologists. Questions about the nature of life, about how brains and bodies work, and about the limits on our abilities to shape life processes transcend academic categories. Like so many other 'scientific' questions, they are also major cultural questions and demand widespread attention. The sciences have made great contributions to new categories of thought, research techniques, theories and bodies of knowledge. But the story does not end there.

This book surveys artists, and some scientists, who seek liberation from specialized compartments and definitions. Pursuing larger cultural questions, they have tried to remove their isolating disciplinary blinders. The scientists have been willing to undertake inquires outside the arena of traditional research. The artists have been eager to move into areas of scientific and technological research usually pursued by technical specialists. In forging a new art for the twenty-first century, they have tackled projects that might normally be categorized as science, ranging in focus from astronomy to zoology. They have made the questions, tools, research processes and contexts of science into the materials of art, creating sculpture from body cells, trying to breed extinct species, composing music by means of brainwaves, building installations that visualize real-time data from the world's oceans, and allowing viewers to interact with robotic sculptures by means of hand gestures.

A wide range of contemporary experimentation in these hybrid areas is explored in this book, celebrating iconoclastic daring and also summarizing problematic aspects and theoretical

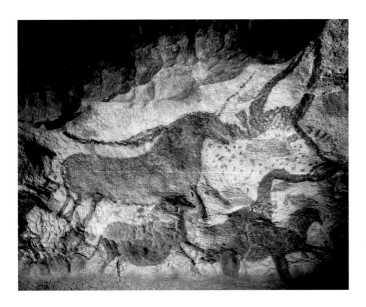

Hall of Bulls, Lascaux, France, 28,000–10,000 BCE. Cave paintings are considered landmarks in the histories of both science and art. They are appreciated for their careful observation of animal species, anatomy and physiology, as well as for their spiritual energy and the craft implied in successfully representing motion and intent.

complexities. The artists discussed work in and with genetics and cellular biology; the biology of living systems and ecology; human biology; the physical sciences; alternative interfaces such as motion, gesture and voice recognition; 'smart' objects, kinetics and robotics; code, artificial life and artificial intelligence; and databases, surveillance and information visualization.

<div align="center">* * *</div>

The precise definitions of the terms *science*, *technology* and *art* remain elusive and are often debated. It is important to consider them, however, since many artists engaged with the sciences probe questions of definition as a matter of course. Many of their works defy categorization, and that is part of what makes them so interesting.

Science is usually thought of as the attempt to understand natural phenomena using the scientific method, which involves observation, the formulation of hypotheses, experiments to test them, and the drawing of conclusions that confirm or modify them. Complexities lurk beneath this definition, however. Science is usually seen as being focused on the natural world, but the term is also used for the social sciences (such as psychology and sociology) and for formal sciences such as mathematics. Also, many different processes coexist under the umbrella called science – observation, experimentation, visualization, theory construction and so on.

Anyone whose work focuses on observation and experimentation with plants could be seen as doing science, for example. But scientific method entails critical assumptions that differentiate it from other disciplines, including as it does a commitment to cycling through theory, observation, testing and revision. There are accompanying aspirations to achieve radical objectivity as well as insulation from socio-political pressures – in other words, eliminating personal bias and subjecting all findings to repeated testing and independent

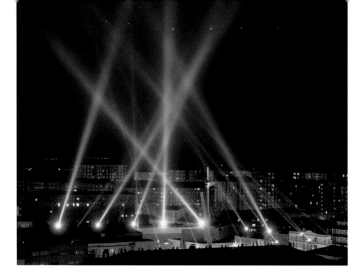

Rafael Lozano-Hemmer, *Vectorial Elevation, Relational Architecture 4*, 1999–2004. This interactive installation with robotic searchlights was controlled by the public via the web using a 3-D interface. The event was staged in several cities; shown here is the 2002 installation at Artium, the Basque Museum of Contemporary Art, Vitoria-Gasteiz, Spain, where eighteen searchlights were involved. Each web participant was able to design light-control patterns and could see real and virtual views of their 'sculptures'. Lozano-Hemmer invented new technologies for robotic control as well as interfaces for mass participation via the web.

verification. And there is a commitment to participate in the scientific community – collaborating in building theories and sharing new discoveries.

Technology, on the other hand, can be defined as techniques for making and doing things. Anything developed by humans could be considered a technology – construction, writing, government, painting, ceramics. However, in popular usage, the term is usually applied to more recent applications such as electronics or bioengineering. Even the phrase 'high technology' is slippery; one era's frontier can become the next era's commonplace. Consider attitudes towards computers thirty years ago and today. Some observers propose that technology is applied science; science discovers basic principles, then engineering applies those to solving problems, with the focus on doing things instead of increasing knowledge. This situation has become complicated, however, because researchers in technology often move into areas where there is little established scientific knowledge, thus opening up new worlds

for science to explore. For example, researchers attempting to enable computers to simulate human intelligence have raised new questions about the nature of the brain.

Whatever definition of science and technology one accepts, the artists discussed here work with many of the core processes (or constituents) of scientific and technological practices.

In the last century, defining art has become a challenge. In earlier times, it was identified with time-honoured media such as painting, printmaking and sculpture, and was pursued for aesthetic purposes: the creation of beauty, the achievement of realism or the visual exploration of symbols, for example. In the twentieth century, many aspects of art's traditional definition were augmented as artists started working with non-art media, contexts and concepts. New media included technological tools, installation formats, performances, happenings and earth works. Dividers between art genres such as sound, theatre, cinema and the visual arts were torn down, and the dominance of Eurocentric forms and ideas was questioned. The traditional barrier between viewer and artwork was challenged. Artists pursued many agendas besides the creation of beauty, including conceptualism, cultural commentary and socially engaged interventions.

The experimental art discussed in this book can be thought of as the progeny of these earlier explorations. For example, biological and ecological artists, who work with living systems, can be seen as descendants of the Land artists of the 1960s, '70s and '80s who considered the actual landscape to be their medium. Art that focuses on scientific concepts, the organization of information systems or computer code can be seen as a reprise of the Conceptual art of the 1960s and '70s with its concentration on ideas as opposed to material manifestations. And artists working in non-art settings and on socio-political interventions can be seen as descendants of the happenings, performances and social-sculpture events of the same decades.

Recent philosophers of art such as Arthur Danto and Pierre Bourdieu have acknowledged that boundary testing had been profound enough to make reaching a consensus regarding new definitions extremely difficult. Many philosophers subscribe to what is known as the institutional theory of art, according to which its definition is dynamic, being formed by whatever the network of art-world participants – artists themselves, curators, historians and critics – consider to be acceptable. In spite of art's having broadened out to incorporate these expanding definitions, acceptance by critics and public alike has not been automatic. Much of the experimental work described in this book has not yet been assimilated into mainstream institutions such as museums, galleries and the most popular art magazines.

The unsettled status of this new hybrid art waiting at the doors of recognition gives the reader a unique chance to observe the process of redefinition in action. Is the rejection of such work similar to the exclusion experienced – and overcome – by, for example, photography, video or performance art during the nineteenth and twentieth centuries? Remember that these media were not accepted into museums until many decades after their invention. Paradoxically, the art world is somewhat ambivalent, simultaneously promoting experimentation/iconoclasm and the preservation of historical standards. However, the budding interest of museums in areas such as robotics and art and biology suggests that this slow process of acceptance might be speeding up, as has been illustrated by shows at the Museum of Modern Art in New York and the Tate Modern in London.

Perhaps such new work's exclusion signals something more profound, however. Its close alliance with scientific and related disciplines

makes it easy to dismiss as part of those worlds. Visual access is not necessarily straightforward (for example, some works can only be seen through microscopes or via other special instruments). The literacy required to understand and appreciate such work is not widespread. For instance, recognizing both the craft of, and the conceptual leap being made by, an artist exploring computerized artificial intelligence is somewhat dependent on understanding the scientific challenges in that field as well as the nature of the artistic gesture required to move beyond the science. Perhaps most interestingly, some of the practitioners – especially the young ones – see themselves as outside the worlds of both art and science, and are attempting to carve out a new niche of cultural experimentation and invention.

In response to the mainstream art world's hesitancy to address the emergence of this genre of sophisticated experimentation, a parallel world of institutions and organizations has developed to show, support and interpret it. Many museums, festivals, university programmes, publications, websites, art/science collaborations and funding structures have newly sprouted (see 'Online resources', pages 203–4).

Interesting issues are thrown up in the face of such efforts, including the question of what to call the activities under consideration. ('Electronic',

'new' or 'extended media' do not quite capture the scope.) What should their relationship be to traditional or historically validated and digital media? (Many festivals that used to feature computer art are now attempting to include these wider-ranging research projects.) And what is the relationship between this art and research in other technical fields such as interface design or biology?

Support organizations and publications have taken a range of approaches to these questions. New programmes such as the University of Washington's DXARTS offer a 'creative research convergence zone for intrepid artists and scholars' who seek to research beyond the conventional arts. Students come to this particular programme with backgrounds in art and in technical disciplines such as computer science and biology. As to journals, *Leonardo*, published by MIT Press in America, has a forty-year history of (to quote its website) 'promoting and documenting work at the intersection of the arts, sciences, and technology, and … encouraging and stimulating collaboration between artists, scientists, and technologists'. The International Society for Arts, Science and Technology organization (ISAST), which produces *Leonardo*, also sponsors websites, a book series and abstracting services, and collaborates with other groups in presenting conferences. Recent articles in the journal have focused on generating sound from the electrical characteristics of bone and using photosensitive bacteria in performance.

The Belgian website we-make-money-not-art.com does an amazing job of covering media/research conferences, interviewing artist/researchers, and unearthing interesting

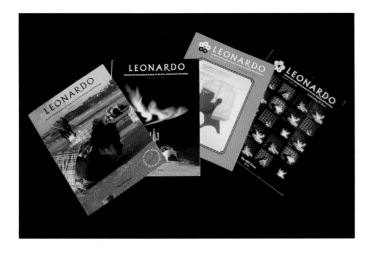

Covers of the journal *Leonardo*, 2007. *Leonardo*, published by MIT Press, has a forty-year history of 'promoting and documenting work at the intersection of the arts, sciences, and technology, and … encouraging and stimulating collaboration between artists, scientists, and technologists'.

developments in and outside of the arts in fields ranging from activism and biology to surveillance and wearables. Organizations like Arts Catalyst in Britain seek, according to its website, to 'extend the practice of artists engaging with scientific processes, facilities and technologies in order to reveal and illuminate the social, political and cultural contexts that brought them into being' through public symposia, exhibitions and commissions. Recent initiatives have supported artistic exploration of weightlessness and radioactivity.

Another important area of support consists of specialized research centres and funding sources. SymbioticA is an 'artistic laboratory dedicated to the research, learning and critique of life sciences', providing 'an opportunity for researchers and artists to pursue curiosity-based explorations free of the demands and constraints associated with the current culture of scientific research'. SymbioticA is sponsored by the School of Anatomy and Human Biology at the University of Western Australia. In Switzerland, the Artists in Labs Program sponsors residencies in which artists can work in advanced laboratories. The programme's description notes that '[t]he intention of the AIL program is to share common goals, to broaden the dialogue, generate ideas and raise awareness of the contributions both artists and scientists can make to the larger challenges of our time'.

Finally, new work is presented to the public through museum exhibitions, festivals and competitions. Ars Electronica in Austria has a long history of exhibitions and competitions for technology-based experimental artistic work. Both artists and scientists are invited to speak at sponsored conferences. Recent festivals have focused on such themes as New Sex, Code, Simplicity and Privacy. The yearly Prix competition awards prizes in the areas of web and interactive art, and in 2007 added a new category called hybrid art, which focuses on trans-disciplinary approaches and the 'process of fusing different media and genres into new forms of artistic expression as well as the act of transcending the boundaries between art and research'.

* * *

The works discussed in the following chapters confront the problem of definitional boundaries head-on. Sometimes the projects do not look like either art or science (the term *science* is used here as shorthand for both scientific and technological research). This confusion can be productive for thinking about both. Some works celebrate science's accomplishments; some critique its arrogance.

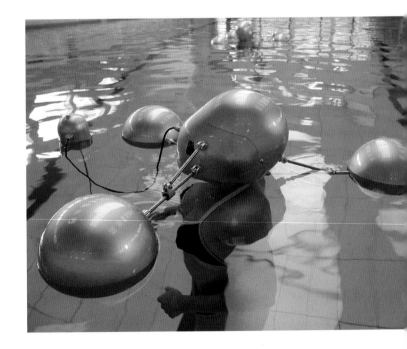

James Auger, Jimmy Loizeau and Stefan Agamanolis, *Iso-phone*, 2004. This installation combines telephone and flotation-tank technology to create a 'telephonic communication space of heightened purity and focus'. Here a participant is shown floating in a pool wearing a helmet (which blocks out ambient sights and sounds) and three flotation spheres (which enable effortless suspension and reduce other kinaesthetic cues). The helmet contains telephone equipment to enable the wearer to converse with people in remote locations. Although undertaken as an art installation, the project raises new research questions about links between psychology, physiology and telecommunications.

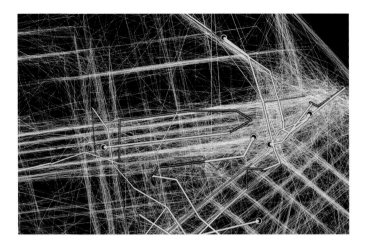

Covers of Ars Electronica festival booklets from 2005 and 2006. Each year Ars Electronica brings together artists, scientists and theorists to focus on trans-disciplinary themes. Sponsored by the Austrian National Television Network since 1979, Ars Electronica is one of the most venerated organizations supporting experimental technology arts. It also supports a museum, a research centre and the annual international Prix competition, awarding prizes in music, web and interactive art, and hybrid art.

Peter Richards, Susan Schwartzenberg, Scott Snibbe, Stamen Design, Tomas Apodaca and Amy Balkin (Exploratorium, San Francisco), *CabSpotting*, 2005. Movement data from GPS-enabled taxis in San Francisco are visualized to reveal the invisible dynamics of economic, social and cultural trends. The white lines are a composite of four hours of taxi trips; the density of the lines is directly proportional to the frequency with which specific streets were travelled. The yellow lines show the paths of the most recent trips of ten 'live' taxis being tracked.

Some artists invent totally new technologies that have no utilitarian function or market, simply for purposes of play, curiosity or provocation. Some work in their own labs, while others collaborate with scientists and technologists. In the science and technology worlds, questions of definition are similarly fraught.

Artists engage scientific and technological research at many different moments in the scientific research process, identifying questions that would be unlikely to be pursued by other researchers. Taking telecommunications research in unorthodox directions, for example, James Auger and his colleagues wondered in *Iso-phone* whether telephonic communication would be fundamentally transformed if communicators were isolated in sensual-deprivation flotation tanks.

Artists invent new ways of investigating themes arising from research, making the processes, tools and concepts themselves into public installations and performances. Rafael Lozano-Hemmer's *Vectorial Elevation* investigated innovative web interfaces to control physical devices in spectacular events that explored the concept of public space. The earliest version invited web visitors from around the world to control eighteen robotic searchlights illuminating the sky above Mexico City.

Artists also invent ways to visualize research results and make investigative processes public, and their priorities may or may not match those of scientific researchers. Artists may seek to add a critical dimension with which to view research or introduce totally new agendas. San Francisco's Exploratorium (a museum of art and science) and the Stamen Design group created a project called *CabSpotting* which invented new ways to use the information derived from a taxi company's collection of GPS data. This data had been assembled by triangulating drivers' geographical

positions based on a comparison of time differences among global-positioning satellite signals. By devising intriguing ways to animate taxi paths collected over time, the project created a provocative, rich portrait of urban structure and behaviour, for example locating centres of activity at various times of the night.

Artists can act as research-and-development innovators, inventing or refining new technologies and making use of emerging science. However, they differ from most developers in a significant way: their goals are typically not for profit or intended to be primarily utilitarian. Instead, they undertake to develop tools that help to realize specific artistic goals or satisfy intellectual curiosity. For example, *Aphrodite Project* adapted GPS, mobile-phone and wearable technologies to develop devices that would probably not engage commercial interests. Offering instead a critique of how research priorities are set, the project created shoes that sex workers could activate unobtrusively by moving their feet in order to summon law-enforcement assistance in dangerous situations.

Many artists feel that cultural commentary, including the deconstruction of hidden narratives in cultural structures, should be a major agenda, especially as they reflect on science and technology. Questioning the narratives of progress usually associated with research, they fear that the growing linkage of research with corporate and governmental power is distorting science. They further suspect that science may be becoming arrogant in its new powers, losing its commitment to radical circumspection and embarking on research paths that may be dangerous rather than serving the general good – for example, the rush to create genetically modified food without a full understanding of its possible consequences. In this artists are joining philosophers, critical theorists and sociologists in a critique of the idealized vision of science. Objectivity is seen as almost impossible, universal 'truth' as elusive, and (even more subtly) dominant scientific paradigms as constricting conceptualization and visualization. Given these practical and theoretical concerns, some artists, having educated themselves deeply in the relevant

Norene Leddy with Andrew Milmoe, Ed Bringas and Melissa Gira, *Aphrodite Project*, 2006. These technologically enabled platform shoes, designed for sex workers, use mobile-phone and GPS technologies to allow women to send location and emergency messages via their footwear. The small coloured lights are the control panel; the video screen and speakers allow the user to broadcast videos, in this case one about Aphrodite, the ancient Greek goddess of love. The project questioned the moral attitudes and value judgments that come into play when determining what technology projects to develop.

science practice, create events that both demystify science and empower the public to participate in debate. This controversy about the nature of science and the status of its accomplishments is an important element in understanding contemporary artistic work with science and technology.

* * *

This book takes an open stance, presenting both the critique and the celebration. Cultural theorists have suggested that artists are inevitably influenced by all elements of their epoch, including science, even if there is no explicit focus on the connection. For example, art historians believe that the advent of photographic technology in the 1800s contributed to the rise of non-representational art even in the cases of artists who never explicitly thought about the new medium. In a similar way, artists working with conventional media today are inevitably shaped by developments in fields such as biology, physics and information technology. One example is sculptors' use of plastics and new metal alloys.

The artists featured in this book, however, locate the connection with scientific or technological research at the conceptual and artistic core of their work. Often they have a long history of related experimental projects. Many of them have participated in cross-disciplinary education, collaboration and residencies, and would claim that this type of hands-on experience is the best way to understand the cultural implications of new developments. And many of them have abandoned conventional practice to invent new media and contexts for their work. This book showcases artists who have achieved notoriety in the emerging art networks focused on hybrid work. They have won competitions, been selected by juries and curated into shows, been chosen for artist-in-residencies in research settings, and are prominent in discourse in this world.

* * *

Such artists are revolutionary now, but in fact they are recapitulating some aspects of art/science cross-fertilization from the past. Indeed these fields have not always seemed so dissociated. Eras in which art and science had a dynamic relationship have often been landmark periods characterized by cultural fertility. In prehistoric times, for example, the same persons were often what we might term artists and scientists in one. Cave painters were intense researchers in the areas of zoology, anatomy and physiology; their paintings reveal a sophisticated understanding of animal life processes. Open a history of science or a history of art, and you will find prehistoric cave paintings as a first significant milestone in both. Similarly, the 'architects' of Stonehenge were innovators in both engineering and astronomy. The metal artists of the Bronze Age founded metallurgy and materials sciences in the course of discovering that strangely coloured soil had hidden features and could be converted via smelting and alloying to create items of utility and exquisite beauty. In part the drive to discover new materials was motivated by the desire to create new objects that succeeded on both aesthetic and functional grounds.

As much of a genius as Leonardo da Vinci was, he was not a totally unusual personality in the Renaissance. He was in fact participating in a culture one of whose core values was that artists and scientists could not succeed without being vitally interested in each other's work. Artists' training included engineering and anatomy. Leonardo as well as others had a notion of 'deep seeing', which meant understanding the underlying processes of the world (somewhat in the way scientists would) and which was seen as an essential tool for the making of art. For example, studying flow dynamics helped when an artist wanted to paint water; studying flight mechanics helped when painting birds; and investigations of anatomy and dissection enabled artists to be better painters and sculptors of the body. Seeing involved

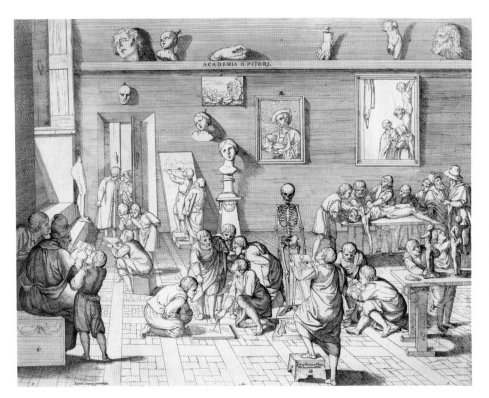

Pietro Francesco Alberti (1584–1638), *The Painters' Academy, c.* 1615. This engraving shows typical trans-disciplinary artistic education during the Renaissance, which included anatomy, engineering and mathematics, in addition to painting. Note the groups at the left studying geometric drawings and analysing the arch in the drawing leaning against the wall, and the group at the right dissecting a cadaver.

(Research Library, The Getty Research Institute, Los Angeles, California (2007.PR.29))

more than just perception; it also consisted of the attempt to penetrate underlying forces and principles.

In the decades of upheaval between 1880 and 1930, both science and art underwent radical revolutions. Scientists developed new paradigms, such as the theory of relativity and an understanding of the bacterial origins of disease, and forged the agendas that continue to shape research today. Similarly, artists pioneered approaches that broke down the conventions of perspective and representation, definitions of appropriate subject matter, opinions regarding artistic materials and contexts, and the relationship of art with social and technological forces. New technologies of perception, communication and production shaped the landscape. Artistic responses varied from deep involvement in novel theories of time and space, to utopian attempts to engage creative individuals in building a better world through science and technology, to scepticism, resistance and the exposure of the dark side of scientific and technological 'progress'.

Cultural historians such as Linda Dalrymple Henderson who have looked at the art-science connection have found the parallel upheaval in notions of time and space fascinating. Relativity and alternative geometries challenged the sanctity of the Newtonian view of space and time, which had served almost flawlessly for hundreds of years. Science moved away from strict empiricism to an increasing reliance on unobservable, theoretical constructs. At the same time, modern art challenged the solidity of objects, the sanctity of the single point of view, and conventional, non-relativistic concepts of time. Artists increasingly moved towards a reliance on abstract approaches in order to understand and represent the essence of reality. At one time it was thought that modern painters and sculptors might have been directly influenced by a knowledge of scientific research, and attempts were made to trace acquaintance networks from experimental mathematicians to experimental artists. Although there is some slight evidence for this, the view favoured today stresses the influence

of a common zeitgeist that encouraged practitioners in all fields to question tradition. At exactly the same time, colonial expansion was resulting in contact with cultures with unfamiliar worldviews, new technologies were rapidly altering the experience of everyday life, and political and religious movements were asking radical questions.

* * *

Today we are trying to forge our own rapprochements, and there is a resurgence of interest in encouraging a tighter integration of art, science and technology. What is the cultural value of this kind of artistic activity? How do the arts and science benefit? What can be learned from the work described in this book?

General cultural impact is perhaps the hardest to assess. It may be that a broad interest and literacy in science and technology is critical in a techno-cultural society. This kind of literacy helps the citizens of democracies make wise science-related policy decisions in connection with such tough issues as bioengineering and pollution. Thus a culture of direct (e.g. through funding) and indirect (e.g. through young people picking science as a career) support is created and encouraged. Even more pervasive is a faith that widespread knowledge about areas of such practical and philosophical importance makes for a vibrant, adaptive culture. Science-related arts are seen as useful in making information come alive for general audiences.

There are historical precedents for public involvement in research. In the course of the development of the microscope and of electrical technology in the eighteenth and nineteenth centuries, research was deeply integrated into the wider culture. Amateurs made major contributions to the development of technology, to particular applications and to theory. For example, Antony van Leeuwenhoek, developer of one of the first microscopes and discoverer of cells, was a general

tradesman who became involved in research out of general curiosity. (In fact the word *amateur* had as its original meaning – derived from the Latin verb 'to love' – someone who was involved with a topic out of love for it.) Widespread public interest, including lectures and media featuring new developments, was of critical importance; for example, holiday tours were organized around use of the microscope. In the 1970s and '80s there was a similarly wide participation of uncertified researchers (including artists) in the rapid development of the microcomputer and communication technologies.

Edward Nairne (1726–1806), and Thomas Blunt (died 1822), chest microscope, *c.* 1780. The development of microscope technology and of scientific studies using microscopes was propelled forward by a large amateur public. A portable chest microscope was often used on nature tours to the beach. Social gatherings were convened to share what had been discovered as well as information about new developments.

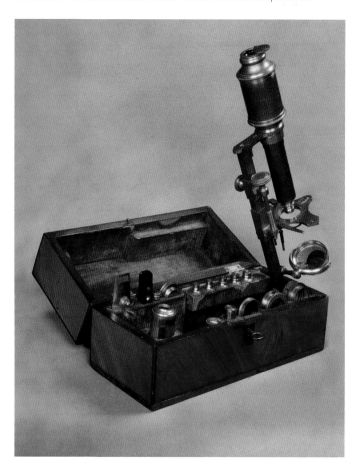

Today the fruits of research provide rich new materials and techniques that artists can use – for example, new visual imagery from inside the body or interactive techniques such as motion detection. Perhaps more importantly, knowledge about frontier areas of research enables artists to serve their historical function of offering commentary and different perspectives on contemporary developments.

* * *

Many art/science collaborations are based on the assumption that artists can enrich research processes, and some funders, including the European Union, specifically support collaborative projects. In 2003 the American Academy of Sciences commissioned a study that produced a report, *Beyond Productivity*, which concluded that alliances between the arts and research could make a significant contribution to society. The report noted that '[c]reativity plays a crucial role in culture; creative activities provide personal, social, and educational benefit; and … [creative industries] are increasingly recognized as key drivers of economic development…. There are major benefits to be gained from encouraging, supporting, and strategically investing in this domain'. Clearly artists can contribute to many aspects of the research process by framing new agendas, designing unorthodox approaches and inventing ways to visualize findings. From a cultural theorist's point of view, artists can help researchers become aware of unrecognized perspectives and cognitive frameworks, as well as help establish connections with audiences outside the research community.

Some scientists, such as the biologist Lewis Wolpert, are sceptical about these possibilities, however. In an article in the *Independent* (25 February 2000) entitled 'Arts vs Science: The Critical Difference', Wolpert lambasted efforts to bring artists into the research process and noted that the

Ken Goldberg, *Tele-Actor*, 2001–3. In a commentary on the future of surveillance and control, the actions of a live person, equipped with wireless web camera and microphone, are determined by the votes of web observers. A web page shows what the person experiences in social situations, such as a party. Goldberg devised wireless systems and software to link the group dynamics of a real-time online community with a 'human robot'.

arts are unlikely to contribute to the sciences because the two disciplines are so different. For example, the arts place great value on individual idiosyncrasy, whereas science is a collective effort in which individual differences are eliminated by application of the scientific process. Also, the arts celebrate the seeking of multiple answers while the sciences drive towards the right or best answer. In fact such criticisms oversimplify both art and science. The artists and scientists involved in the projects featured in this book believe that there are many ways in which art and science can enrich each other.

* * *

Interested readers will find that there are rich resources to explore in addition to those discussed in this volume. Some of the artists mentioned (for

example, David Rokeby and Bill Vorn) have been engaged in significant experimental work for decades. Beyond the one or two samples described, many fascinating practitioners could not be included, nor could work completed outside the book's timeframe of 2000–7. Readers will also discover additional areas of hybrid artistic inquiry, for example telecommunications, telepresence, experimental web technologies, wireless or locative media, games and many others. Finally, several interesting areas of artistic experimentation could not be discussed due to constraints of space.

It may be impossible to appreciate, understand and practise art without an awareness of the meta-narratives that underlie it, especially when exploring the relationship between science, technology and culture. While the chapters of this book offer brief introductions to some of these themes, interested readers will find links suggestive of the rich archive of available material in the 'Online resources' (pages 203–4) section. Some of the relevant cultural themes include critiques of the scientific process; socio-economic influence on research agendas; 'post-human' (as in new possibilities for human capabilities resulting from scientific research) attitudes concering the body, identity and body/machine relationships; changing concepts of time, space and physical reality; reduction of biology to code; hypermedia and distributed authorship (the generation of creative work through the collaboration of network-connected individuals); the nature of databases and networks; surveillance, tactical media and hacking; computer code, artificial intelligence and self-organizing systems; games, entertainment and art; and ethical issues in such fields as ecology, medicine and biology.

In thinking about hybrid art and consulting these various sources, some fruitful questions to think about include the following: Have artists used scientific research to create new ways of looking at the world? Have they updated historically sanctioned forms and media such as sculpture or dance? Have they identified new research agendas ignored by mainstream science? Have they invented new technologies ignored by the marketplace? Have they revealed new critical perspectives on research, its processes and its relationships to society? Have they tried to find new public forms to involve viewers in their research? And what accomplishments of science are they celebrating and questioning?

Most important, though, is whether particular work enhances the way you think about art and science. If it does, it will provide hints about how the arts in general can remain robust and relevant in the context of techno-scientific culture.

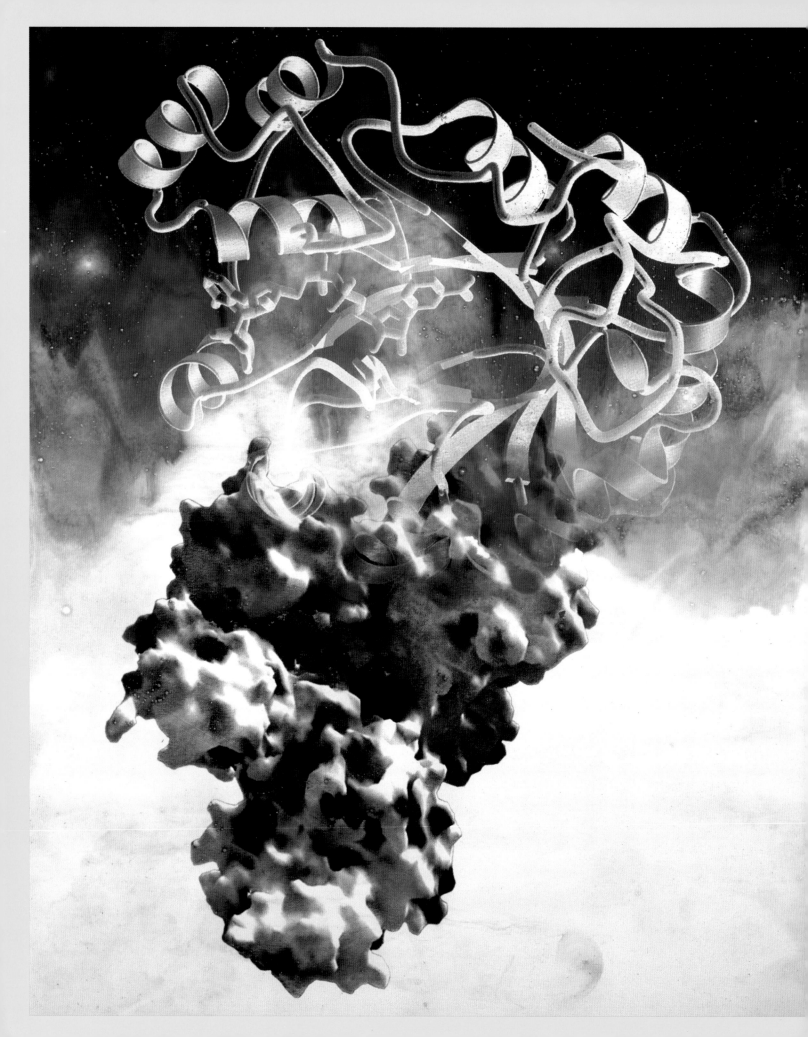

Steve Miller, *Protein 224*, **2003.** Miller created this image in spray enamel and silkscreen in collaboration with the Nobel Prize-winning biophysicist Rod MacKinnon. It stresses the twisting and folding of proteins that present major challenges for scientists trying to understand their structure. Since proteins are too small to be seen with the naked eye, they must be visualized via techniques such as X-ray crystallography. While scientists use different theoretical models to represent the data produced by these technologies, Miller employed an innovative combination of approaches including surface- and ribbon-modelling techniques (respectively below and above).

MOLECULAR BIOLOGY 1

Biology promises to be a major locus of discovery in the twenty-first century. Some analysts believe that the biological revolution will make the enormous impact of the digital revolution seem like child's play. The optimism and resources being devoted to biological research today promise to have a profound impact on everyday life as well as on philosophical notions about life itself. Whenever artists notice so much concentration of cultural energy and focus, they feel summoned to investigate and respond.

This scientific work is not being created in a philosophical vacuum, but is examining both old and new questions. How is biological research conceptualized to begin with? To what extent do genes determine what we (and other organisms) can become? How should we view biologists' confidence that they understand the consequences of the unprecedented interventions they are making through their experiments? And how does one weigh the ethical implications of the new possibilities being thrown up every day?

This chapter focuses on cell and molecular biology, disciplines that typically require microscopes to study and manipulate living organisms at the cellular level and below. Much research energy is being focused on modifying genetics; other fields of interest include the study of proteins and stem cells (the undifferentiated cells of an embryo that ultimately can become any organ in the body).

Since the discovery in 1954 of deoxyribonucleic acid, or DNA, the basic building block of genetics, the pace of research and invention has accelerated greatly. Bioengineering allows specific manipulation of DNA, for example the introduction of new genes into tobacco plants so they produce human insulin. Genetic therapies involving humans attempt to change genetic sequences which cause diseases and disabilities. Using micro-arrays, research that used to take years and cost millions can now be completed in a few hours. Micro-arrays are devices with thousands of small receptacles, each containing molecules which react to a particular gene or other biological element; each molecule is tagged with a fluorescent dye whose glow indicates information about the reaction. A digital imager and computer can thus analyse thousands of micro experiments (each of which would once have required the time and attention of a human researcher) simultaneously. The human genome (the total pattern of the DNA elements in human chromosomes) has now been sequenced using micro-array technology. Future research promises drugs customized to individual people's genetic make-up or bioengineering to enhance particular characteristics rather than just to repair defects.

This chapter surveys the ways in which artists have responded to the advent of new approaches in biological research. Some celebrate the curiosity and accomplishments of researchers in understanding and shaping the nature of life; some engage in criticism, using art to investigate the dark underside of scientific exuberance and to deconstruct unrecognized assumptions in the way science conceptualizes, visualizes and operates. Other artists acquire scientific training sufficient to allow them to pursue independent lines of inquiry, while some of their colleagues engage with research simply to identify issues and generate comments in the form of conventional media such as painting or sculpture. The challenges are significant: working with phenomena below the level of human vision and with emerging technologies for which literacy is still developing. Artists' ingenuity in giving expression to their interests and concerns is remarkable.

Civilization has been engaged in genetic engineering for a very long time. Acting as both folk scientists and folk artists, breeders have propagated plants and animals for utilitarian and aesthetic purposes alike. While breeding does not inspire the same fears as bioengineering because it works with whole organisms, it does generate controversy, calling into question, for example, the principle of human domination of other species and the short leap from breeding to eugenics (shaping populations by selective breeding) to 'improve' the human species. In its modern form as biotechnology, breeding has gained awesome powers: cloning (making an organism whose genetics duplicate just one parent), targeted manipulation of specific traits, and crossing diverse species. These technologies have given rise to troubling questions, such as who should decide which traits are desirable and which are not.

Some artists have focused on breeding as a way to implicitly explore bioengineering and the questions it is

raising. For example, Brandon Ballengée's work focuses on ecological issues such as pollution and damage to the environment. In an extraordinary project entitled *Species Reclamation*, he uses breeding techniques to highlight the tragedy of environmental degradation and species eradication caused by human activity, focusing on resurrecting a species of frog that may be extinct (25). Reflecting specifically on eugenics, Gina Czarnecki and Keith Skene question whether we are ready for the choices biotechnology will enable. Their *Silvers Alter* lets viewers 'breed' virtual humans in a digital world (27).

Cloning has called forth huge controversy. Quite aside from whether a genetically identical organism really *is* identical to one of its parents, human cloning suggests scenarios such as mothers and fathers duplicating their genes in a child, and the creation of clones to provide organs for transplantation. Many governments have banned human cloning experimentation for ethical reasons.

Investigating ideas about the relative importance of genes and environment, Natalie Jeremijenko and the OneTrees organization undertook an ambitious project entitled *OneTrees* (26). This project created a thousand cloned saplings with identical genetic make-up; the saplings were then given to volunteers to plant in diverse environments so that the relative influences of nature and nurture could be tracked.

Proclaiming that bioengineering technology is a scientific landmark, supporters in the scientific community are predicting great advances in changing genetic sequences in the chromosomes that control heredity. Critics note, however, that there is more involved than a simple narrative of progress. Scientists may underestimate their lack of knowledge, be diverted by the profit motive, and move into controversial fields such as genetically modified food and the patenting of new organisms. Underlying these worries is the well-known Frankenstein fear. Is it hubris to undertake the god-like action of creating new life?

Artists have felt summoned to explore this continuum of opinion. Eduardo Kac (27) and Joe Davis, for example, undertook projects which modified the DNA of E. coli bacteria in order to carry messages. Davis's experience demonstrates an important feature of hybrid work. As a pioneer in the 1980s, he experienced great resistance from both the artistic and the scientific worlds for his 'outrageous' ideas. But freedom from convention is precisely one of the gifts the arts can bring to research. The concept of embedding bacterial messages is now a validated scientific discipline.

Taking the provocative position that the manipulation of genes for purely aesthetic purposes has become acceptable, Dmitry Bulatov undertook a project called *Static Chimerical Design* in which he changed the colouring of tadpoles genetically so that they could pass it on to their offspring (26). Eduardo Kac, perhaps the best-known artist working in this particular area, has created several works involving genetic engineering. In *GFP Bunny* (1), he arranged with researchers in France to genetically modify a rabbit embryo (ultimately named Alba) so that its fur would have a fluorescent glow. The researchers decided not to release the rabbit because of controversy about the validity of using such technology for this purpose, and a 'Free Alba' protest movement ensued.

Other artists take a more confrontational approach to some of the controversial socio-political aspects of bioengineering such as the ways in which profit can corrupt science. In this they are concerning themselves specifically with a critique of the influence of corporate motives in research by creating new kinds of artistic interventions: a melange of performance, guerilla theatre and installation. Although some critics dismiss this work as politics rather than art, these groups see themselves in the tradition of the Situationists and the German 'social' sculptor Joseph Beuys. These biotech events often incorporate the artists' own scientific-research activities and educational components to demystify research processes in general.

Critical Art Ensemble, perhaps the best known of these interventionist groups, has enacted a series of events in tactical media and biotech, focusing on such issues as eugenics, reproductive technology, genetically modified food and pharmaceuticals (29). Instead of simply agitating against what they see as corporate malfeasance, they work to disseminate a deeper understanding of the underlying science and make educating the public a key aim. For example, *Free Range* (2004) offered European audiences a portable lab to which people could bring foods to be tested for genetic modification.

Some artists are quite unnerved by the possible outcomes of bioengineering and the chimeras it might create. Illustrating this concern, Alexis Rockman's *The Farm* creates information-rich, 'scientifically accurate' paintings of possible bioengineered organisms based on an examination of both historic and future research trends (30–1).

Several artists have explored the research processes used in genetic engineering, mining them for the visual language they provide and commenting on the assumptions

on which they are based. Paul Vanouse's installations such as *Latent Figure Protocol* question the objectivity of the visual displays created by electrophoresis (a genetics-analysis tool in which a sequence of genes subjected to an electrostatic field reveals its properties by the traces left by each part as it moves), showing how the process can be manipulated to leave traces in the form of an arbitrary target image decided beforehand (35).

Not long ago, accessing and imaging DNA were esoteric processes; new technologies have made it possible for companies to analyse hair samples and provide corresponding DNA images to private individuals. Artists have used such imagery to update the genre of portraiture by incorporating it into sculpture, music, dance and conceptual work. For example, Justine Cooper's *Lamina* sculpture uses the DNA sequence in the ACE gene of her buyer (a gene supposedly responsible for athletic ability) to determine the structure of animated light sculptures (34).

Artists are also exploring the areas of embryology and proteins. In a landmark work entitled *Nature?*, Marta de Menezes used butterfly-wing patterns as her palette, having mastered a method of manipulating the process of butterflies' embryonic development in order to produce the desired patterns (33). In the area of proteomics (the study of the way in which proteins are activated by genes), biologists are making progress in understanding the ways in which the complex folding patterns of molecules are essential to the ability of genes to shape anatomy and physiology. Steve Miller creates images inspired by these unprecedented morphological shapes (18).

Finally, research on embryonic stem cells, the multi-potent cells capable of becoming any kind of tissue, has generated great hope as well as controversy (for example, reservations about using human embryos in experiments). Many of the artists active in this field are associated with SymbioticA. This unique hybrid art/science lab, sponsored by the School of Anatomy and Human Biology of the University of Western Australia, supports artists to work in frontier biology-research areas. One SymbioticA group, Tissue Culture and Art Project, uses tissue-culture research processes to create provocative artistic installations that grow quasi-living organisms (tissue kept alive outside bodies), thus questioning how life is defined and the position of humans in relation to other living beings. For example, *Disembodied Cuisine* grew quasi-living frog-skin tissue to serve as a new kind of meat, thus questioning human-animal relationships around the subject of food (36).

MOLECULAR BIOLOGY

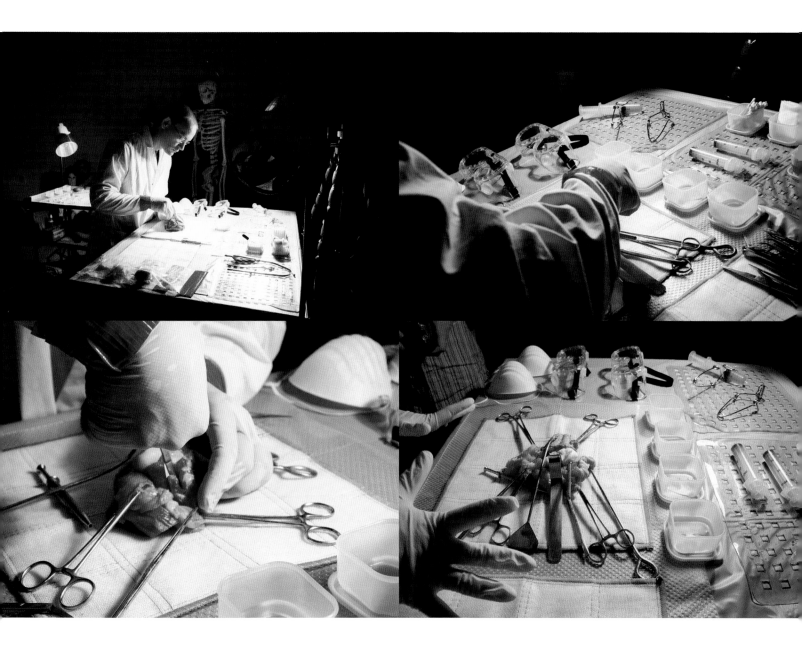

Jennifer Willet and Shawn Bailey,
BIOTEKNICA: Public Autopsy Performance,
2005. Meat is prepared in the style of an
autopsy to acquaint the public with medical
and research techniques. The image shows
a lab worker dissecting the meat, and
equipment such as scalpels, clamps
and flasks of preserving medium.
The Bioteknica project includes a
mock research organization, website,
art installations and public interventions
to educate the public and stimulate
critical reflection based on the conviction
that 'Science belongs to us all.'

Koen Vanmechelen, *Gallus domesticus,*
Genealogy: Cosmopolitan Chicken Breeding,
2000. Different species of chickens
from around the world are cross-bred,
symbolizing hopes for international
understanding. The dotted lines show
the order in which the birds are bred
to create a chicken with genes from
all of the 'parents'. The project also
includes sculpted chickens created
using processes such as 3-D scanning
and rapid prototyping (automatic
computer-controlled construction
of physical models in materials such as
plastic particles directly from 3-D data
files). Vanmechelen aims to stimulate
discussion about topics such as
globalization, racism and genetic
manipulation.

Christine Borland, *HeLa (Hot),* **2000.**
The installation consists of a typical
research bench with a digital-microscope
display of live so-called HeLa research
cells – cancer cells used in biological
research because of their unusual trait
of immortality. Like many of Borland's
works, *HeLa* is motivated by a desire
to increase public awareness that the
ability to respond selectively to genetic
information, made possible by new
research techniques, poses a cultural
and moral dilemma. For example, should
foetuses with 'undesirable' genes be
terminated?

GALLUS DOMESTICUS

MECHELSE COSMOPOLITAN

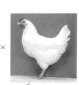

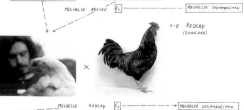

- Out of the F1 generation a stable variation can be bred through line breeding in every country
- Out of the F 1 generation " The Cosmopolitan chicken" the new chicken will be bred by cross - breeding

study: Gallus Domesticus Mechelse cosmopolitan part 1

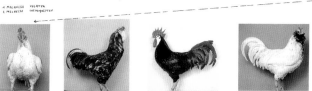

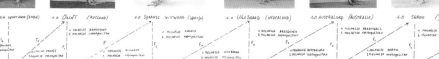

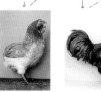

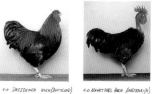

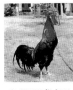

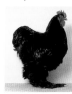

Brandon Ballengée, *Species Reclamation*, 1999– , photographed at Exit Art, New York, in 2000. This project attempts to recreate the possibly extinct *Hymenochirus curtipes* (Congo frog) by selectively breeding related frogs, which may carry some of the extinct frog's genes. The installation shows photographs of the breeding experiments, documenting all stages of development. Ballengée considers the adult frogs to be 'sculpted' living specimens.

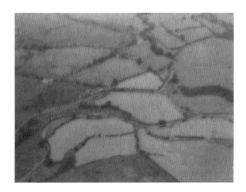

Heather Ackroyd and Dan Harvey, *Field Study – Aerial View*, **2003.** An aerial view of cultivated fields in Wales is reproduced by means of a unique technique: shining light through a negative image on to seedling grass instead of photographic paper. Under controlled conditions and using hybrid seed which loses its colour at a slower rate than other grasses, the imprinted image can be sustained over a prolonged period. The artists received grants to work with scientists to bioengineer a strain of grass with this resistance to fading.

Shiho Fukuhara and Georg Tremmel, *Biopresence*, **2004.** The artists plan a system that will insert fragments of a dead person's DNA into tree DNA to create a tree as a living memorial. The mock-up suggests the emotional attachments that might be engendered as people encounter a tree with DNA from a deceased relative. The work references the major research effort to use transgenic plants to grow human proteins – for example, tobacco plants growing insulin.

Natalie Jeremijenko, *OneTrees*, **1999– 2004.** Genetic clones are planted in diverse environments to monitor the relative influences of nurture and nature; the 80 genetically identical plantlets, ultimately to be planted in various San Francisco locations, already look different after several weeks' growth. The *OneTrees* website explains, 'Cloning has made it possible to ... copy organic life and confound the traditional understanding of individualism and authenticity.... The debate that contrasts genetic determinism and environmental influence has consequences for understanding our own agency in the world.'

Dmitry Bulatov with Konstantin Lukjanov and July Labas, *Senses Alert (Fragment of GFP-catalogue): Static Chimerical Design Patterned from Tadpole Xenopus laevis*, **2001– .** The multicoloured head of a tadpole, created by the team's bioengineering of frog genetics by introducing GFP genes. GFP, or Green Fluorescent Protein, and its relatives are jellyfish proteins, which turn various colours when exposed to ultraviolet light; the colourization is used by scientists to track biological functions. Bulatov takes the provocative position that genetic manipulation for aesthetic purposes is appropriate in the age of bioengineering, and sees the tadpole as having acquired new aesthetic qualities to pass on to its progeny.

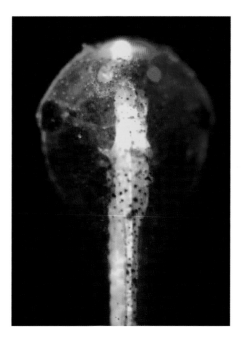

•••••••••••••••••➤

Eduardo Kac, *Genesis*, **1999.** This transgenic work was made with artist-modified E. coli bacteria, ultraviolet light, and internet and video components. At the right is a text from the book of Genesis about man's dominion over other creatures; at the left are the letters of this text converted into DNA base patterns. In the centre is a live microscope projection of a bacteria colony that was bioengineered to contain the biblical code. Web viewers could turn on ultraviolet lights aimed at the cultures, thus causing mutations in the bacteria, whose DNA was ultimately retranslated into a new version of the biblical words. Kac was exploring assumptions of dominion represented by bioengineering.

Gina Czarnecki, and Keith Skene, *Silvers Alter*, 2002. Viewers of this installation can select virtual humans to produce offspring and then decide whether the offspring may survive to parent the next generation. Large wall projections of naked figures with various personal and racial characteristics are controlled by a computer that senses audience motion as an indicator of what offspring should be encouraged. Here a synthetic person stands in front of an enlarged image of human hair (often used as a source for DNA extraction).

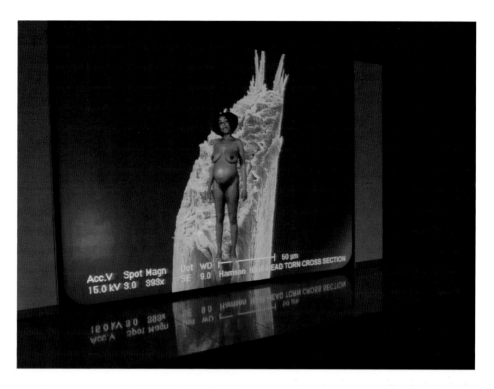

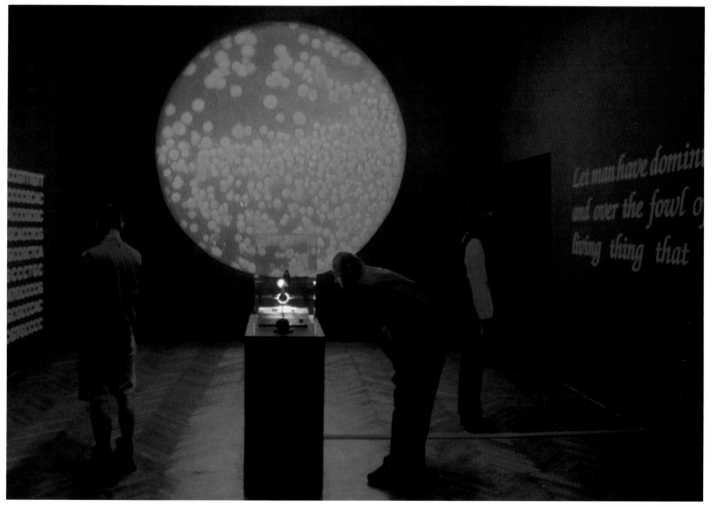

N55 and Heath Bunting, *N55 Rocket System: PROTEST 1*, **2005.** This low-tech, home-made rocket system was designed by N55 for distributing information from the sky, including 'Superweed' seeds, which were developed to be resistant to Monsanto's Roundup® herbicide. Roundup®-ready seeds are genetically modified to resist the herbicide, so that weeds can be sprayed without killing the crop. But the seeds must be purchased annually because they do not reproduce, and they may pollute nearby crops and cause health problems. Bunting's tactical media strategy was to render Roundup® ineffective, hoping that this would disable its indiscriminate use and stimulate debate about how scientific research is evaluated and used.

Kathy High, *Embracing Animal*, **2005–6.** An elaborate rat 'playground' is composed of environments for observing, entertaining and caring for castoff transgenic rats used in research projects on rheumatoid arthritis. High's project explores the moral complexities of human relationships with transgenic creations, especially those which include human genes.

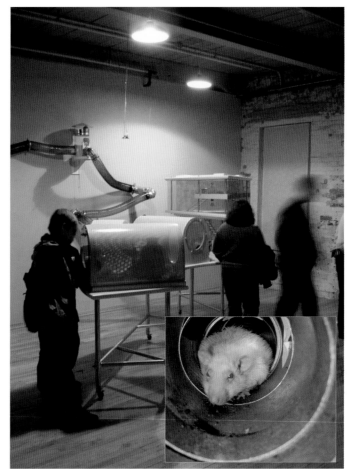

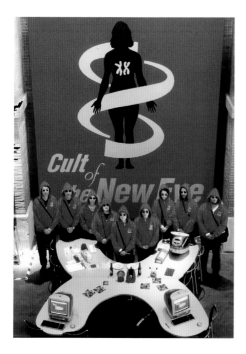

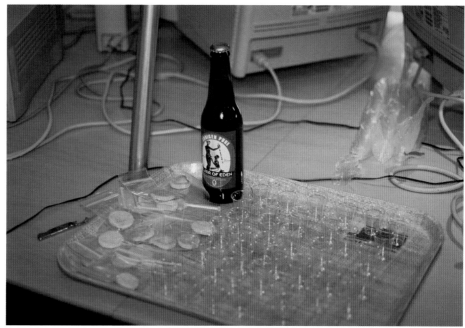

Critical Art Ensemble with Faith Wilding and Paul Vanouse, *Cult of the New Eve*, 2000. In this performance/installation, parallels are drawn between historic periods dominated by the Catholic Church and the current era obsessed with bioengineering. One illustration shows the performance group and the paraphernalia they use to draw parallels with church rituals, while the other shows wafers and beer brewed with genetically engineered yeast containing human genes – part of a new Communion. In inviting the audience to drink this beer with human DNA, the event demonstrates art's difference from science in its willingness to make research personal and passionate.

Critical Art Ensemble with Beatriz da Costa, *GenTerra*, 2001. This performance/ installation is intended to teach viewers about biotech research methods as a way of increasing literacy about the risks of releasing genetically modified creatures into the environment. As the project description explains, 'The public have the chance to create their own transgenic organism, created by using human DNA derived from blood samples. The participants can weigh up the pros and cons of transgenics for themselves.'

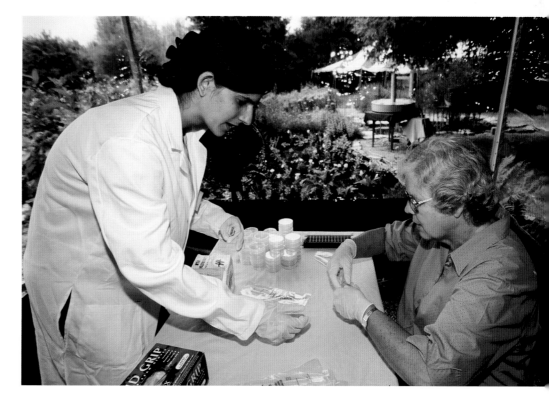

Alexis Rockman, *The Farm*, 2000.
The image shows familiar farm animals and then moves to informed speculation about how they might look in the future as a result of bioengineering. Also included are vegetables bioengineered to grow into geometrical shapes useful for packing and shipping. The project originally took the form of a painting, but was also presented as a New York City advertising hoarding in a project called DNAid mounted by the art group Creative Time.

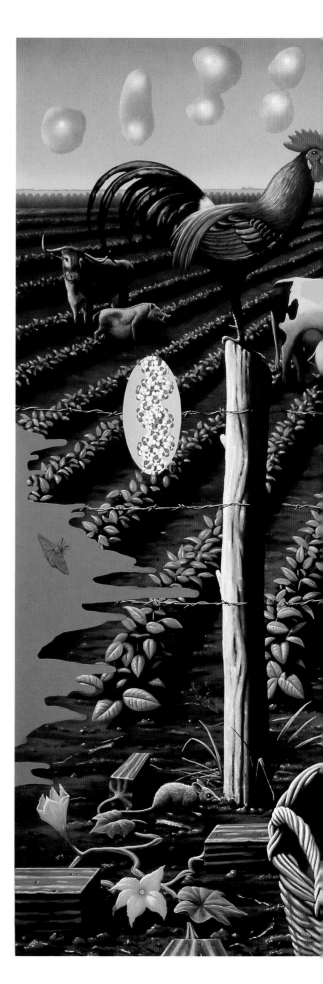

MOLECULAR BIOLOGY

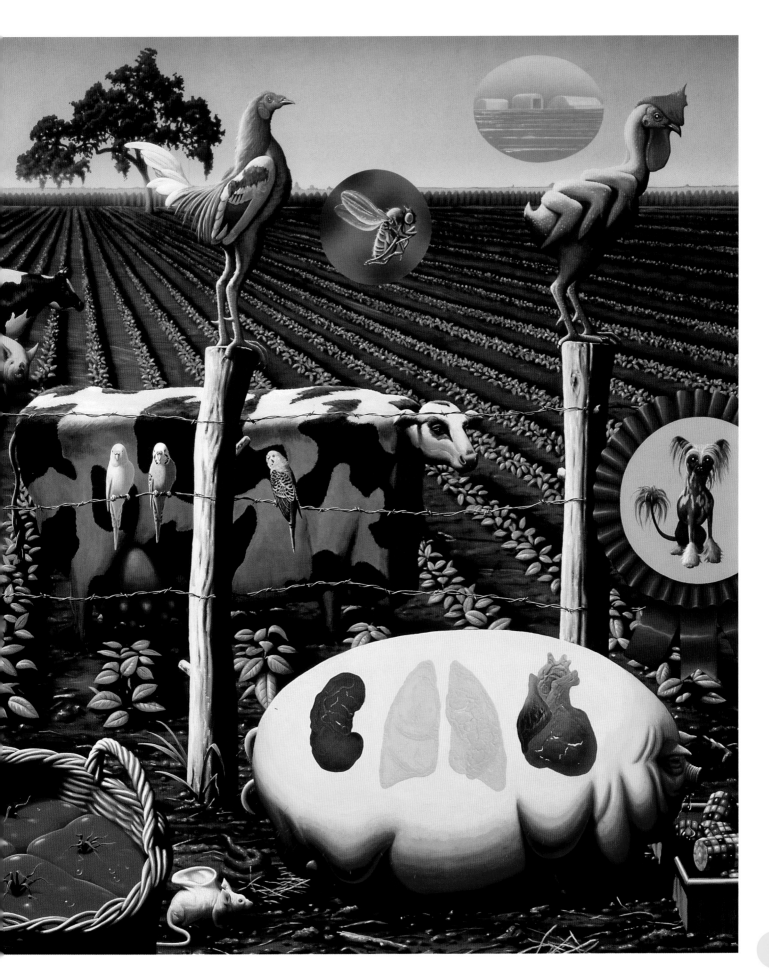

Marta de Menezes, *Nucleart*, 2003.
Art created by the use of fluorescent
DNA markers to colour particular
chromosomes is based on research
about where the chromosomes are
located in cells. The protein markers
glow when subjected to coloured lights.
Only visible through a microscope, the
different patterns result from the artist's
use of varying approaches to the staining
of one or more chromosomes in different
positions in the cell.

Jaq Chartier, *Chart w/Reds & Mixes*, 2006.
Inspired by scientific tests, Chartier
subjects materials such as paints and
stains to various transformative processes
caused by sunlight, passing time and
interaction with other materials. In this
wooden diptych she buried the stains
under other materials such as white
'stain blockers' and then tried to
reactivate them. The final painting
became a reference guide charting
the effectiveness of the blockers vs
the tenacity of the stains and their
components. The results resemble
electrophoresis, a research process
in which biological elements leave
differentiated traces when subjected
to electrostatic fields.

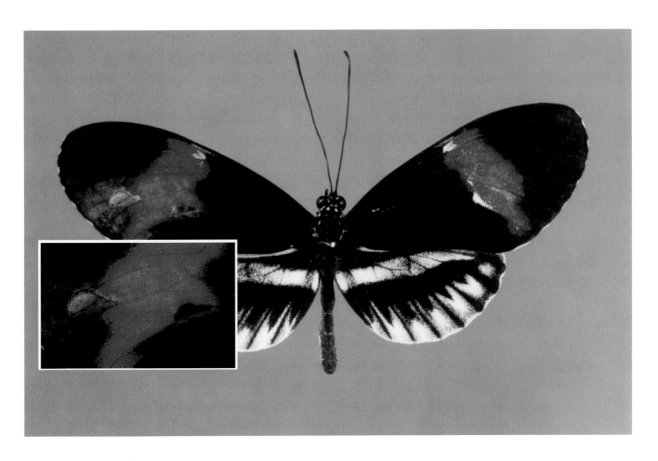

Marta de Menezes, *Nature?*, 2000.
The artist manipulated the wing-pattern-determining areas of butterfly embryos with the aim of producing unique patterns. The image shows a *Helliconius* butterfly with one modified and one unmodified wing; the blow-up shows a modified section. In this work de Menezes was modifying single individuals, not genetic make-up.

Justine Cooper, *Lamina***, 2000.** The moving pattern of lights and dark spots on this personalized kinetic sculpture are based on the client's ACE gene DNA sequence. The ACE gene is believed to be responsible for athletic ability.

◄········

Mark Quinn, *DNA Garden***, 2001.** This work is composed of a stainless-steel frame, polycarbonate agar jelly, bacteria colonies and seventy-five plates of different cloned plant and two human DNA samples. DNA is, according to the White Cube gallery's website, meant to '[emphasize] the broadly genetic similarity between humanity and other forms of life'. Quinn was one of the first artists to include images of sitters' DNA in portraits.

···············►

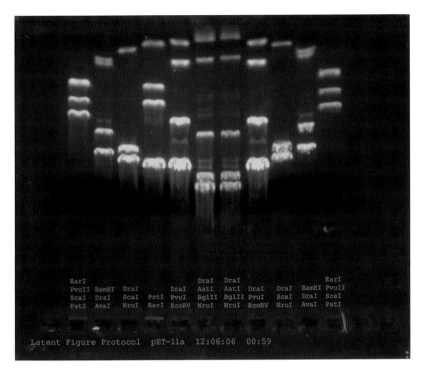

Latent Figure Protocol pET-11a 12:06:06 00:59

Paul Vanouse, *Latent Figure Protocol*, **2006.**
Here the DNA-electrophoresis research process has been manipulated to produce a specific target image, the international copyright symbol. Electrophoresis allows researchers to make conclusions about DNA qualities by seeing how far protein elements are moved when subjected to an electrostatic field; this image shows DNA traces left on a research surface. Vanouse questioned the objectivity of the process by choosing enzymes and DNA fragment sizes that would be moved the appropriate distance to create the desired image.

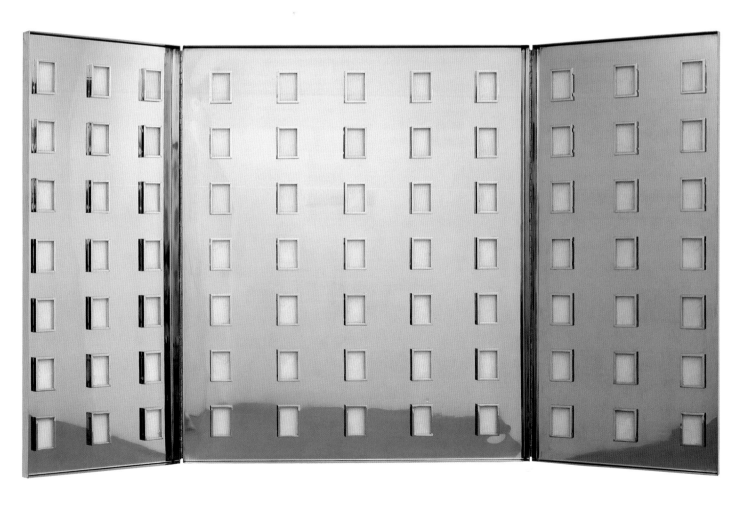

Tissue Culture and Art Project (Oron Catts and Ionat Zurr), *The Victimless Leather – A Prototype of Stitch-less Jacket Grown in a Technoscientific 'Body'*, **2004.** Mouse and human cell lines are cultured to 'grow' a leather-like living layer of tissue laid over a biodegradable polymer scaffold. The image shows the artificial leather in the central glass vessel and the perfusion pump and other lab equipment necessary to keep the tissue bathed in blood-based nutrients to enable it to grow. The artists want viewers to think about the 'implications of wearing parts of dead animals for protective and aesthetic reasons' and, more generally, about human exploitation of other creatures.

Tissue Culture and Art Project (Oron Catts and Ionat Zurr), *Disembodied Cuisine*, **2003.** This project asks viewers to consider the human consumption of other animals by growing in-vitro 'steak' via tissue-culture techniques. The installation, in Nantes, France, includes a working tissue-culture lab with windows through which viewers can observe lab procedures such as the feeding rituals of the 'Semi-Living Steak', in which the artists bathe the disembodied cells in nutrients to keep them alive; a terrarium with live frogs; and a banquet table at which viewers can eat the 'steaks' at the end of the three-month process.

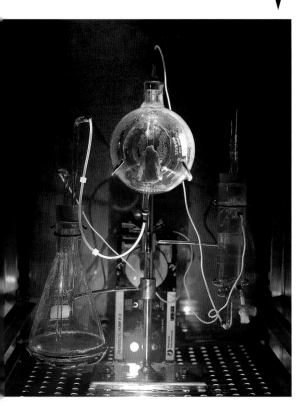

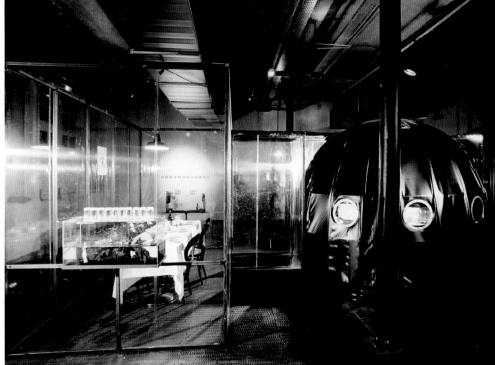

Jane Prophet and Neil Theise, *Cell*, 2003.
This project generates 3-D computer animations to model the behaviour of adult stem cells. The screen grab shows simulated cells in the process of reproducing. In the live interactive system, moving a mouse over the images reveals more information about each cell. Prophet, an artist, and Theise, a cell scientist, received a Wellcome Trust Sciarts grant to pursue the collaboration. The project description explains that '[o]ne aim has been to find new ways of visualising the new and contentious theories of stem cell behaviour, and to find ways to feed the visualisation back into the scientific research'.

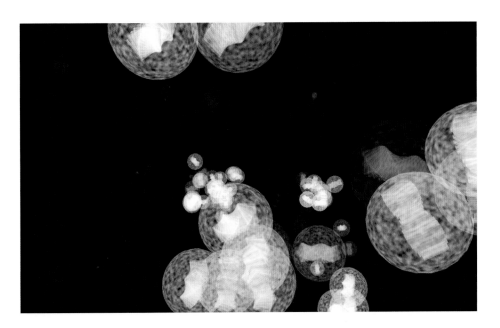

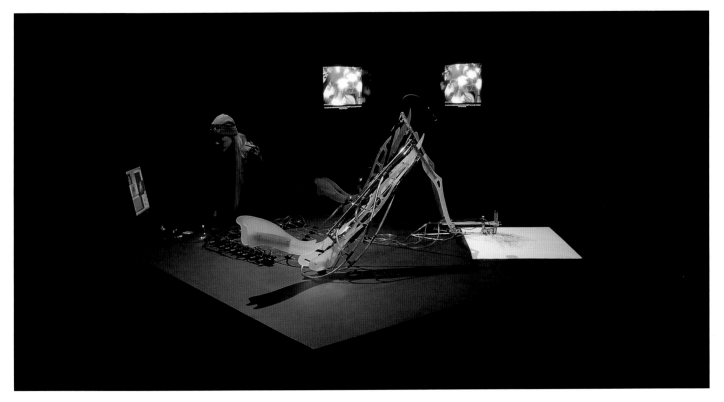

SymbioticA in collaboration with the Dr Steve Potter Lab, Georgia Tech University, *MEART – The Semi Living Artist*, 2001–7. Living rat neurons growing in a culture dish control a robotic drawing arm via the internet. The video monitors show the rat-cell culture located far away. The robot arm is fitted with drawing pens and receives its control signals from the electrical impulses that are typically part of living neurons. (The SymbioticA Research Group includes Guy Ben-Ary, Phil Gamblen, Oron Catts, Dr Stuart Bunt and Iain Sweetman.)

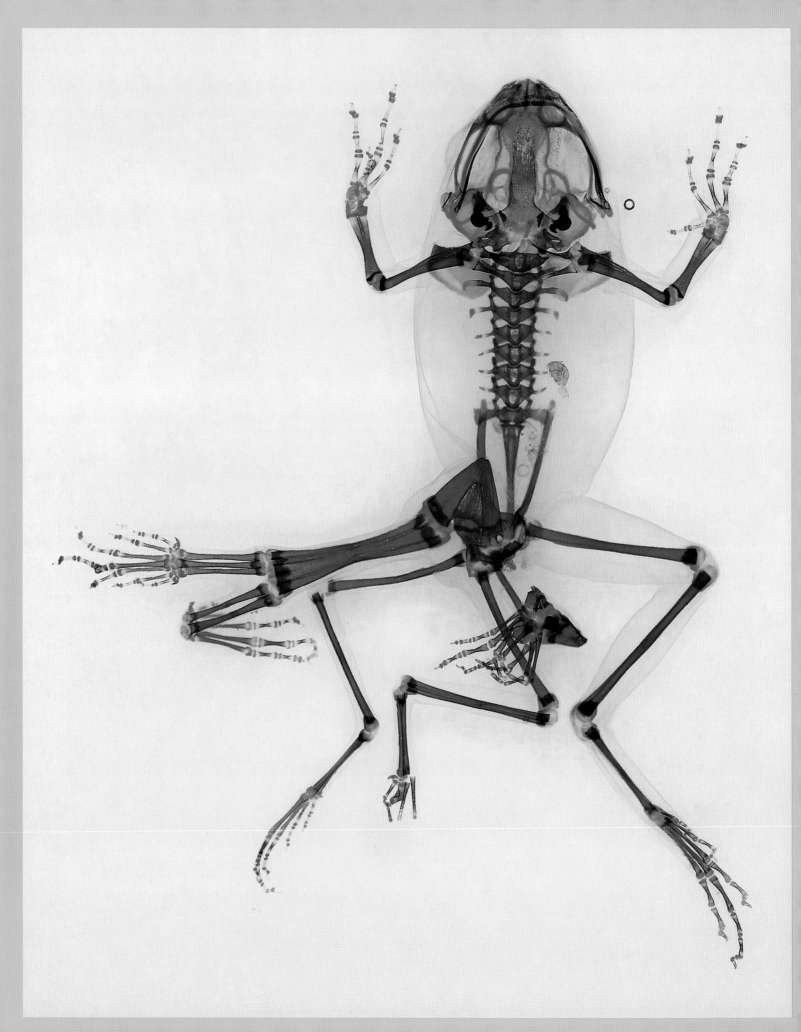

LIVING SYSTEMS

2

Brandon Ballengée, *DFA 18, Triton*, **2001/7.**
This poster-sized image shows a frog malformed by pollution. Ballengée developed a special chemical process that makes skin and other tissue transparent while leaving bones and cartilage stained with various colours. These techniques were considered unorthodox, but are now being adopted by scientists. His careful analytical and observational skills earned him qualification by the US Geological Service as an official guide. Ballengée sees the invention of information-rich, scientifically accurate and visually provocative ways of engaging the public in research as critically important.

For much of its history, biology focused on organisms we could see with the naked eye or with the aid of simple instruments. Scientists studied life in their back gardens and set sail to exotic lands. They observed, documented, dissected and experimented. Why? They were driven by such practical concerns as the improvement of agricultural methods, and by metaphysical agendas such as the quest to understand the essence of life and the differences between humans and other creatures.

Artists similarly focused on the portrayal of plants and animals; indeed, many painters and sculptors became famous for their powers of observation and skill at rendering what they saw. Artistic observation became a major resource for scientists and a model for how to document the world's creatures. Rarely, however, did artists incorporate living organisms into their work. Several trends in and outside of the art world have changed that in recent years. As the arts opened themselves up to new media and to contexts other than museums and galleries, working with living organisms became a compelling possibility. In both popular and scientific culture, the ascendancy of biology and its success in spreading knowledge and visual information about other species stimulated attention. More recently, global warming and international ecological crises have urgently focused our attention on our relationships with other species.

The artists documented in this chapter have all worked with living organisms, from simple life forms such as moulds and worms, through insects and mammals, to entire ecological systems. In doing so they have adopted the frameworks, tools, research findings and processes of contemporary biological research. The diverse agendas they have pursued include updating the traditional interest in animal and plant still-life compositions to incorporate life forms only accessible through research; inventing new art forms that explore dynamic processes of other species;

deconstructing research processes and related ethical questions; and both interrogating and celebrating humanity's connection to the web of life.

Aided by new tools and technologies, biologists have in recent years been intensifying their study of microorganisms and other small life forms such as bacteria, protozoa, moulds, sponges, corals and worms, all of which inhabit the lower branches of the evolutionary tree. These creatures are crucial to our understanding of how life on earth has evolved, and are critical to the maintenance of virtually all living beings (one example being bacteria that control decay or disease).

Artists who have tried to enlist bacteria and moulds in image-making have taken on the challenge of understanding these organisms, their life cycles and the ways in which they can be cultivated to accomplish artistic agendas. These artists see the indeterminacy that is seen in other life forms as related to the art world's interest in random processes. For example, some artists concentrate on the abstract patterns created by bacteria and slime as they grow. Daro Montag's *This Earth* (44) creates images by exposing photographic film to bacterial action in the soil near his home. In *Breath Cultures* (2004) Sabrina Raaf invites visitors to breathe onto a liquid or gel culture medium and then displays the accumulating bacterial growth. Amy Youngs's *Intra-terrestrial Soundings* (2004) uses infrared video and live audio to make the subterranean movements of a worm colony situated inside a sculpture a focus of aesthetic contemplation.

Although plants are sometimes thought of as being less complex than animals, many of them have evolved in sophisticated ways. Artists have explored features of plant biology including processes of survival and decay, evolution and communication.

Focusing on photosynthesis (the conversion of sunlight into carbohydrates that is at the core of the survival of most

living organisms), Philip Ross's sculptures such as *Junior Return* present hydroponic (in other words, growing in water instead of earth), self-sustaining, glass-enclosed environments which make the process of plant survival – the conversion of light into nutrients – the focus of aesthetic presentation (48). Mateusz Herczka's *Vanda* is a life-support system in which computers control the care of orchids and monitor their life processes, as indicated by changing electrical signals on the surfaces of their leaves (49).

In the course of research on plant communication in the 1970s, scientists discovered small amounts of electrical voltage on plants' exteriors. Some claimed that these were reactions to environmental events and might represent an unacknowledged, understudied communication channel – possibly an indication that plants experienced emotions. Several sound-art projects have linked audio to these fluctuating signals. For example, inspired by an interest in global consciousness, the *Trees on the Internet* project (2000) uses its monitoring of the flow of sap in trees to generate music and images on the web. The *Botanicalls* project also links plant communication with an extended network. Humidity sensors placed in these environments monitor moisture levels and ring the owners on mobile phones to tell them via customized voices that the plants are thirsty (50).

The artistic interest in plant communication (sometimes called psychobotany) is also relevant here. Most mainstream biologists dismiss psychobotany as pseudo-science or 'fringe science', perhaps put off by the claims of plant emotion and undiscovered realms of communication. Yet, as we have seen, one possible value of artists' involvement in research is their willingness to explore ideas outside dominant paradigms (this is true across the board, not just in the context of plant communication, as will be obvious throughout this book). Since the history of science has shown that an overzealous policing of conceptual borders can impede progress, this body of unsanctioned artistic research might end up as a valuable resource, one possible example being studies of plant sensitivities to the biological states of other creatures nearby.

Attracted by the idea of mixing the familiar with the alien, artists have created work inspired by the scientific understanding of insect life, observing and intervening in turn. Ursula Damm's *Double Helix Swing* uses a network of cameras and speakers to invite viewers to observe the swarms of midges that form on lakeshores and to change the movements of male flies by manipulating speakers broadcasting the 'seductive' wing sounds of females (54). At first glance, Angelo Vermeulen and Luc De Meester's *Blue Shift [LOG. 1]* installation looks like a light-and-water sculpture. In fact, the aquariums house communities of single-cell algae, water fleas, fish and water snails engaged in a mini-Darwinian drama activated by changing light, colours and behavioural responses (52).

An interest in theoretical issues such as embodiment and the military uses of robotized animals inspired Garnet Hertz to create *Cockroach Controlled Mobile Robot*, in which a Madagascan hissing cockroach controls its host mobile robot through its own movement on a control trackball (52). Borrowing from scientific research, artists also create events which can enhance our fascination with animals and fish through observation and intervention. Revealing the beauty of fish activity in the wild, Julie Freeman's installation *The Lake* used hydrophones to track tagged fish in order to generate a sound-and-animation composition based on their movements (59). Gail Wight's *Rodentia Chamber Music* installation allowed mice to 'perform' inside Plexiglas instruments including a piano, a carillon, a drum, a harp and a cello. The instruments had been optimized to respond to movement patterns learned from extensive observation of mouse colonies (58).

Building on knowledge of homing-pigeon behaviour and wishing to join species symbolically in an ecological intervention, Beatriz da Costa, along with Cina Hazegh and Kevin Ponto, devised a system to monitor pollution levels over several cities, including San Jose, Irvine and Newport Beach, California, and Linz, Austria, by means of pigeons who sent data via small wireless backpacks (57). Natalie Jeremijenko undertook a series of interspecies communication projects called *OOZ* (*zoo* backwards), which proposed to elevate animals to equal status with humans in the observation/reaction process by enabling the animals to shape the installation (56). Looking at the relationships among species, Adam Zaretsky and Julia Reodica created *The Workhorse Zoo*, in which they lived for a week in an enclosure in a museum with a variety of organisms typically used in research (for example *C. elegans* worms and *Xenopus* frogs). This installation invited viewers to reconsider the scientific objectification of animals as it enabled the observation of uncontrolled relationships among species outside a research environment (60).

Attempting a more comprehensive biological analysis than is possible if one studies a single species, ecologists research

how organisms interact with each other and their physical environment. In recent years the term *ecology* has come to have a shorthand meaning denoting concern and activity in interconnected spheres such as climate change, species loss, pollution and energy conservation. Mirroring these larger social interests, many artists have begun to focus on such subjects, some quite passionately. They have organized events to collect baseline data on the use of natural resources and pollution, created installations exploring ecological principles, developed new technologies and instigated socially engaged interventions. Some ecologically oriented artworks involve biology only implicitly, focusing instead on the physical systems that enable life, such as climate.

Basia Irland, who merges the roles of artist, researcher and activist, has executed multilayered public-participation projects such as *A Gathering of Waters* in an attempt to educate viewers by documenting the threats facing the Rio Grande river system in the American southwest, including dwindling water supplies and waterborne diseases (60). Also reflecting on water shortages in many parts of the world, the *Sustainable* installation created by David Birchfield, David Lorig and Kelly Phillips consists of a closed network of pipe-connected robot water gongs. The changing sounds of the gongs reflect the system's attempts to maintain equilibrium by constantly adjusting the water levels between them (60).

Several activist groups such as Superflex are exploring new technologies such as biogas in an attempt to spread ecological awareness and highlight the worth of sustainable technologies (61).

All of these artists and others who work with living systems realize that humans are not alone on the earth, and aim to develop new ways to bring knowledge of other species and their life processes into artistic discourse. In addition, they are commenting on the ways in which scientists pursue their studies of animals as well as searching for appropriate ways to respond to global ecological challenges.

Eduardo Kac, *Clairvoyance*, from the 'Specimen of Secrecy about Marvelous Discoveries' series, 2006. 'Biotopes', the name Kac gives to these works, are glass-covered frames containing colonies of microorganisms in a nutrient base, which slowly change their appearance as a result of their metabolism and external conditions. Kac's choice of microbes and method of positioning them help shape each biotope's appearance. Referring to his interest in this dynamic ecology, he has described a biotope as 'an ecological system that interacts with its surroundings as it travels around the world. Every time a biotope migrates from one location to another, the very act of transporting it causes an unpredictable redistribution of the microorganisms inside it'.

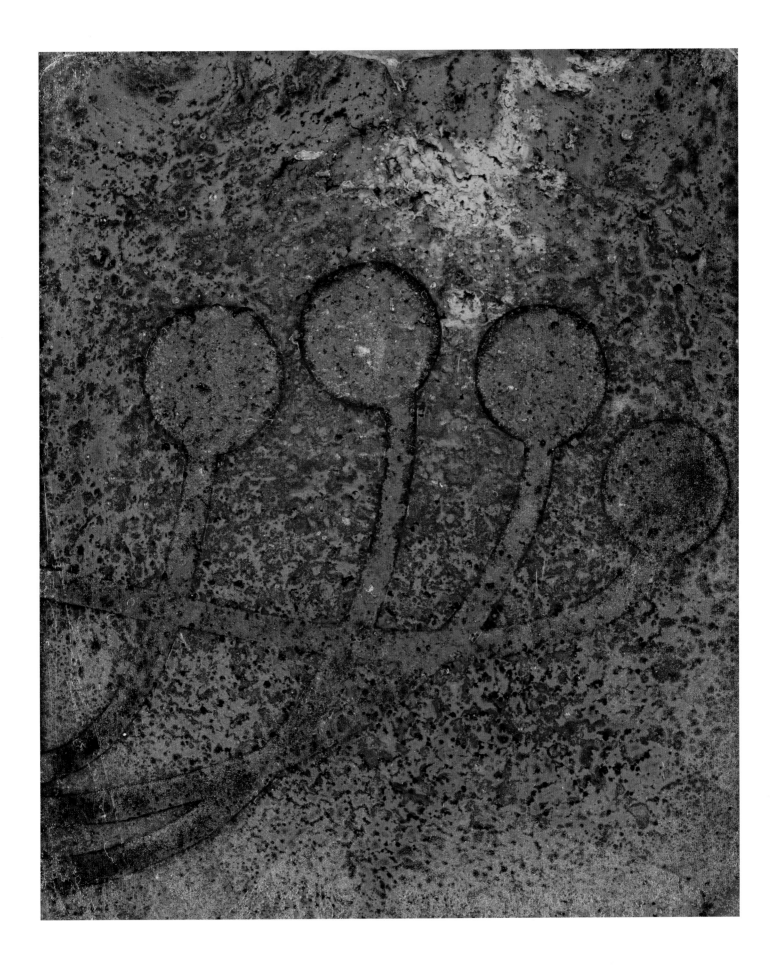

Daro Montag, *This Earth*, **2006.** Five strips of colour film were buried for a month in the soil near Montag's home in Cornwall, England. Soil microbes ate into the gelatin, absorbing different amounts of the dyes and leaving unique patterns of colour. The second illustration shows a microscope image of a section from one of the strips. Montag says that one goal of the project was 'making physical that which is there but not seen'.

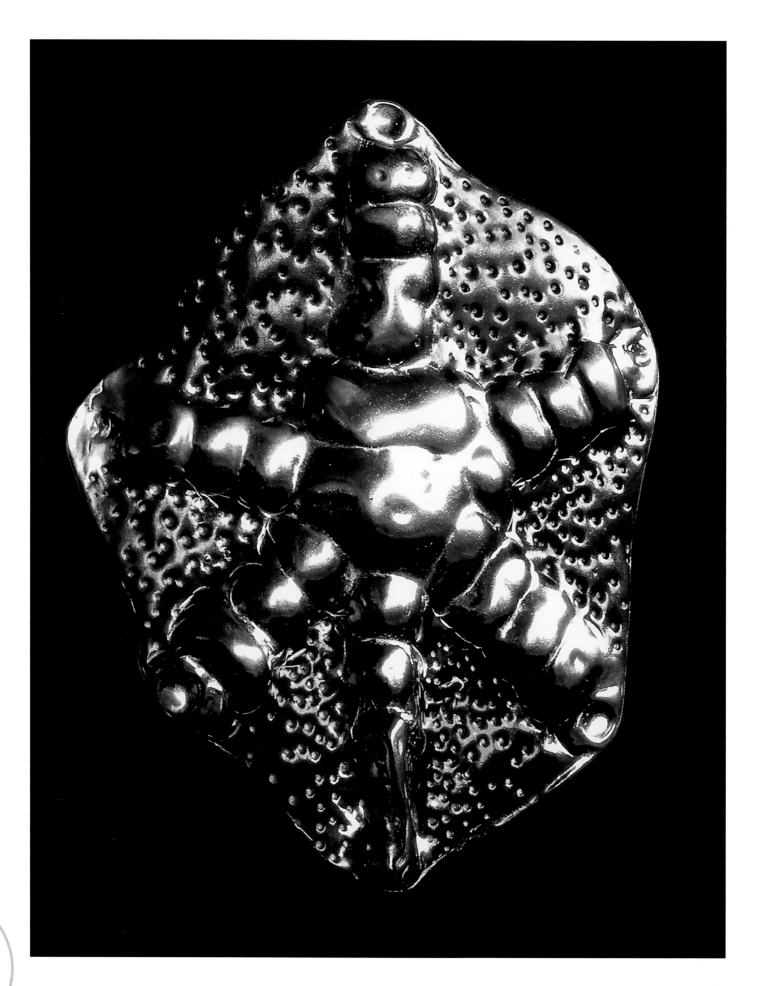

Karin Beaumont, *Oceanides, Art of the Ocean™: Future Skeleton in the Closet*, 2006. This sterling-silver pendant was inspired by the microscopic marine algae *Asteromphalus*. The artist, who is also a marine biologist, uses her understanding of life forms she sees in the course of her research as inspiration for jewelry: 'It's not just seeing the beauty, but perhaps the understanding ... of how they move, how they interact, also helps me with determining the shape and form.'

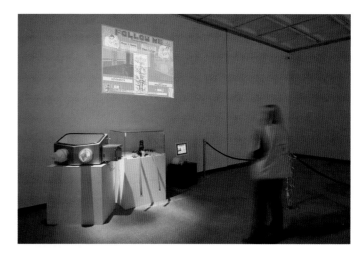

Stephen Wilson, *Protozoa Games*, 2002. In the *Follow-Me* game, humans score points by observing live protozoa's movements closely enough to mimic their behaviours. The illustration shows a moving player, while the displays show a microscope image of protozoa in motion and the computer's video tracking of the player. Also shown are plastic tubes and a glove box, a device used in biology to work with dangerous materials. In the *Control-Me* game, viewers try to convince protozoa to move by singing or speaking to them via the tubes or controlling light switches in the glove box. The installation probes 'the ethics of animal and human experimentation' and the 'nature of intelligence and consciousness'.

Faculty from the Center for Biofilm Engineering and Montana State University School of Art, *Bioglyphs*, 2002. This detail shows a panel from a group of self-illuminating paintings created by using bioluminescent bacteria as an artistic medium. The process raised such research challenges as choosing creatures with appropriate light-producing behaviours, understanding how to formulate the high-salt medium necessary to stimulate emissions and sustainability, and developing gestures to apply the bacteria to the medium. The creators note that the 'pale blue glow produced by these bacteria evokes an aura of the mystery of life in the remote depths of the ocean'.

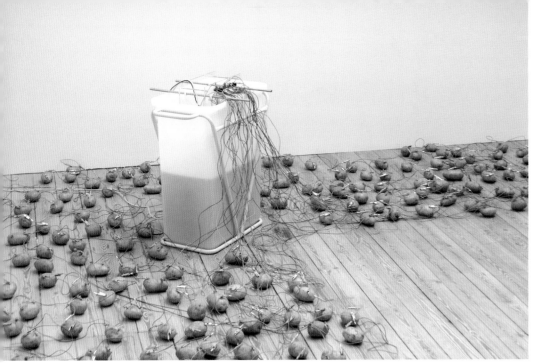

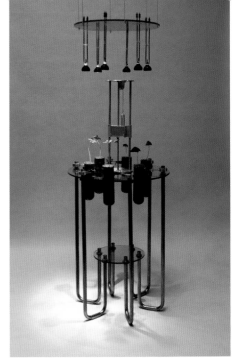

Mogens Jacobsen, *Power of Mind 3*, **2006.**
Power derived from decaying potatoes
(the national food of Denmark) is read
by a sensor connected to a computer.
The acid chemistry of decaying fruits
and vegetables generates small amounts
of electricity; here potatoes are connected
by wires to a vat that helps to accumulate
the electrical charge. Based on the level
of charge generated, the computer reveals
increasing amounts of a politically sensitive
government report on human rights on
the internet.

Allison Kudla, *Search for Luminosity*,
2005–7. In this installation the early-
morning movement of leaves towards
the light is detected by sensors, which
control artificial lighting to reinforce the
plant's circadian activity. Six plants are
fitted with sensors and over each is fixed
a computer-controlled light. Some plants
sleep while others are activated as the
system tracks what Kudla has described
as the 'cyclic yet enigmatic property of
our lives'.

Philip Ross, *Junior Return*, **2006.**
This sculpture focuses on self-sustaining
hydroponic plant environments, in other
words plants grown in water rather
than earth. The illustration shows
an installation composed of several
of these self-contained environments,
each with chambers housing the plant,
the water reservoir, lights, electronics,
an air pump, a digital timer and a
rechargeable battery. The process
of plant survival – the conversion of light
into plant nutrients – is one focus of the art.

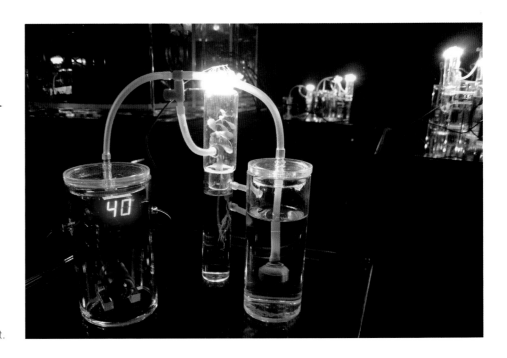

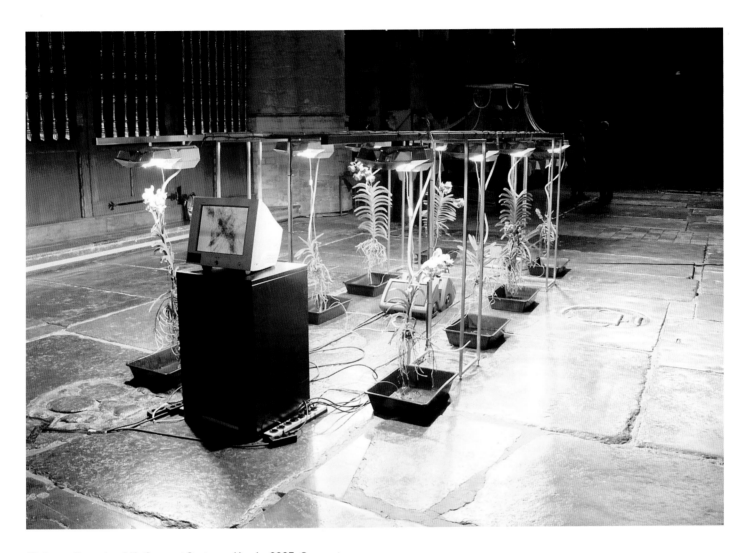

Mateusz Herczka, *Life Support Systems: Vanda,* **2005.** Computers control the care of *Vanda* orchids and monitor their life processes. The image shows eight plants with sensors and computer-controlled lights. As the project website explains, 'The goal is to create a virtual organism ... which can exist indefinitely, kept alive inside computer media in the form of a datastructure.... After the live individual is disconnected, its virtual counterpart will continue to generate signals which mimic the patterns of the original.'

Kate Hartman, Kati London, Rebecca Bray and Rob Faludi, *Botanicalls*, 2006. Humidity sensors in the earth surrounding potplants trigger telephone calls, in which a pre-recorded voice linked to the plant informs the plant owner that the plant is thirsty.

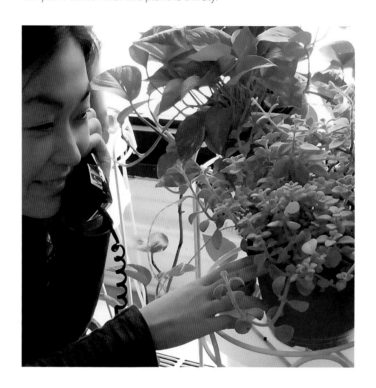

Douglas Easterly and Matthew Kenyon, *Spore 1.1*, 2004. A rubber plant bought at Home Depot is kept in a computer-controlled housing that contains wi-fi components to access the internet and to drive the system's water pumps. The system constantly monitors the price of the Home Depot's company stock via the internet: when the stock is doing well the plant receives more water, when it declines so does the water supply. The artists see the installation as a metaphor for the idea that many of the cultural systems we perceive as self-contained are really parts of larger interconnected webs.

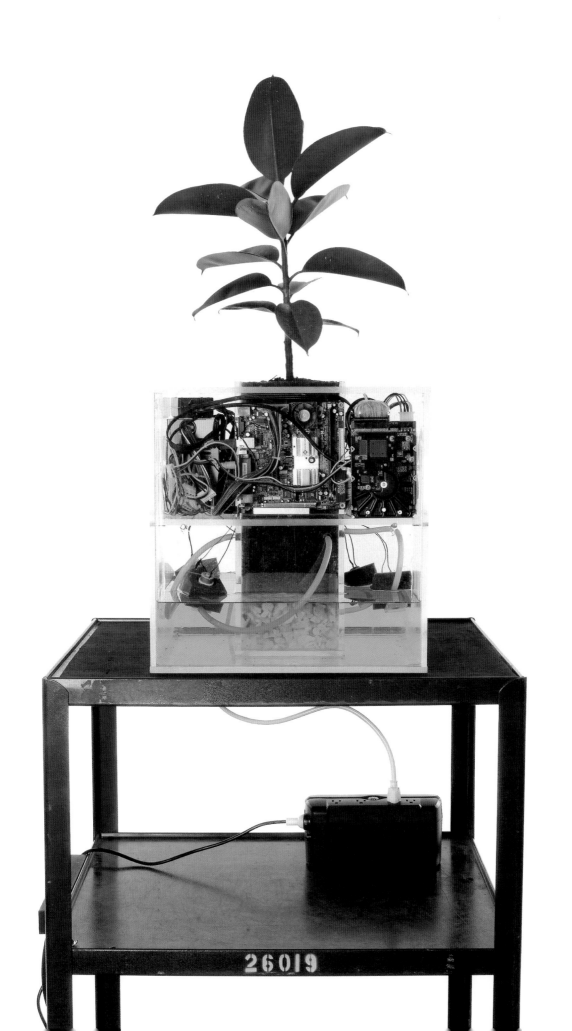

26019

Andy Gracie (hostprods), *Small Work for Robot and Insects*, 2003. In this two-chamber environment a robot and crickets co-exist. The robot uses neural-network software to analyse cricket sound production and develop sound repertoires and actions, which in turn stimulate the crickets to respond.

One aim is to see if the two entities can evolve a functioning proto-language. The project website describes the agenda in this way: 'The work frames an interest in exploring connections between machine and nature that are outside the typical areas covered by cybernetics or purely scientific study.'

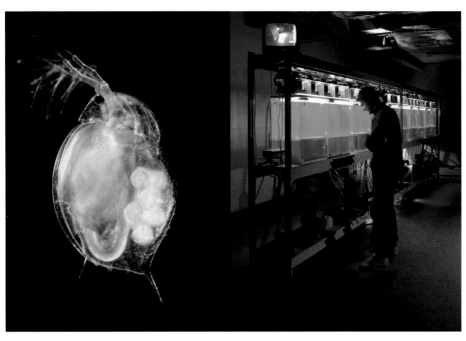

Angelo Vermeulen and Luc De Meester, *Blue Shift [LOG. 1]*, 2005. The aquaria house communities of single-cell algae, water fleas, fish and water snails. Visitors induce Darwinian evolutionary pressures on the fleas by changing the colour of the light from yellow to blue. Repelled by blue light, the water fleas escape into unprotected areas, where they are eaten by fish, leaving fewer light-responding offspring. For the sake of statistical comparisons the installation includes five dual aquaria replicating the experimental conditions. Vermeulen has noted that he is interested in the 'interplay of Science's desire to understand everything and Art's willingness to entertain the unknowable'.

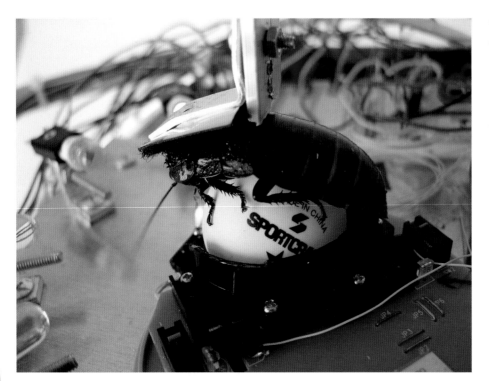

Garnet Hertz, *Cockroach Controlled Mobile Robot*, 2004–5. A cockroach sits atop a large mobile robot and controls the robot's direction and velocity. The robot is part of a series of projects linking dead and living animals by means of electronics and telecommunications. For example, in *Experiments in Galvanism* (2003–7), a web server was embedded in the body cavity of a dead frog, thus allowing gallery and web visitors to twitch its legs via electrical stimulation. Hertz sees his projects as addressing theoretical issues, such as embodiment, post-humanism and cultural commentary on bio-robotics and the military uses of robotized animals.

Miya Masaoka, *Ritual with Giant Hissing Madagascar Cockroaches,*
2002. This performance, intended to explore 'empathy and ...
inter-species interactions', involved live cockroaches crawling on
the artist's naked body; when their movements interrupted laser
beams, sounds of their hissing were triggered, and the noise of
their movements was also part of the sound source. Masaoka
described the cockroaches' activities on the blank canvas of
her body as a metaphor for the way humans construct culture.

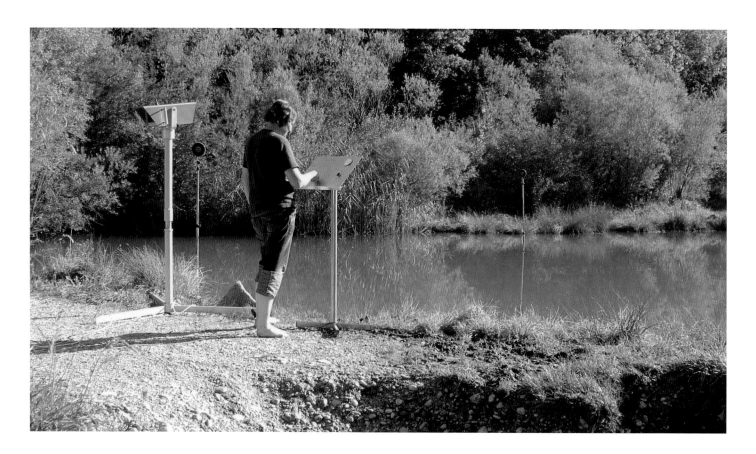

Ursula Damm, *Double Helix Swing*, **2006.** This installation in a lake induces midges to form swarms and records them. Research shows that swarms consist of male midges aiming to attract females by means of unique wing-beating patterns. Building on this, Damm distributed loudspeakers broadcasting female wing-beats under the water, and designed image-analysis software to take still pictures when the cameras detected swarms forming. The illustration shows a viewer at the interface panel.

Laura Beloff, *Fruit Fly Farm*, **2005.** The wearable *Farm* is an acrylic ball containing a fruit-fly colony which viewers are invited to adopt, observe and carry around with them. The public can call an enclosed mobile camera (shown on top of the inner globe) to access current images, which are also posted to a website. The inner globe carries fruit for the flies to snack on. Beloff wants participants to think of them as a 'living community' rather than 'a nuisance and a pest'.

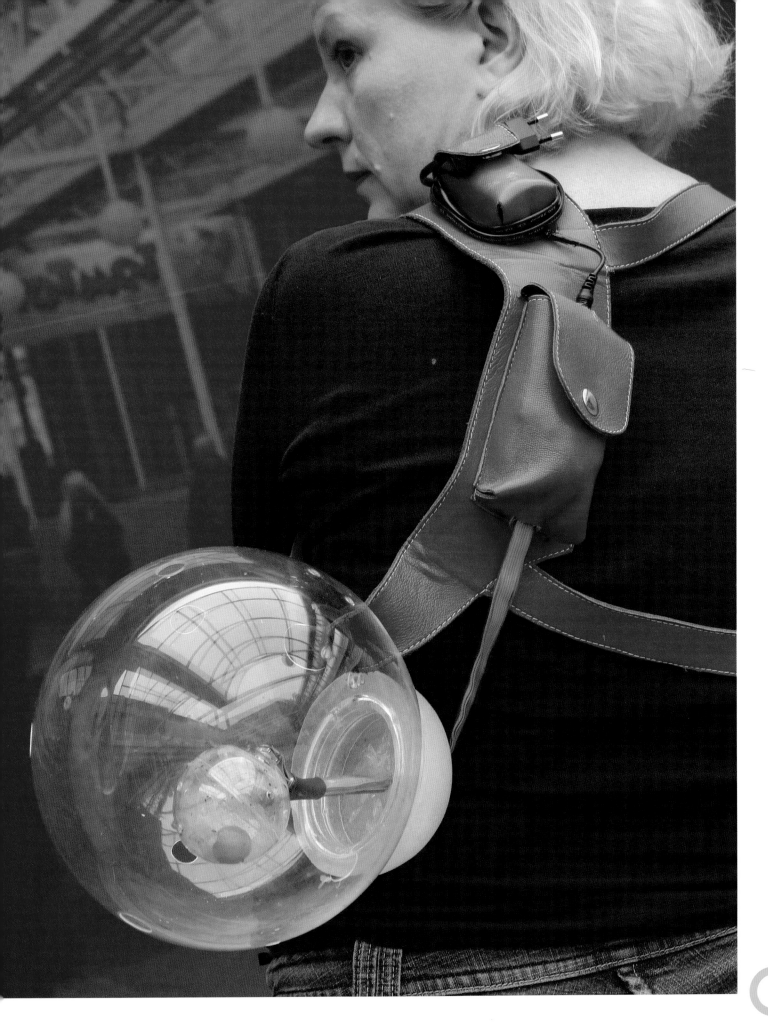

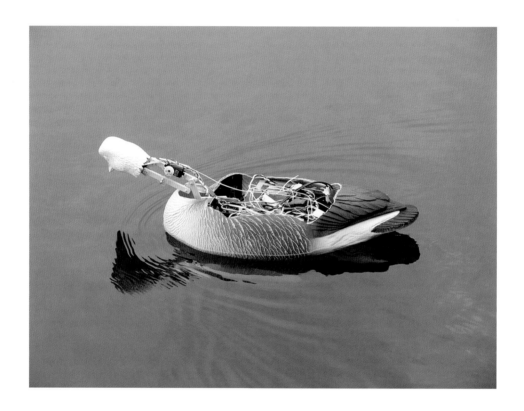

Natalie Jeremijenko, *OOZ*, 2002–6.
A series of interspecies communication projects proposed to elevate animals to equal status in the observation/reaction process. The illustration shows a cutaway view of a goose robot from one of the projects. Viewers, using a 'goose chair' to convert human motion into robot-control impulses, try to manoeuvre the robot geese to behave in a way that live geese in the same stretch of water accept, so that the two can interact. A description on the Langlois Foundation's website references 'an architecture of reciprocity, i.e. any action you can direct at an animal, it can direct at you'.

Beatriz da Costa with Cina Hazegh and Kevin Ponto, *PigeonBlog*, **2006.** Based on the artists' study of pigeon behaviour, homing pigeons are fitted with backpacks to gather data on air-pollution levels. The computerized backpacks contain GPS and altitude-monitoring equipment and mobile-phone systems for sending information. Questions addressed by the project include: 'How can a non-academic public become involved in grassroots scientific data gathering? How can real-time information about current localized pollution levels be made public? How can a mutual[ly] beneficial human and non-human relationship be developed in an urban context inhabited by both beings?'

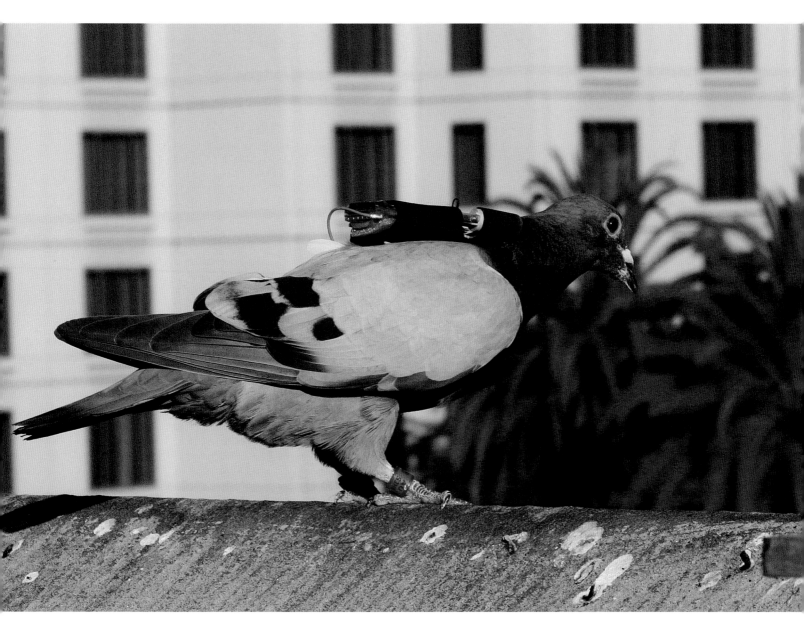

Vitaly Komar and Alex Melamid,
Asian Elephant Art and Conservation Project, 1997– . Elephants are taught to paint and the sale of their paintings generates income for elephant refuges. The image shows Elisa, a popular elephant artist from Bali. Komar and Melamid founded this not-for-profit project to help save Southeast Asia's elephants and their handlers, who were being put out of work by logging restrictions. The paintings sell for £200–£2,800. Komar and Melamid's conceptual agenda is humorously summarized as follows: 'Elephants are ... innocent and not corrupted by the art market.'

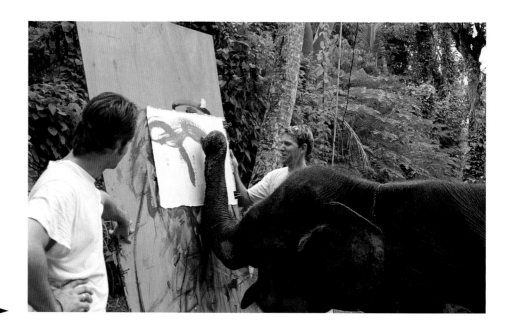

Gail Wight, *Rodentia Chamber Music*, 2004. The installation allows mice to perform inside clear Plexiglas versions of musical instruments at approximately human scale. Based on detailed observation of mice in several projects, Wight placed sensors in good positions to be activated by them. For example, motion sensors on the vertical runway in the harp (left) activate its strings. As Wight notes, 'I've looked for some intrinsic aspect belonging to this other creature, and used that as the central process or focus of the work.'

Julie Freeman, *The Lake*, 2004. This project creates sound and animated displays based on tracking the movements of fish in a lake. Tags inserted into the fish generate bio-acoustic signals which are picked up by hydrophones (microphones for receiving sound under water); the installation broadcasts spatially distributed sound to indicate fish movements. This blow-up of the face of one the tagged fishes is projected on a steel tank located nearby.

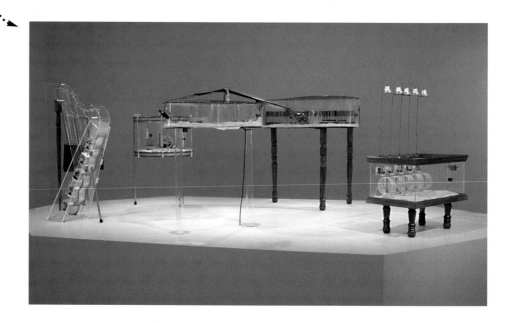

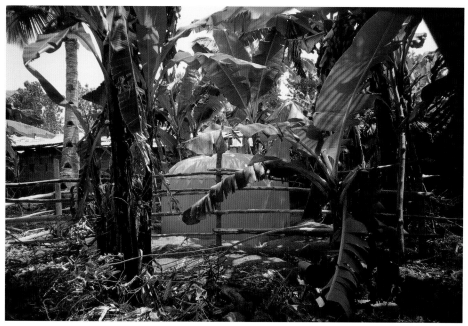

Superflex (Rasmus Nielsen, Jakob Fenger and Bjørnstjerne Christiansen), *Biogas Project,* **2002.** These artists work with people in Third World countries to create simple, user-friendly biogas generators for purposes such as illumination. A family in Thailand is shown eating in the glow of a lamp powered by a biogas generator. The generators are series of spherical vessels connected by valves and piping which capture gases such as methane given off by cow dung, rotting vegetable matter and other organic material. This project was part of Rirkrit Tiravanija's *The Land Project,* in which he bought a plot in Thailand and invited artists to undertake ecological investigations.

Ingrid Koivukangas, *Five Circle Project: Vancouver,* **2002.** This detail from an installation consisting of a grid of 144 jewel boxes, shows compartments containing natural materials found at twenty sites located on concentric circles overlaid on a map of the city of Vancouver. The project was designed 'to provide the viewer with a starting point to begin contemplating their own landscape and possibly their part in its preservation'. Trees were planted at the sites, and video recordings were made.

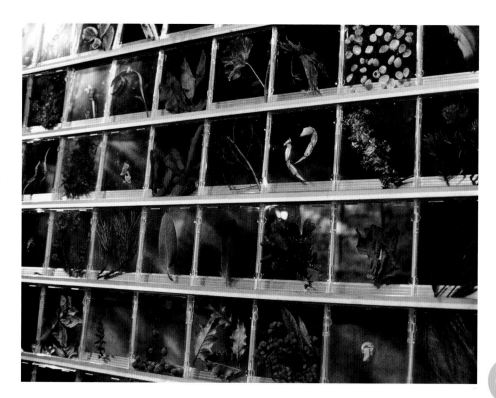

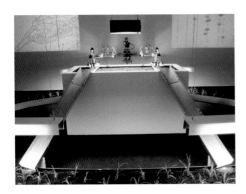

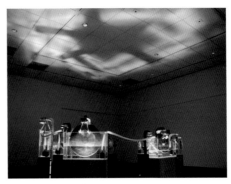

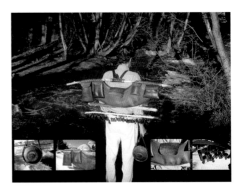

Andy Gracie (hostprods) and Brian Lee Yung Rowe, *Autoinducer_Ph-1*, 2006. This bio-artificial nutrient ecosystem for growing rice uses water-fern azolla, a traditional Southeast Asian fertilizer. Synthetic bacteria – computerized life forms that read sensors from the system and modify its behaviour – create emergent parasitic and symbiotic balances between the rice plants, live bacteria and other aspects of the ecosystem. The image shows a microscope, a projection showing live and artificial bacteria, glass chambers/ pools for the ferns, and robotic arms which deliver the organisms to fertilize the plots. The artists seek to comment on over-industrialized agriculture systems.

David Birchfield, David Lorig and Kelly Phillips, *Sustainable*, 2004. Water gongs arranged in a network constantly seek to maintain stable water levels by pumping water to neighbours. The installation consists of seven tanks, which contain gongs, computer-controlled mallets to sound the gongs, pumps and plastic pipes. The artists have explained the metaphor of the work this way: 'The network of water gongs share a limited resource of water, and its constantly shifting allocation between the members of the system models the shifts of natural, cultural, and intellectual resources throughout the networks of our local and global communities.'

Basia Irland, *A Gathering of Waters: Boulder Creek, Continental Divide to Confluence*, 2007. The work is a series of events to study and document ecological threats such as dwindling water supply and waterborne diseases. The main illustration shows a hiker with a hand-sculpted backpack made from recycled car tyres; the small illustrations show a canteen, pouches for holding maps and logbooks, a brace, and small bottles for water and plant samples. Irland, who merges the roles of artist, researcher and activist, has executed many multilayered events. Her process, half performance and half scientific study, often involves the community in data collection. She is often the only artist invited to address international scientific conferences about water.

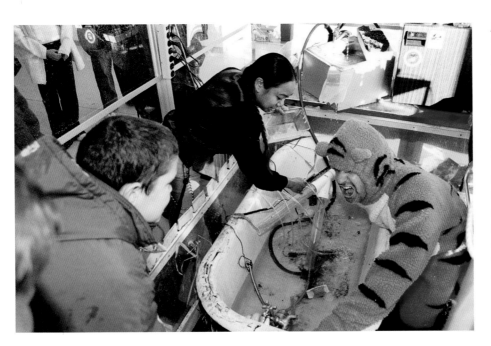

Adam Zaretsky and Julia Reodica, *The Workhorse Zoo: Animal Training Day*, 2002. For one week the artists lived in a small portable laboratory in a museum with a variety of organisms, including species popular in scientific experimentation, such as E. coli bacteria and *C. elegans* worms. The image shows Zaretsky dressed in a tiger suit (referring to the artists' being observed like zoo animals) and Reodica adjusting the living conditions for some of the fellow-inhabitants. The work critiqued science's reductionist approach to isolating species in artificial situations, the objectification of organisms, and the separation of humans from the web of life.

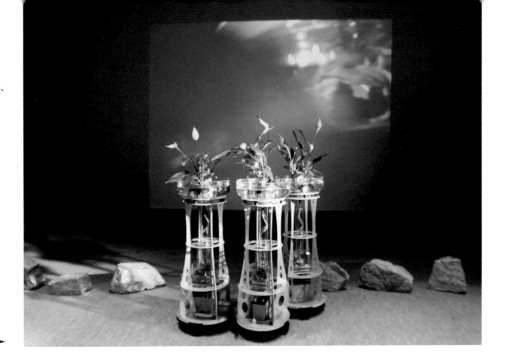

Ken Rinaldo, *Augmented Fish Reality,* **2004.**
Fish moving in small aquaria control the movements of their host robots to interact with other fish and humans. The image shows three of the robots. The fish move in the aquaria at the top; fish-motion sensors send control impulses to electronics in the bases of the robots. The projection shows fish-eye views from wireless videos inside each robot. The installation is based on Rinaldo's reading of biological research which sees fish as intelligent, able 'to mentally map their environments in finding food, creating relationships with each other and avoiding predators'. ⋯⋯⋯➤

Kira O'Reilly, *Wet Cup*, 2000. Warmed glass spheres placed over cuts in the artist's body slowly extract blood as they cool (cooling creates a partial vacuum). Working in the traditions of extreme theatre and body art, O'Reilly employs bloodletting as a provocative aspect of her art. She has developed a sophisticated understanding of the biology of blood and alternative technologies to work with it. O'Reilly hopes her performances stimulate her audience to 'consider the body as a site in which narrative threads ... knot and unknot in shifting permutations'.

HUMAN BIOLOGY

Research in human biology is of obvious interest because it has practical implications for our health and well-being. From a philosophical point of view, it illuminates our quest to understand ourselves and the nature of life. Theoretical and technological advances have stimulated interest in how the brain works, the origins of emotion, the imaging of internal structures and processes, and medical intervention. Illustrating the optimism about the ultimate powers of many areas of study and experimentation, researchers in pharmacology believe that they will be able to create 'designer drugs' tailored to individual people's genetic make-up and geared towards specific biological goals. Although this area is somewhat controversial, a move is already apparent away from remediation towards enhancement of such functions as physical strength, intelligence, sexuality and longevity. The optimism and excitement in both the biology and the medical-research communities are palpable.

Critical theorists such as Michel Foucault and Donna Haraway, however, have cautioned that the paradigm of progress must be examined, asking, for example, how research problems and priorities are identified, and noting that many 'givens' such as gender, disease and pain may be cultural artefacts rather than facts of nature. New technologies also assault time-honoured notions of privacy by exposing the insides of our bodies to public view. Theorists warn that imaging systems do not provide unadulterated access to core levels of reality, but rather produce screen images based on sets of decisions embedded in the technologies that underpin them. Functional Magnetic Resonance Imaging (fMRI), for example, determines oxygen use in the brain – thus implying activity levels – by reading the magnetic spin of molecules. The resulting screen images derive from the mapping of spin values to visual qualities such as colour and brightness. While the developers of

fMRI equipment claim that this system of visual representation was chosen to optimize scientific information, others might have chosen different mappings. Critics also note that research projects aimed at augmentation of different traits do not adequately address such ethical and cultural issues as their relative desirability. The name *trans-humanism* has been given to the body of analysis attempting to understand how the possibilities and limits of human existence are changing in light of new technologies.

The artists discussed in this chapter have begun to develop work that addresses many of these research areas and theoretical questions. Their diverse agendas include updating traditional approaches to portraiture to include research-based imagery from inside the human body; using science's ability to monitor bodily processes to create new forms of interactive art; deconstructing the assumptions of medical interventions and bringing research processes and concepts into the public arena; and engaging in debates about trans-humanism and attempts to stimulate and enhance the body.

Some artists have used scientific tools to create provocative sculptures and events which provide new perspectives on visible body elements such as the skin. For example, the American Julia Reodica's *hymNext Project* used tissue-culture techniques to generate a synthetic hymen, the part of the female anatomy examined to determine virginity (66). The Belgian artist Wim Delvoye's robotic installation *Cloaca Original* provocatively simulated the human digestive system, taking food in at one end, processing it and extruding solid waste from the other end twenty-seven hours later (67).

Since thought, the senses and the emotions are felt by many people to be resistant to scientific analysis, biologists'

progress in deciphering brain function is a highly charged activity that has generated great interest in both philosophy and the arts. One of many projects looking at philosophical as well as scientific questions, *Einstein's Brain Project*, was devised by a Canadian collaborative of artists and scientists. Their project *Shapes of Thought* created three-dimensional synthetic shapes visualizing a brain's responses to recollections of traumatic events (68). Britain's Wellcome Trust Sci-Arts programme, which funded collaborations between scientists and artists, supported several projects focused on brain research. In one, the artist Clara Ursitti collaborated with odour scientists to create smell-based works such as *Pheromone Link TM*, a scent-based dating agency (68). The artist Andrew Carnie and the neuroscientist Richard Wingate worked together on *Magic Forest,* a digital-media event featuring image sequences of neuron development (68).

Utilizing physical qualities such as light, sound and magnetic spin, medical-imaging researchers have invented radical ways of looking at bodily processes and structures inside the body. Artists are drawn to imaging technologies both to explore the sensual opportunities this new information offers and to stimulate public consideration of its implications.

The British artist Annie Cattrell's *Sense* converted the data collected from fMRI scans of brains during sensory experiences (seeing, hearing) into three-dimensional sculptures (72). Phillip Warnell's *Endo-Ecto* performance offered live images from the artist's own digestive track as a capsule endoscopy, or pill camera, made its way through his system (75).

Technologies such as biological imaging have stimulated debate about whether their outputs should be considered art. For some, the images generate aesthetic resonance based on traditional photographic criteria such as composition, colour and form. Others, however, feel that the images should be considered as mere scientific illustration if they offer nothing aesthetic beyond the use of imaging devices to make them.

Medicine and disease are of course a major locus for biological research and action. Artists find these areas intriguing because medicine, with its economic power and critically debated concepts, is a controversial arena. In *Mosquito Box*, the German artist Oliver Kunkel asked viewers to confront their knowledge of, and disinformation about, the dissemination of the AIDS virus by inserting their hands into a box filled with mosquitoes

that apparently had been flying in proximity to people with AIDS (76). In a very different context, the architects Jean-Gilles Décosterd and Philippe Rahm's *Melatonin Room* offered a vision of how architecture can incorporate medical knowledge: the room's lighting system was based on research about the health benefits of particular kinds of illumination (76).

Medicine and biological research are no longer the only places for technological interventions involving the human body. Increasingly, trans-humanist artists are challenging the body's limitations as well as prohibitions against modifying and augmenting it. Precedents include ancient body-modification traditions in both Western and non-Western cultures, including piercing and tattooing, and pioneering work by the French artist Orlan, who undertook plastic surgery on her own body as a series of artworks.

Illustrating the interest in augmentation, *Psymbiote* by isa gordon in collaboration with Jesse Jarrell and DEvan Brown investigated cyborgian ways to integrate displays and actuators controlled by manual triggers, automatic body processors and remote control through bodies and clothing (78). (A cyborg is an entity part-organic and part-mechanism.) Working with the most delicate of human muscles, those of the face, Arthur Elsenaar and Remko Scha's research project on the use of electrical stimulation to control expressions has moved into 'facial choreography', creating 'choruses' of people whose facial distortions are controlled by a computer (79).

Perhaps the most renowned artist commenting on bodily extensions, Stelarc, has mounted installations in which his body was controlled by his audience, the internet and artificial intelligences. This Australian artist has developed various augmentations such as a third hand, exoskeleton walkers and a prosthetic head. His *Blender* installation used tissue-culture techniques to amalgamate cells from his own body and that of a fellow artist (78).

As far as the monitoring of bodily processes is concerned, scientific researchers have developed noninvasive devices to read brainwaves (EEG), heartbeat (EKG), pulse rate, breathing and skin resistance (GSR), among other functions. The medical and biological research communities are optimistic that monitoring bio-signals can significantly enhance our understanding of brain and body function as well as facilitate intervention when necessary. The relevant technologies have already become part of a range of consumer devices – for example, exercise

monitoring, biofeedback for mental enhancement and telemedicine monitoring of the elderly. Future scenarios might involve decoding thoughts sufficiently to enable communication and control, for example of artificial limbs by paraplegics.

Artists experimenting with these technologies seek to reflect on our ability to assess internal functions and to investigate the appropriate artistic use of bio-signals. The latter have been brought into play to control music, games, web surfing, video and kinetic sculpture. Moving into areas as yet largely unexplored by scientists, artists have experimented with sending bio-signals over telecommunication lines, linking them to specific locations and finding ways to create systems which can integrate signals from many people. For example, Lynn Hughes and Simon Laroche's *Perversely Interactive System* linked a viewer's relaxation (as indicated by a GSR feedback device) to his or her ability to motivate a synthetic video character's openness to encounter (81). In *Pimp My Heart*, Takehito Etani linked a car's bass-amplifying sound system to blast out the driver's heartbeat, detected by a wearable pendant (83). Kal Spelletich and the American robot group Seemen have invited viewers to control a variety of machines via body signals. For example, their *Lie Detector Halo* (2003) spurted fire when a voice-stress detector indicated that a lie was being told.

Christian Nold's *Biomapping* is an ambitious British project that has created 'emotion maps' synthesized from data gathered as people explored their neighbourhoods wearing GSR emotional-arousal sensors and GPS location sensors (83). *Brainscore*, a virtual-reality performance for two operators created by the Slovenian artists Darij Kreuh and Davide Grassi, challenged viewers to control the movements of avatars (3-D computer-graphic personas representing them) by means of their own brainwaves and eye-tracking technology, which notes the direction of a person's gaze by determining the relative position of his or her pupil (80).

We may think we know our bodies, but these artists and others like them are introducing us to radical ways of thinking about physical functions. Their work hints at the profound challenges with which we will be confronted as scientific research unfolds further.

Julia Reodica, *Living Sculpture Series: hymNext Project*, 2005. An artificial unisex hymen was grown from the artist's own vaginal cells and mammalian smooth-muscle cells, using tissue-culturing techniques. The tiny bit of living tissue is shown in nutrient liquid media and enclosed in an acrylic magnifying box; it is shaped like the biological symbols for male and female. The project critiqued the traditions of using hymens to test virginity, seen by many as indicators of male hegemony.

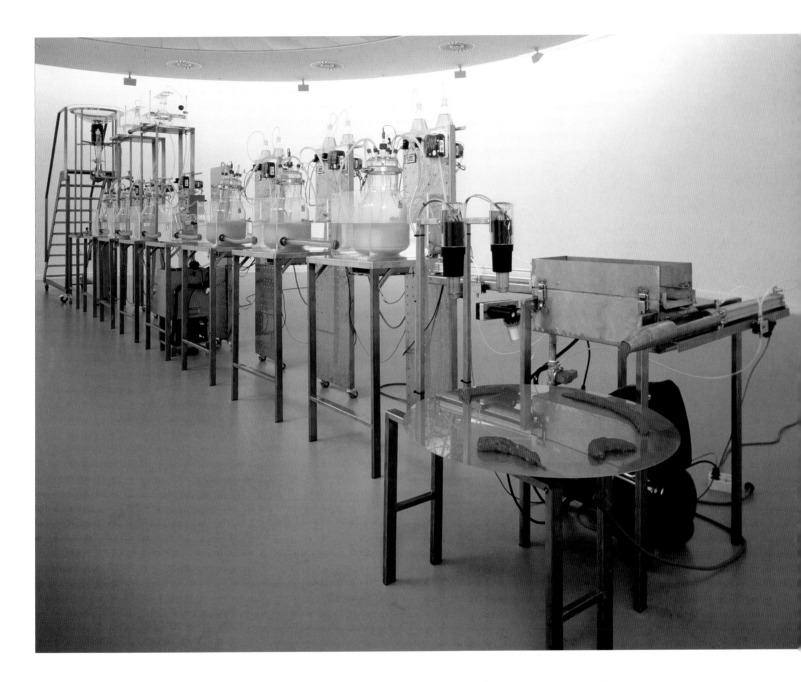

Wim Delvoye, *Cloaca Original*, 2000. This robotic installation simulates digestion by taking in food, digesting it and excreting artificial faeces. The photo shows six glass vessels connected by electronics and plastic piping; the vats apply a variety of biochemical and physical processes to the food matter as it is moved along. Dan Cameron, a curator at the New Museum in New York, analysed the installation's appeal this way: 'Delvoye forces viewers both to consider our social discomfort with such functions and to question the elaborate cultural mechanisms that we have constructed to keep them from view.'

Clara Ursitti, *Pheromone Link TM,* **2001.**
In this scent-based dating-agency installation, viewers choose their partners guided only by sniffing a selection of T-shirts previously worn by them. This tongue-in-cheek approach is based on research showing that many animals use pheromones (chemical odour traces) to guide mating and other behaviour. Ursitti, who collaborated with odour scientists over several years, sees her installations as an 'important test case for working at the borders of art and science and for developing languages for areas of inquiry without developed languages'.

Andrew Carnie, *Magic Forest,* **2004.**
The nine stills from this slide-dissolve installation showing the growth of neurons in the brain are derived from work by the neuroscientist Richard Wingate. The data was collected from microscope inspection of brain slices. The mass of the head fills with neurons, which become increasingly more developed and interconnected, then ultimately recede into dissolution. Convinced that artists and scientists can be major resources for each other, Carnie believes that '[a]rt is too important to be left to artists – science too important to be left to scientists'.

Susan Aldworth, *Brainscape 24,* **2006.**
This etching is from a series based on the cerebral angiograms of thirty hospital patients. A cerebral angiogram is an X-ray of a high-contrast dye flowing through the arteries of the head or brain. Aldworth, who has collaborated with many researchers focusing on the physicality of consciousness, has noted, 'I still cannot escape the thought that I am seeing all this and thinking all this because of the very thing that I am looking at. The brain is a very strange and marvelous thing. It is not like a heart or a kidney. It is thinking flesh.'

Alan Dunning, Paul Woodrow and Morley Hollenberg, *Einstein's Brain Project: Shapes of Thought,* **2006.** A visualization of data taken from a participant monitored by electroencephalograph (brain-wave electrical activity) and electrocardiogram (heart electrical activity) when asked to recall a traumatic event in which he had been injured. The illustration shows a conversion of the readings into 3-D computer graphic slices during the period of recall (indicated along the top), which lasted for eight-and-a-half hours. The project is a long-term collaboration between artists and scientists to investigate and critique the ability of new technologies to represent cognition and affective states.

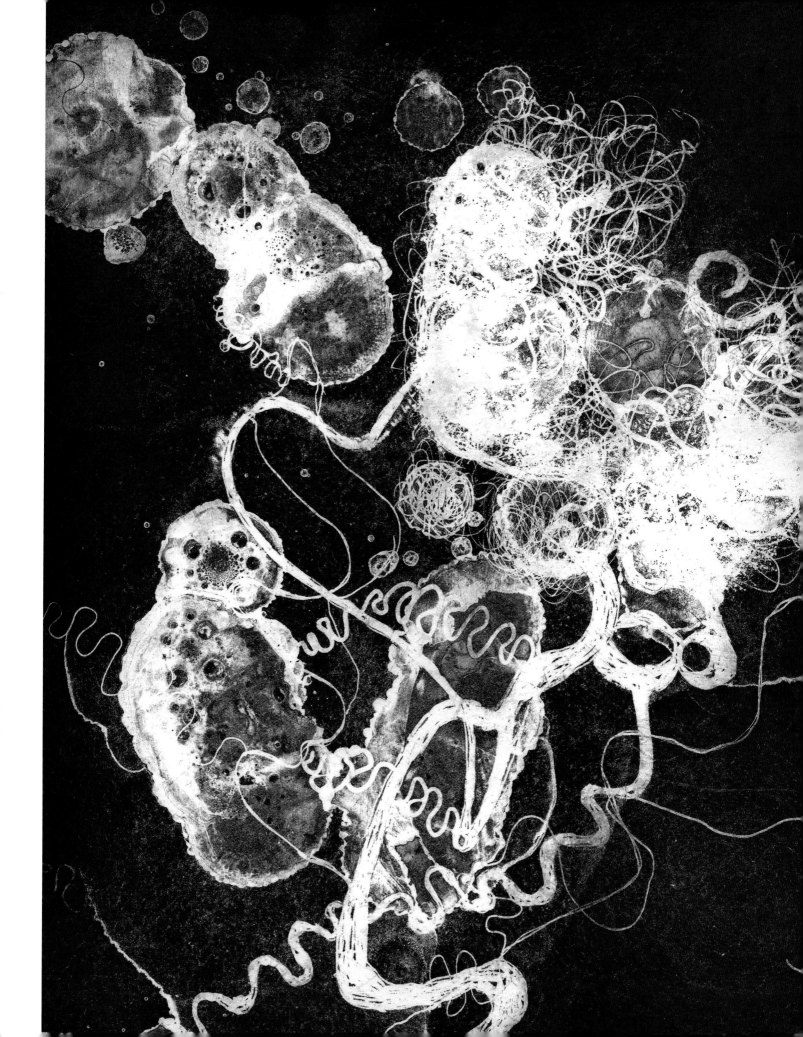

Marta de Menezes, *Functional Portrait: Self-portrait while Drawing,* **2002.** This series of fMRI digital images shows increasing brain activity as the artist becomes involved in the process of drawing. The red areas show the fMRI device's detection of high oxygen usage in certain parts of the brain, which researchers attribute to higher levels of activity there. De Menezes sees this series as a continuation of the attempt by portraitists to capture personality as well as surface appearance.

HUMAN BIOLOGY

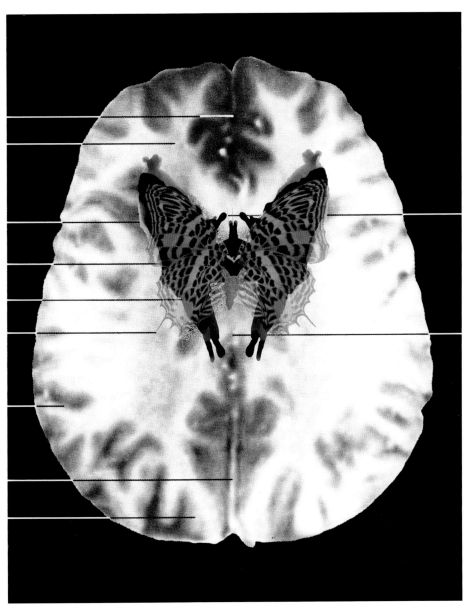

Suzanne Anker, *MRI Butterfly Suite*, **2008.**
Images of butterflies superimposed on
MRI brain scans explore similarities of
structures across biological domains.

Anker creates a 'dialogue of signs'
by working with images from different
fields that share similar symmetries
around various axes.

Annie Cattrell in collaboration with Drs Morton Kringelbach, Mark Lythgoe and Steve Smith, *Sense*, 2001–3. Functional fMRI brain-scan activity data from a person experiencing stimulus to each of the five senses was recorded and the data converted into 3-D computer models. fMRI scanners show changing oxygen usage in the brain as a person goes about mental activities, giving hints about the relation of these mental functions to brain anatomy. Cattrell used rapid prototyping to translate the computer data into plastic models, which she coated with gold to create sculptures of areas of the brain related to each sense.

Marilene Oliver, *Family Portrait*, 2002.
Slices of the full-body MRI scans of
four members of a family were used
to create life-size sculptures. MRI
detects tissue patterns in a cross-section
of the body by recording the magnetic spin
of the hydrogen atoms that make up the
organs. Oliver, who laments the way new
technologies alienate us from the physical
body, embedded the cross-sectional slices
into acrylic sheets and stacked them to
create full-size 3-D structures.

**Diana Domingues and Artecno Group /
NTAV Lab,** *Heartscapes*, **2006–7.** Viewers
are invited to navigate an immersive CAVE
virtual-reality animated world built from
images of the heart's interior. CAVE is a
four-wall VR-projection system in which
visitors experience realistic interactive
multi-sensory presentations. In this
approach, which Domingues calls
'immersive poetics', viewers' heartbeats
and movements influence the flow
of imagery and sound.

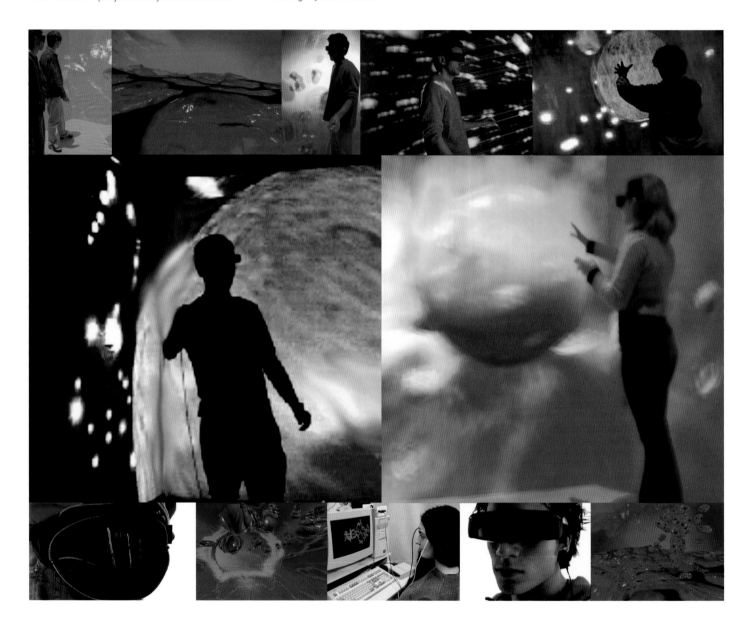

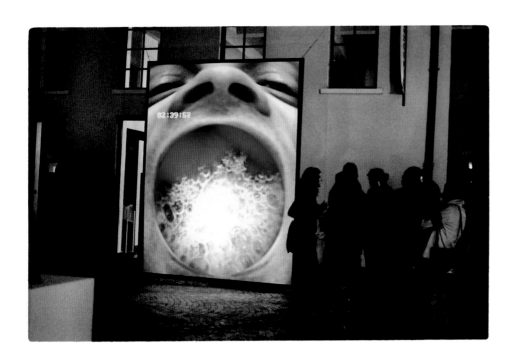

Phillip Warnell, *Endo-Ecto*, **2006.**
In this performance, a pill-camera
projection shows a time segment
from a pre-recorded 'voyage' through
the artist's gastro-intestinal tract,
presented within an image of his mouth.
As the commentator Ric Allsopp explained,
'What were considered visionary and
imaginary entries into the individual
body, associated ... with the traditions
of shamanic, magical and theatrical
performance, are now routinely
materialized through remote
imaging technologies.'

Oliver Kunkel, *Mosquito Box*, 2003.
Viewers are invited to insert a hand into a box filled with mosquitoes that have supposedly been exposed to people with AIDS. Isolation boxes, typically used in medical research, have flaps to prevent organisms from contaminating the world outside. The project asks viewers to confront their knowledge and disinformation about the biology of AIDS dissemination.

Jean-Gilles Décosterd and Philippe Rahm, *Melatonin Room*, 2000. In this space, lighting cycles and colour frequencies are designed to optimize human productivity through hormone stimulation. The illustration shows a person in a prototype room using bright green light, which reduces the production of melatonin, a hormone associated with tiredness and the regulation of biorhythms. The project demonstrates how architecture can incorporate medical knowledge while enhancing 'the analogical, the poetic, the aesthetic and the rhetorical'.

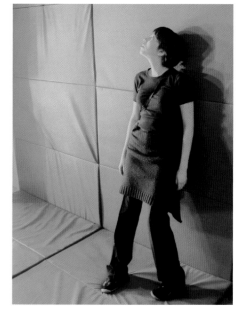

Paddy Hartley, *Short Cuts to Beauty: Face Corset 16*, 2004. A facial 'aesthetic garment' (made of plastic) that intentionally reconfigures the soft tissue (for example, creating artificial high cheekbones or protruding lips) to alter appearance provides a commentary on popular cosmetic surgery procedures. Hartley has collaborated with Dr Ian Thompson, who conducted pioneering work in the production of facial implants to repair bone injuries with Bioglass (synthetic ceramics that can merge with biological materials).

Jane Prophet in collaboration with Francis Wells (surgeon), *Distinctions and Counterposes*, 2004. MRI data from hearts was used to create 3-D models of vascular structures via rapid prototyping. Selective Laser Sintering (SLS) built the models by laying down cross-sections of the structures in the form of plastic powder and fusing them via a laser beam. Prophet then coated the hearts with copper and silver leaf arranged to emphasize surface structures. She notes that 'the transference of data from one field to another and the act of reconstruction echoes the process of organ transplant'.

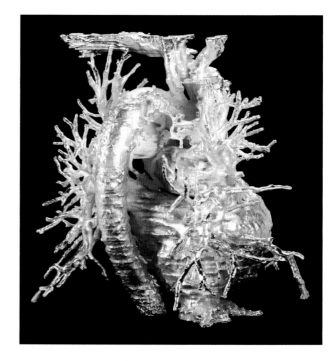

Tobias Zucali and Christopher Rhomberg, *Project Maschine-Mensch: Conveyor Belt Experiment*, 2006. A computer activates the two participants' arms via muscle stimulators to knock items off a mock assembly line. The project comments on the potential inhumanity of body control when 'humans are reduced to modules'.

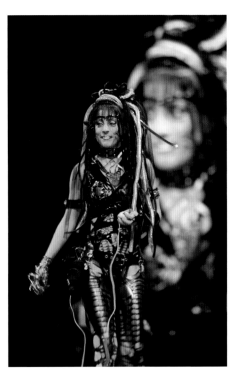

isa gordon in collaboration with Jesse Jarrell and DEvan Brown, *Psymbiote*, 2005. gordon is shown in a performance persona visualizing future developments in wearable and body-sensing technologies. The outfit includes LED displays of bio-signals, a titanium exoskeleton glove that can be used as a data-input device, and a heads-up small-data display (by her right eye). gordon is interested in exploring trans-human enhancement and aims to 'place herself in the eye of the storm: the conceptual terrain at the collision of bodies and machines, the mutation of her own identity through transformation of the body'.

Christophe Bruno, *Wi-Fi SM*, 2003. A muscle-shocking device worn on the arm is linked via wi-fi to a computer. The project offers people the opportunity to link pain to the flow of internet events by monitoring the appearance of negative words on news sites. The device activates the pain stimulator whenever it encounters words such as *death*, *kill*, *murder*, *torture*, *rape*, *war* or *virus*.

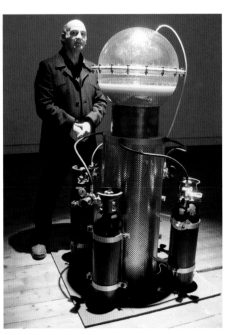

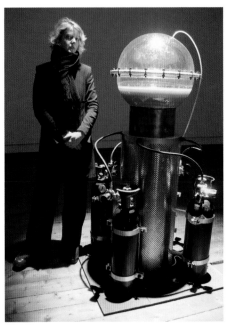

Stelarc and Nina Sellars, *Blender*, 2005. In this installation, tissue (subcutaneous fat, connective tissue and nerves) from both artists is continually mixed together and biologically maintained in specially designed vats, which contain blood and other nutrients. Famous for questioning the body's obsolescence, Stelarc has proclaimed that 'It is no longer meaningful to see the body as a site for the psyche or the social, but rather as a structure to be monitored and modified. The body not as a subject but as an object – NOT AS AN OBJECT OF DESIRE BUT AS AN OBJECT FOR DESIGNING'.

Arthur Elsenaar and Remko Scha, *The Varieties of Human Facial Expression, 16 Samples / Version 2*, 2007 (stills from a video recording by Josephine Jasperse). This project explores the 'choreography' of facial expressions by enumerating all possible on/off patterns in each of six muscles to which computer-controlled stimulators administer shocks. Elsenaar and Scha's article 'Electric Body Manipulation as Performance Art: A Historical Perspective' is a classic; their latest research aims to produce coordinated multi-person 'dances' of electrically stimulated faces as part of cultural investigations of the body as object.

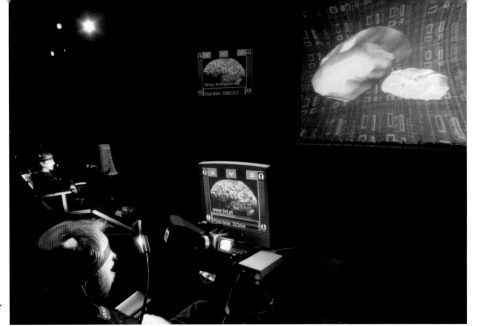

Lynn Hughes and Simon Laroche, *Perversely Interactive System*, 2002. The installation links the viewer's relaxation (as indicated by a Galvanic Skin Response feedback device) to her ability to motivate a synthetic video character to show openness to encounter. (Research links lower skin resistance to the absence of perspiration and thus to greater relaxation.) The video-projected woman typically has her back to the viewer until the latter's relaxation level is sufficiently high; then she turns and advances hesitatingly in accordance with further relaxation.

Darij Kreuh and Davide Grassi, *Brainscore – Incorporeal Communication*, 2000. Participants control the movement of avatars in a VR computer-graphic world via brainwaves and eye-tracking. The illustration shows two participants in control chairs, wearing headbands that read their brainwaves via EEG; the big projection screen shows the avatars they are controlling. Kreuh and Grassi were attempting to offer new perspectives on 'the identification of operators with their avatars, leading the audience to perceive a concrete co-existence (as a kind of promiscuous co-penetration) of two Realities at the same time'.

Kal Spelletich and the Seemen, *Master Mind Machine*, 2007. Here a robot responds to the viewer's EEG pattern: the robot's position changes from reclined (relaxed alpha waves) to tall (agitated brain state), and its arms move, flash lights and shoot air blasts. The image shows it hovering at almost full height above an evidently tense woman wearing the EEG-detecting headband. In other projects the Seemen invite viewers to control a variety of 'bio-morphic operated machines' via body signals such as heartbeat, respiration, skin conductivity, muscle flex, proximity sensors and lie detectors.

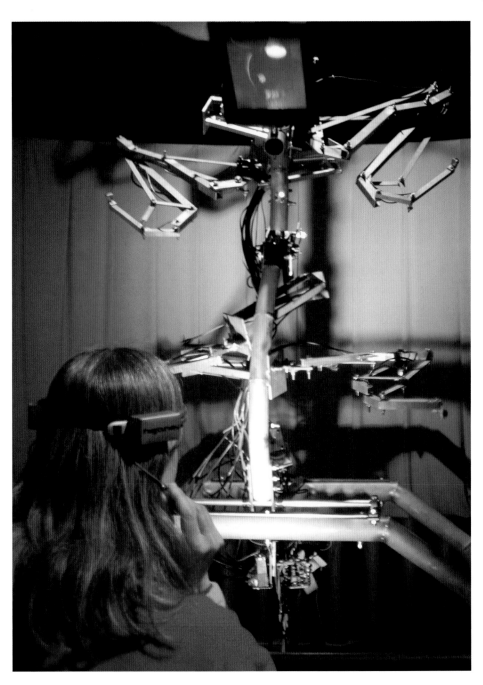

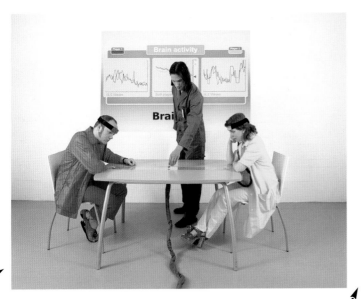

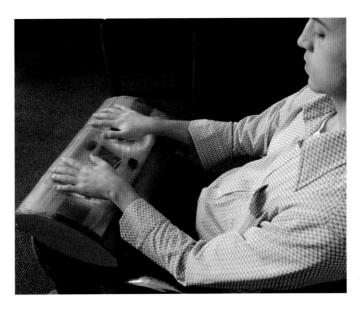

Interactive Institute Smart Studio, *Brainball*, **2001.** The degree of relaxation in the competitors determines the speed at which a metal ball moves to the goal; relaxation is detected by headbands that pick up EEG activity. The ball is moved by differentially activating computer-controlled electromagnets located under the table. *Brainball* comments on the obsession with competition and conscious strategy in games; a later project called *Brainbar* mixes drinks based on visitors' stress levels. The Interactive Institute is an innovative network of laboratories linking artists, researchers and industry in the development of experimental projects.

Thecla Schiphorst and Susan Kozel (Whispers research group), *Exhale Skirts*, **2005.** Performers wear networked devices that sense body signals (e.g. breathing and pulse), communicate these to a central display and send data about other people in the vicinity to the wearers. Sensor/ communication devices are attached to the dancers' bodies. The photo, from the Siggraph 2005 Wearable Fashion event, shows 'exhale skirts' activated by breath data that drives small motors and fans in the skirts' linings. Whispers ('wearable, handheld, intimate, sensory, personal, expressive, responsive systems') is an interdisciplinary team of artists and scientists trying to integrate touch and other intimate contact with technology.

Gilad Lotan and Christian Croft, *imPulse*, **2006.** This project asks people in remote locations to place their hands in indentations (containing pulse detectors) in modular units. Each device then sends the heartbeats of its user to the partner device, where they generate light displays and vibrations that are experienced by the other user. Project goals include exploring 'the creation of intimacy through a technological interface' and facilitating 'a moment of understanding between two viewers or users'.

X Rokeby, *MEMEX: A Cyborg Pilgrimage in the Age of Amnesia*, 2003. X Rokeby undertook a forty-day walk along the streets of London as a cyborg. The illustration shows some of the equipment he carried: wearable computer, portable EEG monitor, digital camera, personal one-eye data display and GPS. Trying to create 'Virtual Memorial Sculptures', he specifically visited locations where murders had been committed. There he would meditate and upload live music (computer-modified by his brainwaves) video-linked to his current GPS location. The data was sent to a website on which people could track his pilgrimage.

Takehito Etani, *Pimp My Heart*, 2006.
A system built into the car detects a
driver's heartbeat and broadcasts it via
a high-powered automobile sound system.
The diagram shows the key components:
heartbeat-detecting pendant; finger-worn
pulse detectors; computer for analysis,
sound generation and light activation;
LED lights under the car and round the
windows; seat vibrator; large speakers;
and projectors for displaying cardiac
waveform on the windows. Etani notes
that this installation 'achieves an ultimate
unity between car and driver'.

**Christian Nold, *Biomapping:
Greenwich Emotion Map*, 2006.** Galvanic
Skin Response readings are linked
to GPS locations in Greenwich, England,
to create a map indicating the average
emotional agitation associated with various
locations. The cumulative readings are
illustrated by the height of the purple 3-D
graphs superimposed on an aerial image.
The agitation data is collected from
participants walking around carrying
recording devices consisting of GSR
detectors and GPS receivers. Nold has
organized communities to do this mapping
in many places in the world.

PHYSICAL SCIENCES 4

Carter Hodgkin, *Right Shift*, **2007.** Computer modelling of imaginary subatomic particle collisions and trajectories is used as the basis for making prints, drawings and paintings (in this case a pigment inkjet print). Since subatomic particles are below the threshold of sight, scientists often rely on technologies such as cloud chambers to see them. Particles moving through vapour leave traces which allow inferences about their charge, mass and speed. Hodgkin wrote computer code to model the characteristics of imaginary subatomic particles and set them loose in a virtual cloud chamber. She sees the results as 'both fanciful and threatening', invoking the 'behavior of the matter of which we are all composed, as well as referencing the atomic reactions which could effect our demise'.

What are things made of? What forces control their movements, behaviours and transformations? What controls the winds? What is the nature of the universe?

The physical sciences, such as physics, chemistry, geology, climatology and astronomy, have made great progress in investigating these questions. They have applied knowledge and reshaped everyday life by inventing novel materials such as plastics and semiconductors (materials that enable electronic chips), and by harnessing energy in unprecedented ways, such as nuclear and solar energy. New disciplines like materials science and nanotechnology (manipulations at the scale of a billionth of a metre or yard) claim that humans eventually will be able to create both organic and inorganic substances atom by atom.

Modern physical sciences continue to discover mysteries and challenging new questions, such as the location in the universe of dark matter (theories about which predict the existence of 95 per cent more material than has been observed by astronomers) and the aetiology of global warming. Most contemporary research does not study visible phenomena. It requires exotic instrumentation, such as particle accelerators (which speed up atoms and cause them to collide at nearly the speed of light in the hope that they can be decomposed into their components) and radio telescopes (used by astronomers to study astronomical phenomena that cannot be seen by visible light). It also must use complex chains of theoretical inference to gather evidence to test what can never be seen or touched. Finally, it must face intellectual challenges such as relativity (according to which time is not constant, and mass and energy can be transformed into one another) and uncertainty (the realization that observation changes what is observed). Meanwhile, researchers are realizing that phenomena like weather may never submit to the determinist aspirations of modern science, demonstrating

non-linear chaotic characteristics instead. (Chaos theory describes physical systems whose behaviour is difficult to predict because very small perturbations get amplified and change it in a way that appears random.)

The physical sciences have given new dimensions to the arts' interest in the landscape. They invite artists to focus on that which is too small, too big or too fleeting to be seen. They challenge artists to use the information and processes of research to open doors onto such phenomena and to make the relevant philosophical questions part of artistic discourse. For example, Chris Henschke's *HyperCollider* video 'game' challenges viewers with a hands-on experience of the anomalies of the theoretical constructs of black holes (collapsed stars with such intense gravity that nothing, including light, can escape from them; 91).

Scientists studying the elementary forces and building blocks of the universe work with particle physics. The accelerators they use create high-energy atomic collisions which unleash a puzzling menagerie of subatomic particles and forces. Blowing apart the old, simple model of the atom, they have discovered multitudes of subatomic particles with exotic properties, and are moving towards a grand unifying theory that will conceptually integrate the principles explaining elementary particles with those explaining the galaxies. These scientists are trying to flesh out the conundrums of relativity and uncertainty through concrete experimentation. Because of physics' primacy in probing the nature of matter, many consider it to be one of the core sciences.

How have artists entered into this world? How can they create engaging objects and events that address its research and philosophical implications, especially when access is so difficult and the background theories so challenging to learn? Some scientists, worried that the public has not been adequately engaged in understanding their research,

have initiated projects to invite artists into their labs. The description of the artist-residency programme at CERN, the leading European Union physics research lab, demonstrates the faith some scientists have in art as a tool for reflecting on the profundity of their research, but also reflects their disappointment in the arts' relatively slow response:

> Perhaps this is because Science has not been seen as culture, but has remained cocooned as a difficult activity reserved for a small group of specialists and the artists have generally ignored it. A paradox has developed, societies are now largely defined by their scientific skill and yet the world of art, a mirror of society, has so far made little comment.... Sooner or later the artist will have to confront the challenge of representing and commenting on these foundations of human life.

In fact artists have responded to the challenge of bringing particle physics into their discourse in various ways. For example, working within the tradition of interactive media installation, *Eon* by Shawn Brixey (90) and *Camera Lucida* by Evelina Domnitch and Dmitry Gelfand (91), focus on the poorly understood, possibly subatomic, phenomenon of sonoluminescence (the conversion of sound to light via collapsing bubbles in ultra-pure water).

Modern physics and engineering have assiduously investigated the nature of gravitational and electromagnetic forces, yet they retain their mystery. How can something unseen exert such power? When the radio pioneers Nikola Tesla and Guglielmo Marconi suggested at the beginning of the twentieth century that messages might be carried thousands of kilometres by means of invisible waves, people thought they were crazy. Artists remain drawn to these invisible forces, both to find ways to understand them and to explore their potential dangers.

Gravity, which is omnipresent, confronting us whenever we take a step, has always been of interest in arts such as dance and sculpture. Science's questioning of the commonplace has intrigued artists interested in the continuing theoretical debates about the nature of gravity. For example, Sota Ichikawa and Seiko Mikami's installation *Gravicells, Gravity and Resistance Project* describes an experience in which the 'deconstruction of ... natural phenomena shifts the visitor's habitual sense of gravity, and hence alters the perception of one's body in space' (93).

The harnessing of electromagnetic forces is both essential to modern life and taken for granted. Many artists feel that it is valuable to fight complacency – to actively appreciate, rather than ignore, electromagnetic phenomena such as the earth's magnetic field, electrical storms and radio, or to wonder about electromagnetism's dangers. Projects, conferences and shows in recent years have focused on themes such as making electromagnetic information visible, audible or tactile, and reconciling the fascination/danger duality of living in an environment filled with invisible information.

The British artists Fiona Raby and Anthony Dunne's 'Design Noir' approach illustrates this. Their work uses products and services as a medium to stimulate debate among designers, industry and the public about the social, cultural and ethical implications of issues such as omnipresent electromagnetic fields. In their *Placebo* design series (2001), for instance, they created furniture much of which included detectors, one example being a table that glows when a call is received from a mobile phone. The artistic power of this work derives from its interweaving of humour and serious issues, and its clever integration of social commentary into everyday design practice.

Over the centuries, scientific investigators have studied the characteristics of gases, liquids, solids and the various elements. Inspired by the medieval discipline of alchemy, they began to wonder how materials could be combined and transformed. Updating alchemy's successor, chemistry, for the contemporary era, nanotechnologists are predicting that we will have the power to construct virtually anything atom by atom sometime in the next three decades. This remains a controversial claim, however, because we may never achieve the necessary understanding and control of atomic-level forces.

Artists like Dove Bradshaw, meanwhile, have made transformation the focus of their art. But rather than striving for total control, Bradshaw embraces change and chance, subjecting her sculptures and paintings to weather, water and chemical processes. The appeal of her work derives from her chemical virtuosity, which allows her to let these indefinite processes produce visually compelling results, and from a postmodern questioning of science's faith in determinism.

Other artists have attempted to find ways to work at nano-scale. Based on collaborations with Australian science labs, Paul Thomas's *Midas* uses tools such as Atomic Force

Microscopes, or AFMs, which allow viewing at atomic scale, to look at how atoms mix on surfaces where people touch objects. Thomas's visualizations of atomic vibrations have created a modern-day updating of the myth of King Midas, who turned everything he touched into gold (98).

Earth scientists and climatologists study everyday phenomena – the landscape, oceans and weather – as well as unusual events such as earthquakes, storms and climate change. Science has advanced our understanding of the make-up of the earth's core, the composition of the atmosphere and the behaviour of the ocean's currents, but significant mysteries remain, such as predicting climate change and explaining the nature of other planets.

Some artists have focused on earthquakes as dramatic and infrequent events, and therefore good case studies for reflecting on science. Our knowledge about seismic events has grown, but remains incomplete: we still cannot predict them. In *Parkfield* the Australian D. V. Rogers retrofitted a large-scale earthquake simulator to create an installation that visually, sonically and kinetically represented seismic activity from remote locations via internet tele-data transmissions (100–1). The appeal of this installation derived from its combination of a visceral experience with conceptual agendas, such as deconstructing Romantic notions of the Sublime and the limitations on our ability to know events at a distance.

Science has given us new perspectives on water, the oceans, the wind and the weather – at the micro level (detailed behaviour of water or winds) and at the macro level (snapshots of worldwide weather or ocean conditions). The global crisis of climate change has inspired scientists and artists to find appropriate responses. Artists have created sculptures and media events that have generated appreciation of the aesthetic qualities of these intimate characteristics of water and wind, and more global phenomena such as temperature change, the rise in sea levels, the melting of polar ice and the composition of the atmosphere.

The Canadian Steve Heimbecker makes poetic works like *Wind Array Cascade Machine*, which respond to natural conditions such as shifting winds (102). Other artists work directly with climate scientists. Andrea Polli, for instance, has investigated a variety of weather and climate data in (among other works) her series *Atmospherics/Weather Works*, which builds on highly detailed research models describing the impact of Hurricane Bob in New York (103).

The study of astrophysics ranges from large topics like the origin of the universe and behaviour of galaxies to more local ones such as the nature of the sun, the moon and the planets. Revolutionary technologies – radio telescopes (which search the universe using radio-wave frequency detectors), for example – have enabled new understanding by showing enormous cosmological structures that are invisible to optical telescopes. Artists have been attracted to new technologies associated with space flight and to sweeping questions about the existence of life elsewhere in the universe. They have worked with radio telescopes and cosmic-ray detectors (cosmic rays are high-energy particles originating in deep space), and have tackled theoretical concerns such as the scale of space and the search for extra-terrestrial intelligence. Art/science organizations such as Arts Catalyst in Britain and OLATS in France have tried to encourage artistic work in the space sciences. One ambitious initiative called MIR (after the first Soviet space station) enabled more than twenty artist-devised projects to work with weightlessness by providing access to cosmonauts' parabolic training flights. Just to give one example of astronomy-based art, Adam Nieman addressed the realization that the actual physical locations of entities in space are rarely considered. Trying to make the abstract tangible, his *Space Signpost: Welcome to the Neighbourhood* confronted viewers with an unusual dynamic road sign pointing towards celestial objects (even downwards if the object was on the other side of the earth at the time) to highlight their changing locations and distances from people looking at them (105).

The physical sciences have opened up new ways of seeing and thinking about the world we believe we know so well. For the artists featured in this chapter, scientific research tools and concepts linked specifically with aspects of the physical environment have become the core of their practice.

Anna Hill, *Auroral Arch and Moon over Kopello*, 2003.
This long-exposure photo was taken with a Hasselblad fish-eye lens in Lapland and mounted on aluminium dybond. Auroras, sometimes called Northern or Southern Lights, are natural light displays caused by the ionization of atmospheric molecules due to the unusual electromagnetic conditions in polar regions. This installation investigated the scientific debate about the audibility of auroras: Hill noted that Arctic people long had traditions about the auroras whistling and singing as they appeared. Her sound installations included low-frequency auroral sounds recorded by scientists.

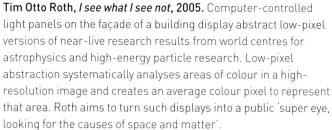

Tim Otto Roth, *I see what I see not,* **2005.** Computer-controlled light panels on the façade of a building display abstract low-pixel versions of near-live research results from world centres for astrophysics and high-energy particle research. Low-pixel abstraction systematically analyses areas of colour in a high-resolution image and creates an average colour pixel to represent that area. Roth aims to turn such displays into a public 'super eye, looking for the causes of space and matter'.

Shawn Brixey, *Eon,* **2003.** Voice is translated into ultrasound, which in turn modulates ultra-pure water, creating areas of light via sonoluminescence. The illustration shows a computer-modelled rendition of the installation, including the water chamber, the star-like spot of light created by the process, and a microscopic viewer. Brixey invites museum and web visitors to send poetic emails which are encoded into ultrasound by means of text-to-speech synthesis.

Evelina Domnitch and Dmitry Gelfand, *Camera Lucida*, **2005–6.**
Here a musical composition, introduced into a camera lucida
installation, is converted electronically to ultrasound frequencies,
which activate sonoluminescence in liquid. The picture above
shows an installation at Nijo Castle, Kyoto, while the image to
the right shows a close-up of the clear light patterns generated
by Xenon-infused sulphuric acid subjected to ultrasound in a 2006
installation. Viewers can manipulate settings to change effects.
The artists see the project as both an artwork and a scientific
study of chaotic, indeterminate behaviour.

Chris Henschke, *HyperCollider*, **2004.** Interactive pinball-like
simulation allows viewers to send particles into a theoretical
universe with black holes and other astronomical phenomena.
The horizontal surface is the 'Geometrodynamic Vortex', based on
physicists' theories about movement of matter and light in the
vicinity of black holes. Participants retract the pinball launcher
and the surface shows an animated spiral trajectory of the virtual
ball. Henschke noted that this installation 'explores the extremes
of relativity and how they disturbed Einstein's own cosmological
philosophy of a balanced, logical, and eternal universe'.

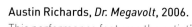

Austin Richards, *Dr. Megavolt*, 2006.
This performance features the artist's body and various props to conduct ultra-high-voltage sparks from a Tesla coil (a device that steps voltage up to high levels which can easily arc through the air). Dr. Megavolt appears to throw threads of light like a 'genie into the air!'

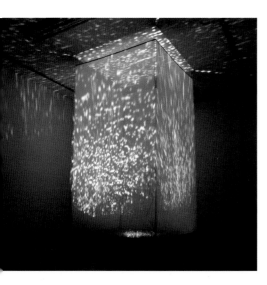

Ando Takahiro, *Photon Counting: Biophoton*, 2004. Experimenting with a little-understood process, the artist placed a dish of germinating seeds close to the bottom of a photo-multiplier tube sensor; this device amplified dim photons released during cell division in the seeds, creating a display of lights.

Seiko Mikami (artist) and Sota Ichikawa (architect), *Gravicells, Gravity and Resistance Project*, 2004–7. The weight and movement of visitors, measured by a sensor-meshed floor, are transformed into sound, light (LED) and geometric topological images. The installation also shows interactive forces created by the earth's movement (read by GPS systems) and theoretically predicts gravitational attraction between people. Here gravity maps of force fields projected on the floor bend and warp in response to the person at the right. The wall projection shows a more abstract representation of these forces.

Informationlab: Ursula Lavrencic and Auke Touwslager, *Cell Phone Disco*, **2006.** The installation displays flashing LED patterns from wall grids according to the proximity of people with mobile phones. Intense flashing follows visitors who are using their phones.

••••••➤

Luke Jerram, *Tide*, **2002.** This sculptural installation focuses on the changing gravitational effects on the tides of the relative positions of the earth, sun and moon. A gravity meter (not visible here) projects changing readings of gravity on the wall; the data is used to change the water level in the two glass vessels, crafted to resemble historical scientific instruments. The installation uses these water levels to generate sound vibrations which resonate symbolically with the tides.

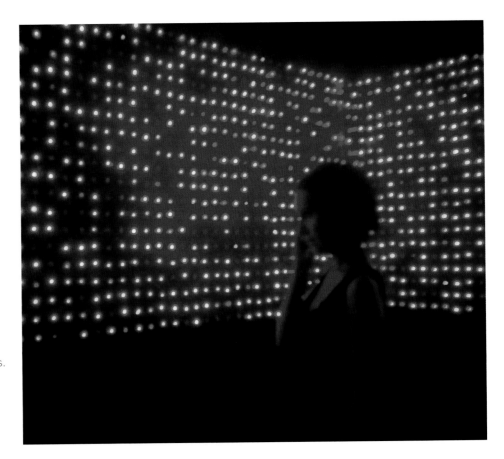

Catherine Richards, *Shroud/Chrysalis I,* **2000.** Two women ritually wrap a participant in copper fabric as protection from electromagnetic fields (the point is ironic). Employing metallic shields, normally used to insulate circuits from each other, Richards builds objects which are both beautiful and unnerving. She has noted the dilemma of the EMF age this way: '*Shroud/Chrysalis I* is an emblem of our new technological environment – is it a body bag or a chrysalis?'

••••••••••➤

Rachel Wingfield, *Digital Dawn*, **2000.**
Window shades are printed with
electroluminescent displays that
change according to ambient conditions.
Electroluminescent panels are flat,
phosphorescent ´cool´ lights, which glow
when subjected to an electromagnetic field.
The eight segments show the changing
leafy vine patterns as they respond
to ambient light levels, in a homage
to both photosynthesis and emerging
textile technology.

Victoria Vesna and James Gimzewski, *Inner Cell*, 2004.
Visitors enter an immersive room-sized environment to experience the molecular structure of a cell. The installation projects their shadows (tracked by infrared sensors) together with geometric forms representing atoms. Video-analysis software determines the contact between the human and atomic forms, causing the shadow people to move the geometric shapes in particular ways. The work was part of *Zero@wavefunction*, an ambitious exploration of art and nanotechnology which included many artworks, websites, educational efforts, publications and exhibits.

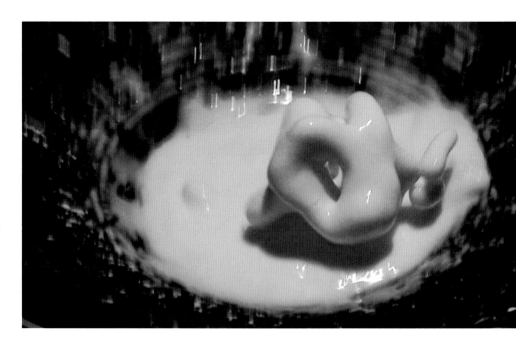

Yoshimasa Kato and Yuichi Ito, *White Lives on Speaker*, 2006. Brain-wave-controlled sound is played through a suspended speaker, causing vibrations in a pool of potato-starch mixture between liquid and solid states. As the vibrations proceed, the mixture changes into abstract blobs, which seem to dance and gyrate. Viewers can interact with the installation by shaping the material with their hands or by connecting themselves to a brain-wave reader that converts brain frequencies into sound vibrations.

Paul Thomas, *Midas*, 2006. An Atomic Force Microscope (AFM) was used to investigate the nanoscale area of contact between a finger and gold dust, where skin and gold molecules mix. The overlaid image in the box is an AFM display representing the deflections of a super-sensitive probe; the varying brightness indicates the atomic-scale topography of a specially prepared mixture of skin and gold molecules. The project, which refers to the myth of Midas, 'investigate[s] how we become part of the worlds around us'.

Sachiko Kodama and Minako Takeno, _<Protrude, Flow>_, 2001. Magnetic ferro-fluid (microscopic magnetic particles suspended in solvent) is controlled by sound and visitor movement. The installation converts a mixture of artist-created and spectator sounds into changing voltages; these are used to change the magnetic fields controlling the fluid, which then forms 3-D shapes. As the artists put it, 'Modelling physical material more freely and making it move more flexibly is a dream long sought after by human beings.'

Jochem Hendricks, _Left Defender Right Leg_, 2002–5. A soccer player's amputated right leg was converted into graphite and, ultimately, into a synthetic diamond. The black velvet pillow is filled with tobacco (the player's favourite), the yellowish object is the diamond, and the white object is his toenail. Hendricks involved two former Soviet research institutes in this project and claims to have worked with the Eastern European black market in order to transport the leg and to obtain a signed waiver from the athlete to permit its transformation. The piece investigates basic body chemistry as well as the ethics of applying transformative processes to human body parts.

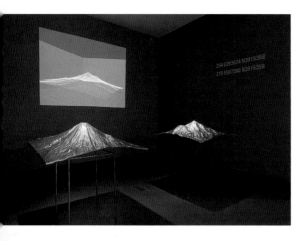

C5 Artist Corporation, *Landscape Initiative: Analogous Landscape: Rim of Fire*, **2005.** These models of Mt Shasta in California and Mt Fuji in Japan were part of a project comparing the experience of climbing volcanic mountains with data supplied by new mapping technologies. The models were computer-fabricated out of aluminium, and based on space-shuttle and satellite DEM (Digital Elevation Mapping). The projected 3-D image is a record of terrain from actual ascents using GPS navigation.

John Roloff, *Stratigraphic Column I*, **2002.** The images making up this composite show largely Cambrian and Ordovician marine sediments from Death Valley, California, and from the stone of dismantled local buildings. The images were digitally stretched to form stratum-like structures; these were wrapped round the column to create a sequence of discrepant and misaligned patterns. The column looks like a cutaway of a cliff one might see in nature, but has strata one could not find next to each other. Roloff's site-specific installations often refer to geological qualities of locations nearby and include maps and mineral specimens.

◀·········

D. V. Rogers with Andy Michael, *Parkfield Interventional EQ Fieldwork*, **2008.** A floor-shaking device used to simulate the effects of earthquakes was taken from a geology museum and linked to seismic data in Parkfield, California, which is above the San Andreas fault and is keenly studied by geologists. Each section of the grid can be activated independently by computer-controlled vibrators that respond to, and show the form of, the various ground waves caused by seismic movement. The project attempts to disrupt romantic notions about landscape and question our ability to know about faraway events.

··············▶

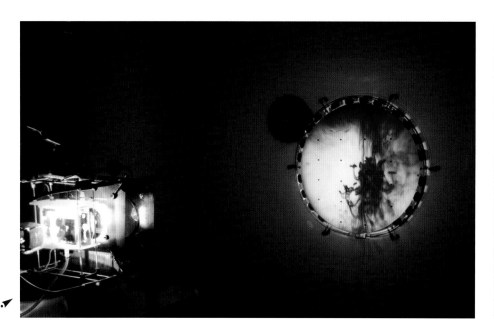

Federico Muelas, *Dripping Sounds,* **2001–2.**
The dispersion of ink in water serves
as the visual focus of this installation.
An automated system drops ink into a
container; its swirling motion is projected
on to a large circular screen. Behind the
screen is a grid of light sensors that
convert the evolving figures of ink into
sound, which in turn fills the space
via twenty speakers.

Steve Heimbecker, *Wind Array Cascade*
Machine, **2003.** Partly inspired by fields
of wheat nodding in the breeze, an array
of rods with motion sensors captures
meticulous details of wind velocity
and direction at each micro location.
The data is streamed to shape sonic
and visual patterns at a distant installation.

Electronic Shadow (Naziha Mestaoui
and Yacine Ait Kaci), *Ex-isles,* **2004.**
In one of a series of striking immersive
installations, the presence of visitors
activates light shadows in a pool of
luminous water. When a visitor enters
a light island beside the pool, a glowing
silhouette 'swims' across the water,
leaving a trail. Web visitors can also
generate these moving shadows.

Douglas Bagnall, *Cloud Shape Classifier,*
2006. Software classifies cloud shapes
according to fifty-seven parameters derived
from a database of photos and learned
viewer preferences. Viewers are asked to
develop profiles of their cloud preferences
in a process that questions 'whether one
of our most sublime "natural" experiences,
the aesthetic appreciation of clouds,
can be systematized and automated'.

Andrea Polli, *Atmospherics/Weather Works*, **2004.** This multi-channel installation uses spatialized sonification (a technique that converts data to sound to aid conceptualization) to map the behaviour of major storms which have passed through New York City in recent decades. The promotional card includes photos of cloud formations, a graph based on soundings from a weather balloon sounding (by Dr Patrick Market), and a topographical rendering of cloud formations. The image to the left shows the locations of sound sources. The web-based sound work allows viewers to pick a combination of elevation levels and geographical areas to investigate a storm.

Marko Peljhan/Projekt Atol, *Makrolab markIIex, Isola di Campalto Operations, Venice*, 2003. A self-contained, sustainable architecture laboratory brings together artists, scientists, tactical media workers and researchers to collaborate on research in telecommunications, weather, climate and migration. Illustrated here are participants working inside the lab. The labs have been sited in various locations; the latest is slated for Antarctica, described by Peljhan as 'the only place that does not belong to any nation state ... [a] very potent place, because of its size and because it is dedicated ... to science and peace'.

........▶

Agnes Meyer-Brandis, *Earth-Core-Laboratory and Elf-Scan*, 2003. Participants use advanced geological research techniques to investigate real and imaginary forms beneath the earth's surface. A non-contact, artist-constructed viewer is connected to a CSS (Core Sample Scanner), specially designed not to frighten life forms in the earth's core. Core samples are collected by inserting hollow probes into the earth to extract cylindrical cross-sections. The artist noted, 'My aim is to combine real and fictitious elements through the use of scientific methods, artistic fantasy and groundbreaking technologies.'

◀........

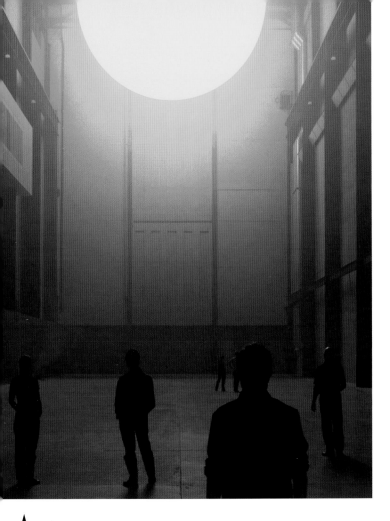

Olafur Eliasson, *The Weather Project*, Unilever series, Turbine Hall, Tate Modern, London, 2003. Consisting of monofrequency light, a reflective panel, a hazer, mirrored foil and steel, and measuring 2.67 x 2.23 x 5.44 metres (88 x 73 x 178 ft), this installation used synthetic fog and sunlight to create a weather environment inside the museum, thus attempting to capture the visceral experience of weather. A synthetic sun almost filled one giant wall while a mirrored ceiling amplified the mesmerizing atmosphere.

Adam Nieman in collaboration with Futurelab, *Space Signpost: Welcome to the Neighbourhood*, 2006. An interactive signpost points to the current locations of celestial bodies chosen by viewers, and displays their (constantly changing) distance. Here participants have picked the planet Venus on the interactive screen.

Yuri Leiderman, *Kefir grains are setting off for flight*, 2003. This project explores the effects of zero gravity on the bacteria that convert milk to kefir. Under normal conditions, colonies of these bacteria form whitish lumps during the conversion process. Wishing to film the behaviour of these colonies when subjected to weightlessness, the artist placed the kefir grains in glass 'spacesuit' containers. This is one of a series of projects created under the umbrella of an international consortium of arts organizations exploring weightlessness.

Takuro Osaka, *Revelation by Cosmic Rays: Perpendicular*, 2002. Cosmic rays are invisible high-energy particles (detectable by sophisticated research equipment) thought to be emitted by astronomical phenomena such as supernovae – rare events in which stars collapse on themselves emitting enormous amounts of energy. In this installation, LED displays are temporarily extinguished when an incoming cosmic ray is detected. Osaka speaks of the change from a feeling of uneasiness in experiencing an 'unpredictable light cycle' to a feeling of easiness, which he attributes to our sense of the existence of space and an intuition that our own existence has meaning and purpose, as manifested in the work.

Haruki Nishijima, *Remain in Light*, 2001. Electromagnetic waves have been captured with specially activated butterfly nets. Each frequency range of captured sounds is represented by splashes of coloured light. A video tracking system allows participants to 'release' the sounds by having their shadows touch the light spots. (See also page 123.)

KINETICS & ROBOTICS

Venturing into the controlling of light and motion, the transformation of everyday items, the mixing of realities to straddle the physical and virtual worlds, and robotics, the artists featured in this chapter are engaged in exploring new kinds of control over motion, light and sound, integrating the mechanical and the organic, and developing mixed realities linking the digital and the physical.

New ground is currently being broken in the areas of robot autonomy, motion and metaphor. The science-related questions that most interest artists have to do with defining what narratives shape the physical worlds we can invent, and what limits there are to the amount and type of intelligence we can design into machines. All of these issues can be considered as part of the latest chapter in the history of the venerable art of sculpture.

Work that focuses attention on the physical is especially important in an age when the virtual world is becoming so important. Theorists such as Jean Baudrillard have claimed that the frenzied circulation of visual and linguistic symbols and signs throughout the media has resulted in our losing our creaturely connection with physical reality. In Western cultures today, many jobs involve no actual physical work, as fewer and fewer people are finding employment in agriculture or manufacturing, for example. Our worlds are increasingly dominated by the tele-remote, by electronic communication and by virtual realities.

Meanwhile, many researchers have become convinced that the current paradigm of specialized computing devices is obsolescent. In time, sensing, computing and communication functions will become invisible and integrated into everyday objects and spaces. One example might be a doorknob able to sense the identity of the person touching it. The cluster of research activities seeking to make this happen goes by a variety of names such as ubiquitous computing, augmented reality, tangible interfaces and smart objects. The work of Mark Weiser at the Xerox PARC think tank in Palo Alto, California, and Hiroshi Ishii's Things That Think Consortium at MIT's Media Lab in Cambridge, Massachusetts, were important early centres of this type of exploration.

Another important theme is autonomy. Researchers hope that they can create objects and robots that can adjust intelligently to their environments, work without human intervention, avoid harmful situations and learn to accomplish their goals independently. It may be that one day artificial intelligence will surpass humanity, though there are those who believe that machines will never approach the capacities of human intelligence.

In the mid-twentieth century there was an upsurge of interest in kinetic and light sculptures – works such as Frank Malina's *Lumidyne System* (1956) and Jean Tinguely's *Homage to New York* (1960) come to mind. Artists today are using scientific research techniques to explore programmed electronics, new materials, and contemporary design and fabrication technologies. Investigating the poetry of motion, for example, the Spaniard Daniel Palacios Jiménez's *Waves* responds to viewers by activating computer-controlled motors that rotate an elastic line to create complex sounds and wave shapes (117). Edwin van der Heide's *Sound Modulated Light* embeds sound signals in the alternating electrical current that illuminates light bulbs, so someone with an appropriate device could reconstruct the sounds from the light's imperceptible vibrations (115). In *Park View Hotel*, the Indian artist Ashok Sukumaran invited viewers to use a special scope situated in a public park to view hotel windows across a street. If the window belonged to a room Sukumaran had chosen to be activated, a light would appear to move across the hotel's façade, tracing a path down to the lights in the park (113).

Some artists are intrigued by the possibilities of conceptual kinetics and are investigating new kinds of mechanical/organic assemblage, creating information displays, experimenting with vehicle-scale devices (at a size people can sit in or drive or float around in) and probing unusual materials and forces such as electroluminescent 'flat' lights or ferro-fluids, which can be controlled by magnets. Modelling biological processes, Andy Gracie's (hostprods') *Fish, Plant, Rack* is a 'quasi-symbiotic environment' in which a robot adjusts a self-contained water, light, nutrient and plant system based on its monitoring of the electricity discharged by blind elephant fish. In this cyclic, recursive system, the robot affects the fish and the fish's responses then cause the robot to readjust the environment (118). Daniel Rozin's *Wooden Mirror* recreates digitized video images of its viewers by manipulating a pixel-like array of wooden blocks painted with different grey-scale values on each of the blocks' faces (118). The American artist Paul DeMarinis's *Firebirds* electrically modulates a gas flame, causing the air around it to vibrate in such a way that it can 'recite' famous speeches (118).

Many artists see the DIY (Do-It-Yourself), open-software and hacker movements as major cultural forces. Defying the habits and 'rules' of consumer culture, they attempt to demystify technology, fight passivity, and empower people by educating them about advanced technologies and cultivating the human impulse to take things apart and subvert their intended functions. For example, a worldwide consortium of technologists and artists created the Arduino project, which designed, developed and distributed an inexpensive microcontroller board, a small, self-contained computer that can be embedded in objects to give them electronic intelligence (120). Ars Electronica awarded Arduino one of its major prizes in 2006. Judging that tool-making and the creation of contexts enabling artistic activity in themselves constitute works of art, Ars Electronica awarded similar prizes to other open-source tools such as the Processing computer language, Linux operating system and Netscape Web Browser. (Open-source tools make code and documentation freely available to users so they can investigate or modify them at will.)

Traditional definitions applied to animate and inanimate objects have largely drawn a clear line between the two. New research has made possible objects that not only move themselves but do so with apparent intelligence. The Canadian artist Nicholas Stedman's *Blanket Project*

offers a robotic blanket that has the intelligence to move through a space in search of people. Crawling over to them, it uses its array of tactile sensors to gently envelop them and respond to their movements (124). Seeking to simulate the experience of drinking from a straw, the Japanese artists Yuki Hashimoto and Minoru Kojima, along with many collaborators, developed a system called *Straw-like User Interface (SUI)*. Even though there is no actual liquid present, the system manipulates pressure, vibrations and sounds to duplicate the experience of sipping.

Mixed reality is the merging of real and virtual, electronic worlds; actions in one world can influence events in the other, and the connection can enhance experience in both. Artists fascinated by mixed reality are exploring ideas such as hyperreality – experiences where the real and fantasy are difficult to distinguish. Many mixed-reality experiments have focused on tables, perhaps because they are emblems of human work and also evoke personal space. For example, the Barcelona-based Music Technology Group's *Reactable* consists of an 'active table' at which people can configure a music synthesizer by moving objects around on it which represent components such as filters and modulators. The computer interprets the placement of the physical objects, activates the corresponding sound generators and then connects the objects via projected lines (123).

Kobito: Virtual Brownies by Aoki Takafumi and various collaborators offers a complex mixed-reality world in which small digital creatures called Brownies, visible on a screen (itself superimposed on a camera view of the real-world scene), can interact with actions in the physical world. For example, moving an activated block on the work's sensitized table can knock creatures about on the screen, and the creatures can in turn move the block via magnetic activators under the table (122).

Haptics, the sense of touch, is a critical channel through which we understand the world. We touch, lift and push things, making barely conscious judgements according to what they weigh, how much resistance they offer and whether they respond or not. A technology called force feedback, often critical in mixed-reality experiments, attempts to introduce this kind of information into the digital world by using apparatus such as computer-controlled electromagnets and gyroscopes to make computer mice and joysticks resist actual hand movements.

Yoshinobu Nakano and his collaborators used haptic technology to create *INVISIBLE – The Shadow Chaser*, in

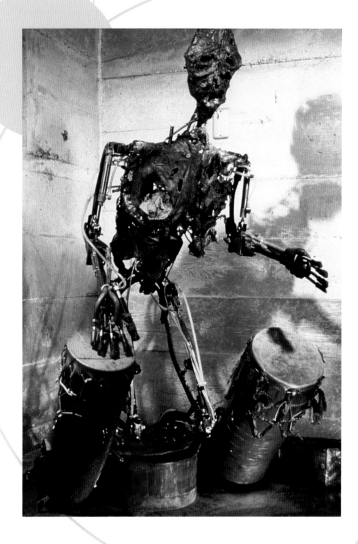

Chico MacMurtrie/Amorphic Robot Works, *The Drumming and Drawing Subhuman*, 2000. This computer-controlled pneumatic robotic sculpture performs on the drums by moving its 'hands' in a style similar to human drummers. It was MacMurtrie who established the collaborative artist/engineer group Amorphic Robot Works, which is famous for its evocative experimentation with robotic motion and dramatic multi-robot performances. Mark Ruch, a spokesman, described the focus on motion this way: '[A]s there is a beauty and elegance in movement itself, there is equally potent an experience in watching a machine (human or organic in form), struggling to stand, attempting to throw a rock, or playing a drum. These primal activities, when executed by machines, evoke a deep and sometimes emotional reaction.'

and investigating the nature of autonomy. This research often reveals metaphorical depth, using robots to reflect on humanity's condition, on our fears that they might exceed us and on the mayhem they might precipitate.

Artists have been innovators in motion research, increasing the subtlety and expressiveness of the ways in which robots move. The collaborative artist/engineer group Amorphic Robot Works, under the direction of Chico MacMurtrie, is well known for its motion experimentation. It has, for example, created many robot musicians *(left)* as well as tumbling robots controlled by the movements of an operator wearing a sensor suit.

Because they understand the intricacy of creative activities so well, many artists have been drawn to the challenge of developing robot painters, musicians, dancers and performers. Robotic creative action is of course part brain and part brawn. How does the robot 'know' how to move, and how can it plan, sense and adjust? Douglas Irving Repetto's *Giant Painting Machine* is a small painting robot that works on large, clear Mylar panels to form enclosed rooms (128). Gil Weinberg created *Haile* (2006), a robot percussionist that listens to fellow musicians, analyses their music and then uses algorithms to improvise in real time. The Canadian Louis-Philippe Demers has created many performances in which robots were the central performers. In *Devolution*, he and his collaborator Garry Stewart consulted with biologists to create a robotic dance piece focused on basic biological concepts such as territoriality and predation (111).

Robots used in research typically symbolize hopes for a technology-enabled, smoothly running world. Artists, on the other hand, often create sophisticated robots intended to inspire reflection on the human condition, including our darker sides. For example, Bill Vorn heads up a long-standing

which participants tracked invisible goblins via footprint shadows on the floor and tried to suck them up into a special 'vacuum cleaner'. The device employed computer-controlled water and air movement in a tank to indicate goblin capture via shifting weight and vibration (127).

Robots are perhaps the most sophisticated machines humans have developed thus far. The term *robot* is used to describe a wide range of electro-mechanical systems, from simple repetitive devices, to remotely controlled ones, to autonomous entities that employ sensors and artificial intelligence or perform tasks in ways similar to human functioning. Some robots are designed to appear anthropomorphic while others resemble unique machines. Robots are potent cultural objects, representing both hopes and fears about the limits of what machines can become. Artists have been in the forefront of robotic research, pushing the limits of these machines' ability to move, act or do creative work,

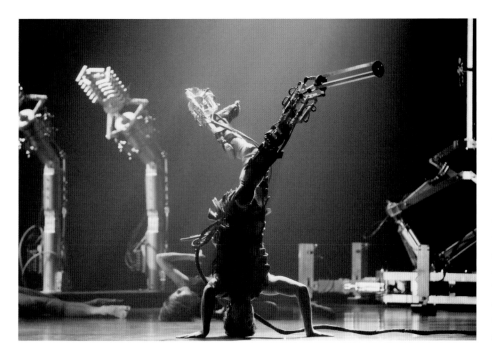

Louis-Philippe Demers and Garry Stewart, *Devolution*, **2006.** In this dance work emphasizing biological processes, ten dancers interact with thirty robots. The illustration shows two white 'worshipper' robots on the left, a tall hexapod robot on the right, and the central dancer with controllable extenders on his legs. The artists consulted with biologists to create a piece focused on 'ecosystem processes: territoriality, parasitism, predation, symbiosis, senescence, birth, death and growth' in which 'robots are given equal status to ... human bodies'.

research programme in Montreal on the 'Aesthetics of Artificial Behaviors' with a special fondness for intimidating, 'deviant' machines (128). It is autonomy, however, that is currently the most important topic of research in robotics. Asking whether we can build machines that inhabit the world and perform tasks without human intervention, Ken Rinaldo's projects explore emergent robot behaviour. For example, in *Autotelematic Spider Bots* a colony of ten robots learn from each other and from their interactions with humans (129).

Research into smart objects and robotics promises revolutionary changes in the definition of sculpture. The increasing presence of computing power in everyday objects will continue to raise questions about the extent to which artists might be involved in designing the intelligence, form and interactivity of such objects in the future.

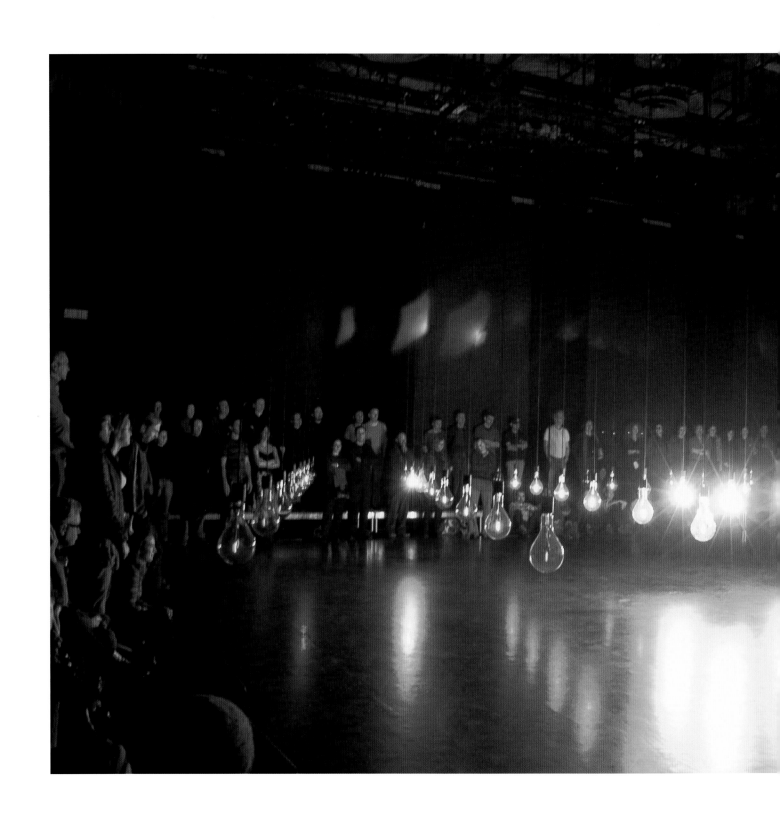

KINETICS & ROBOTICS

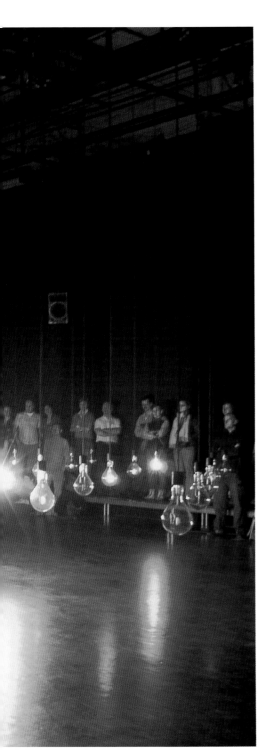

Artificiel group (Alexandre Burton, Jimmy Lakatos and Julien Roy), *Condemned_bulbes*, **2003.** This sound and light installation of giant, 1,000-watt incandescent bulbs, creates a choreography of changing light and sound levels. An innovative controllable dimmer ramps power levels up and down, affecting the light generated by the filaments in the bulbs and associated sound. Artificiel offers performances, during which they control the bulbs like a giant instrument, and makes installations in which a computer program controls the patterns.

Ashok Sukumaran, *Park View Hotel*, **2007.** A special scope, scanning hotel rooms from the street, activates interior lights in a downward sequence across the façade and on into the streetlights. Here a viewer looks through the scope at one of the activated rooms. The blue arrows show which lights come on in the apparent migration from room to room and, eventually, to the street. Sukumaran, who is also an architect, has created many events at which people could control external lights, including *Changes of State* (2005), in which he retrofitted the external lighting of an abandoned theatre.

London Fieldworks (Bruce Gilchrist and Jo Joelson) in collaboration with Dugal McKinnon (composer), *Gastarbyter*, **1998–2002.** An enveloping chair links audible and inaudible sound, physical vibration and neon light. Black cylinders attached to various segments of the chair control physical vibration and tactile stimulators. The artists sought to create an intense multi-sensual experience: 'Ours is a culture which encourages us only to watch and not to listen or feel, nor to analyse how sight, sound and touch infiltrate each other. It is a culture whose excess of "noise" requires that we severely filter what we are capable of perceiving.'

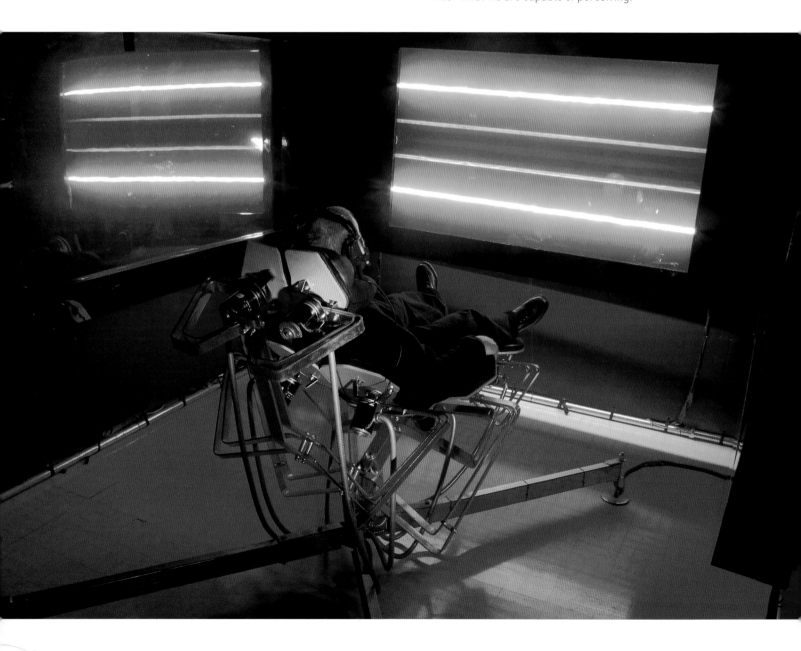

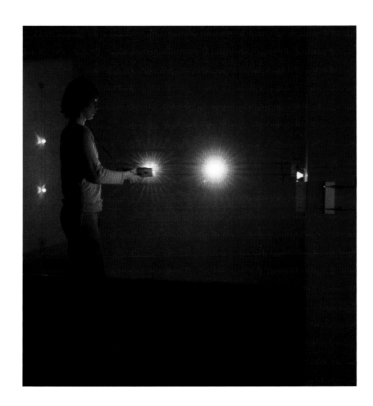

◀··········

Edwin van der Heide, *Sound Modulated Light*, **2003–5.**
The installation imperceptibly embeds sound signals in
the alternating electrical current that illuminates light bulbs;
someone with an appropriate device can reconstruct the sounds.
Electronic modulators can convert sound to low-voltage variations
which 'hitchhike' on light. Van der Heide has created other
installations pushing at the boundaries between sight
and sound – for example, *Spatial Sounds* (2002) subjects
its audience to speakers whizzing by at 100 km per hour
(63 m.p.h.) emanating 100-decibel sounds.

Paul Klotz, *3D-Messenger*, **2006.** This installation transmits
messages by means of a sequence of 3-D letters formed from
grids of LEDs contained inside plastic boxes; each letter animates
in succession. The installation has a website which visitors can
access to send a message.

··········▶

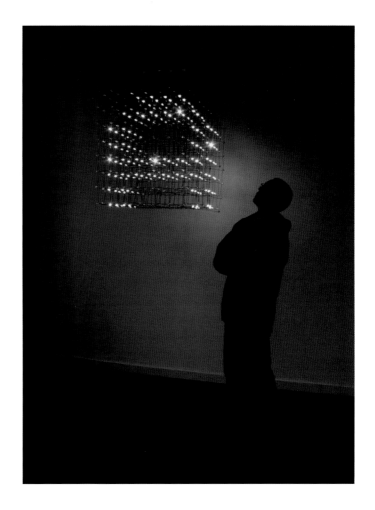

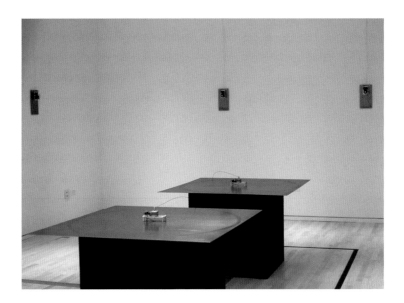

Shawn Decker, *Scratch Series*, 2002. This sound installation explores the rhythms of scratching. The floor and wall pieces each have piano-wire 'scratchers' controlled by embedded microcomputer-governed motors. The controllers pull the scratchers back and forth against the surfaces to reflect patterns from nature (e.g. bird migrations) or physics (Brownian motion, the random motion of small particles suspended in a gas or liquid). Complex rhythms arise as the devices adjust to one another's sounds.

Matt Heckert, *Centripetal Sound Machines*, 2004. Six rotary mechanical strikers sound specially designed resonators. Each striker sculpture has a motor that periodically lifts the circular metal track up and down. As the ring moves up and down, the central pipe strikers, which are attached to pivots, fall along the metal ring, thus creating the sounds. Heckert has said that he wanted to give his audience 'some feeling of being inside a system or mechanism'.

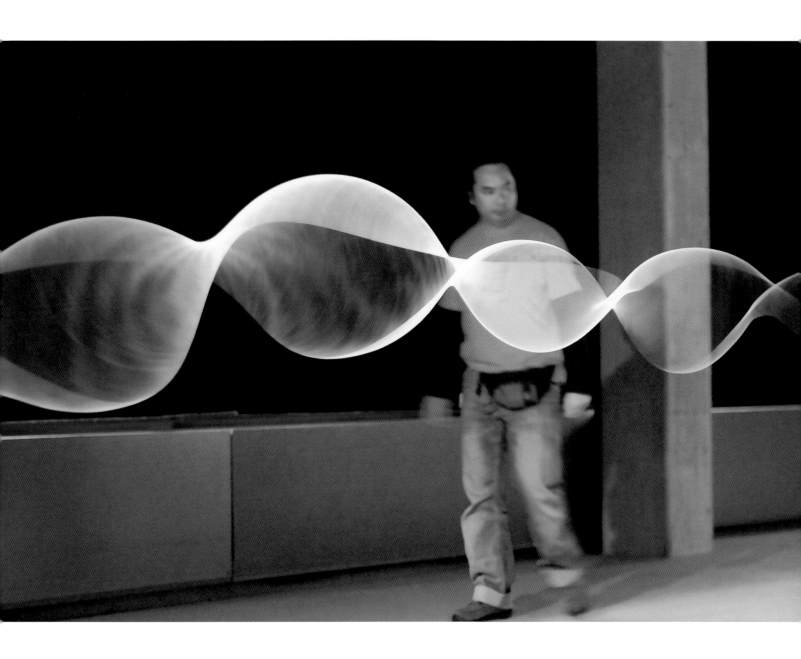

Daniel Palacios Jiménez, *Waves*, 2006. Motors rotate an elastic rope to create complex sound and visual wave oscillations. The photo creates the illusion of solid shapes because the exposure blurs multiple rope positions. The system responds to viewers – there is stillness when there is no motion, regular sine waves with simple motion, and complex, chaotic patterns and sounds with much motion.

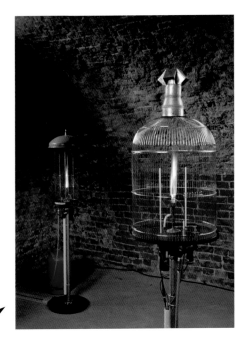

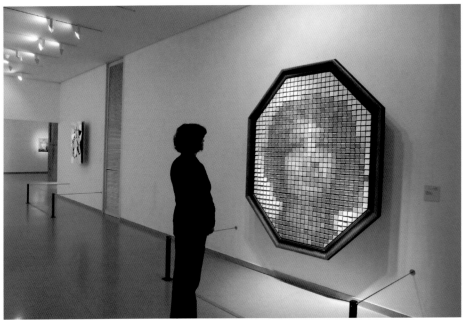

Paul DeMarinis, *Firebirds*, **2005.** Gas flames modulated by electrical signals serve as loudspeakers for speeches made by Hitler, Mussolini, Franklin Roosevelt and Stalin. Each voice comes from a flame trapped within a birdcage. The effect is created by a little-known process discovered in the early twentieth century. As DeMarinis explains, 'An electrically modulated oxyacetylene flame, seeded with potassium ions, is made to vibrate the air. As the air around the flame is instantaneously heated and cooled, expanding waves of sound vibration are produced in the air, creating an omni-directional sound source.' Firebird explores issues in sound technology with a focus on political speech (the flames carry the tone of power and authority even though the speakers' languages are different).

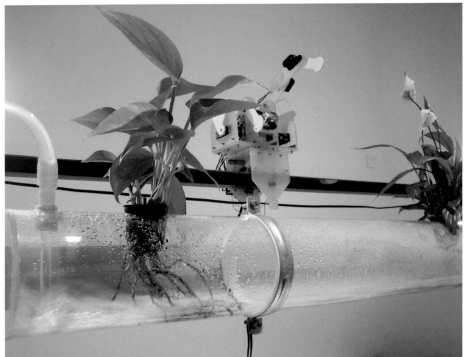

Andy Gracie (hostprods), *Fish, Plant, Rack*, **2004.** A quasi-symbiotic environment in which robot, fish and plants interact and develop emergent languages with which to communicate. The illustration shows the robot that cares for plants by moving back and forth to control nutrients and other conditions. The robot is directed by its evolving interpretation of electrical discharges from a virtually blind elephant fish in a separate aquarium, which 'observes' the plants on video.

Daniel Rozin, *Mechanical Mirrors: Wooden Mirror*, 1999–2008. A computer-controlled installation recreates digitized video images of viewers by electromechanically manipulating a pixel-like array of wooden blocks painted with different grey-scale values. The system reads the grey value of each pixel detected by the camera and adjusts the blocks accordingly. Rozin wants to explore 'the line between digital and physical, using a warm and natural material such as wood to portray the abstract notion of digital pixels'. This is part of a series of related works in which he electromechanically controls materials such as bits of trash, pegs and shiny balls.

Usman Haque, *Open Burble*, 2006. Viewers build and launch 'Burbles', helium-filled structures made out of modular inflatable balloons with sensors, LEDs, accelerometers and microcontrollers. Viewers can control the Burbles in real time via electronic 'handlebars', which they also make themselves. The project website clarifies the importance of community construction: 'Part installation, part performance – for the design and assembly by the public is as much a part of the project as the actual flying is – the Burble enables people to contribute at an urban scale to a structure that occupies their city.'

David Moises, *Flying Carpet*, 2004.
This hovercraft, powered by a leaf blower, comments humorously on cultural myths and the adaptation of everyday tools and gadgets. Moises's sculptures include a variety of other functioning devices including *Hobby Horse* (2006; wheels turned by a drill), *Chain Saw Bicycle* (2001) and *homemade submarine* (2006, made from a water heater).

Arduino, 2005. Arduino is an inexpensive open-source microcontroller electronics platform based on flexible, easy-to-use hardware and software. An international consortium of artists and engineers created it for artists, designers, hobbyists and anyone interested in creating interactive objects or environments. The board allows the user to construct electronic computing projects and to interface sensors and device controllers with computers. It is used in many of the projects described in this book. A generous sharing online culture has grown up in recent years, and many artists believe that creation of these tools is a vital gesture in tactical media.

Kelly Heaton, *Live Pelt, Portrait of the Fashionista*, 2003. A model wears a responsive robotic garment, built out of scavenged parts from Tickle Me Elmo toys, with computer-controlled motion and sounds. Tickle Me Elmo is an intelligent toy with sensors distributed in its body so that it giggles when touched. *Portrait* was part of an installation that commented on the fur trade. A description notes that the exhibit 'encompasses moods both poignant and Frankenstein weird'. Heaton has built several other projects out of appropriated 'smart' objects.

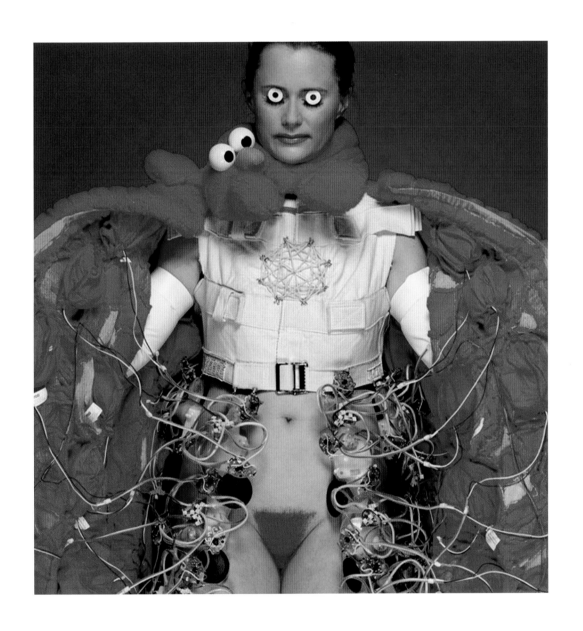

Mika Miyabara and Tatsuo Sugimoto, *MovieCards*, 2005. This system consists of barcode-enabled cards that can be manipulated to create digital video sequences. Software automatically generates a series of cards, each with an image from a video scene and a barcode in the right corner. Users can move the cards around to form whatever sequences and effects they wish.

Haruki Nishijima, *Remain in Light*, 2001. Electromagnetic waves can be captured with specially activated butterfly nets. The backpack connected to the net contains a set of receivers which can pick up ambient transmissions such as broadcast, taxi and police radio; the collectors can 'capture' a small sample by pushing a button. (See page 106 for the installation in which the collected waves are displayed.)

Aoki Takafumi et al., *Kobito: Virtual Brownies*, 2005. In this mixed-reality world, small digital creatures can affect and be affected by actions in the physical world. Here a participant holds a tea-caddy in the physical world; in the virtual computer-screen world there are small creatures standing near the caddy, which is located in a position corresponding to the real one. Illustrating the strange linkage between worlds, if the visitor were suddenly to move the physical caddy to the left, the small creatures would appear to be knocked over in the virtual world. And if the creatures pushed the caddy, the physical caddy would move appropriately (via magnetic under-table actuators).

Michiel van Overbeek, *Nazarenos, 2006.* Four robots shoulder a shrine dedicated to the Virgin Mary and carry it solemnly through public spaces, as is the custom in Spain during Holy Week. Typically such shrines can weigh up to 2 tons and take up to forty people to carry them. Van Overbeek sees the robots and their exotic motion as being in keeping with the mysticism of the ritual.

Music Technology Group (Sergi Jordà et al.), *Reactable, 2004.* In this multi-user environment, 'several simultaneous performers share complete control over the instrument by moving physical artifacts on a table surface'. Objects represent components of a classic modular synthesizer – for example, a sine-wave sound generator. A camera underneath analyses the placement of the objects; a linked computer projects connecting graphics on the luminous surface and generates the appropriate sounds. The project illustrates the art and research worlds' interest in 'mixed realities'.

Nicholas Stedman, *Blanket Project*, 2001– .
This autonomous robotic blanket contains
thirty-one motorized joints which allow it to
assume many shapes, some optimized for
movement and others for touching and
stimulating people. The illustration
shows three time slices in the process
of the blanket approaching a boy.

◄ · · · · · · · · · · · ·

Raffaello D'Andrea, Max Dean and Matt Donavan, *The Table*,
2001. An autonomous, robotic table establishes relationships
with viewers by orienting itself and moving towards them; its
movements and their reactions are captured on video. As the
project website explains, 'The ... table selects a viewer to attempt
a relationship with that person.... As long as that visitor stays, he
or she will be the object of the table's attention ... [viewers] soon
become absorbed in their interaction with the table, anticipating
what it might do and how to respond to its advances.' Another
project, a robotic chair, automatically reassembles itself after
falling apart.

Time's Up, *Gravitron*, **2005.** Force-feedback interfaces let people explore a simulated universe. The difficulty of manipulating the control platforms is correlated with virtual gravitational forces. Here the platform in the lower centre is sloping steeply in response to the gravitational valley indicated in the projection. At the same time, by shifting their balance and moving around on their platforms, the participants try to bend the gravity map. *Gravitron* is part of the 'Laboratory for the construction of experimental situations'. Time's Up's goal is not to develop commercial systems, but to have people consider 'their dependence upon biomechanics, control, perception' and the cultural and technological structures that attempt to regulate them.

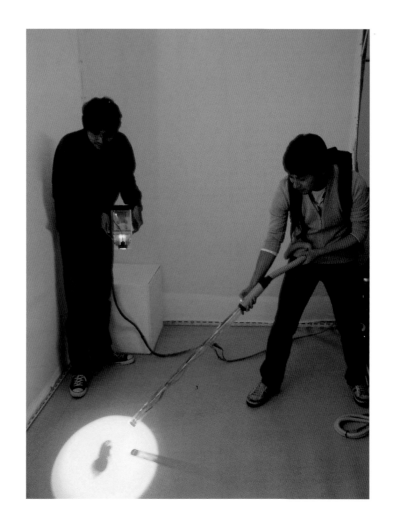

Yoshinobu Nakano and Team Shadow,
INVISIBLE – The Shadow Chaser, **2006.**
In this force-feedback game, invisible
goblins can be detected only by the marks
of their footprints caught in the light of
a special projector. Players listen to 3-D
spatialized sound to estimate where the
goblins are, and then shine the projector
in that direction. Goblins can be caught by
being sucked into a vacuum-cleaner-like
tool. Sound, shifting weights (created by
computer-controlled manipulation of water
inside the tool) and changes in suction
signal success in capturing a goblin.

Natalie Jeremijenko, *Feral Robot Dogs*, 2006. Toy robot dogs sniff out environmental problems by means of pollution detectors. When their sensors find a problem, they display dog-like reactions (for example, barking and jumping up and down). Jeremijenko is attempting to build a community of hackers to subvert the 'inane' features of robotic toys and create critical media events to focus public discourse on environmental problems.

Stelarc, *Exoskeleton*, 2003. In this performance an exoskeleton (a mechanical, pneumatically activated six-legged device resembling a metal skeleton) amplifies the power of human muscles. Standing on top of it, Stelarc can move in non-human ways. Military researchers are working on related devices to allow soldiers to run at superhuman speeds or carry enormous loads. The ominous appearance of such hybrids helps viewers confront their thoughts about what the human body might become..

Douglas Irving Repetto, *Giant Painting Machine/San Mateo* (detail), 2006. Electromechanical devices built of scrap make wall-sized paintings on transparent Mylar. The system comprises a motorized carriage that moves back and forth across the top of the Mylar, with a motorized painting device loaded with acrylic ink suspended below it. Illustrated is a detail of the orange painting device. Electronics constantly change the speed and direction of the motors that control the device. The wobbly suspension and erratic changes result in complex motion and create paintings of great visual impact.

I-Wei Huang, *Steam Walker*, 2006. Working in a realm he calls 'steampunk', Huang experiments with steam power to animate his devices and insect-bots. Huang is fascinated by Victorian technology and was drawn to the challenge of using this 'old' type of power to run miniature robots.

Bill Vorn, *Hysterical Machine*, 2006. Semi-autonomous robots use sophisticated sensors and pneumatic motor control to generate evolving behaviours in reaction to visitors. Spider-like metal bodies suspended from the ceiling use pyroelectric (heat-seeking) sensors to detect viewer activity. They react by directing lights at viewers and activating their pneumatic legs, evoking the sense of a community of 'deviant machines'. Vorn's long-standing research programme on the 'Aesthetics of Artificial Behaviors' attempts to deconstruct social life by using machines to suggest 'dysfunctional, absurd and deviant' behaviour.

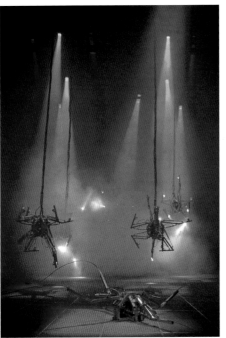

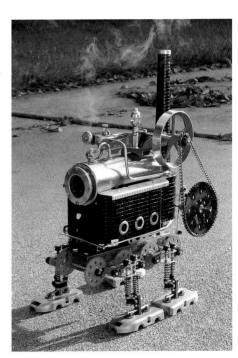

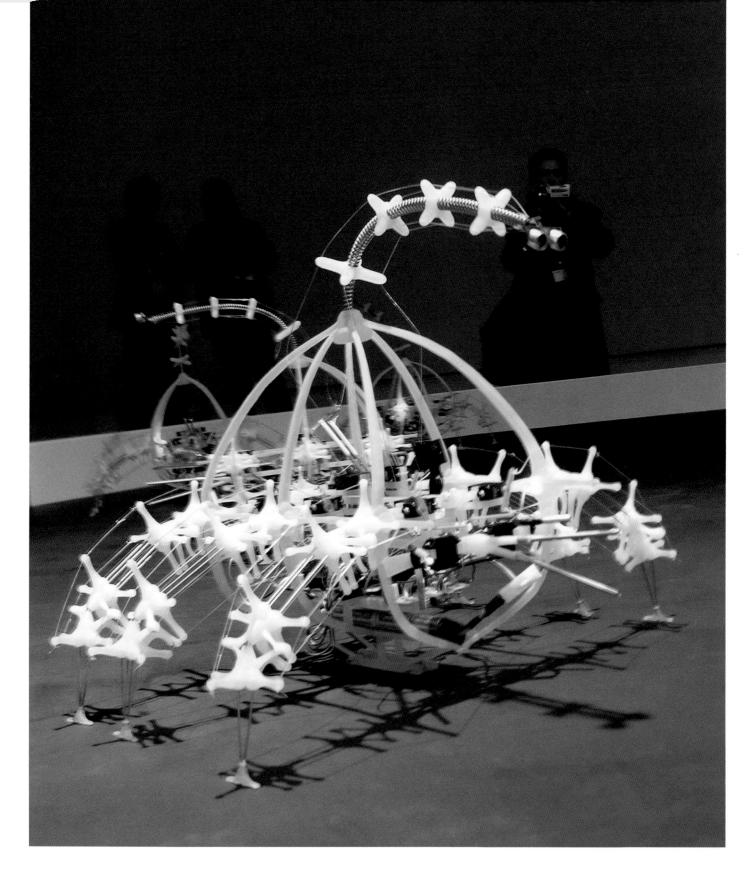

Ken Rinaldo and Matt Howard,
Autotelematic Spider Bots, **2006.**
A community of robots mimic the behaviour of ants and spiders, interact with visitors by means of infrared eyes, tell each other about food and manage their own 'metabolism'. They use the ultrasonic camera eyes on their necks to look for people and to detect their electrical recharge ports, which supply their 'food'; they also communicate with each other, learn from their interactions and develop emergent, artificial-life behaviours.

Angelika Böck, *Eye2eye*, **2000.** This installation features two pre-recorded videos of eyes watching each other. It explores issues of perception and attention by using pupil-tracking technology. Inferences about shifting attention can be made by analysing the relative position of the pupil in the eye. (See also page 146.)

ALTERNATIVE INTERFACES 6

Interface is the name given to the technological arrangements necessary to put information into and retrieve it from computers or similar devices. The set-up we are most accustomed to at the moment consists of a keyboard and mouse for input and a video screen for output. Research labs round the world are bustling with interface experimentation – for example, enabling computers to detect motion and gesture, to recognize faces and facial expressions, and to understand and generate speech. Developers see these expansions as essential to bringing computers even further out of the office into everyday settings. Enthusiasts proclaim that humanizing the interface will result in increased access to digital worlds for more people and for a wider range of activities. Meanwhile sceptics note that the historical rhetoric about the revolutionary impact of the mouse on society was similarly overstated.

Artists are active innovators in interface research because they seek to expand the modalities they use while creating interactive events. They also wish to comment on some of the conventional interface's cultural baggage, such as its links to the constraints of the world of work and its denial of the body. There is a deep strand in Western culture stretching from the ancient Greeks and early Christianity that puts the rational mind before sensuality and emotionality. Liberating the interface calls into question the notion of the computer as a tool that employs and promotes rationality to the exclusion of anything else.

In the area of motion detection, computers can now track the movement of people within their view by using technologies such as video-scene analysis, which tracks the changing locations of objects in successive video frames. Artists' installations explore the use of motion to control sound, image, animated text, film, light and kinetic objects, and

have integrated motion detection into dance performance and database access. These art forms in which the motion of participants can become an aesthetic and conceptual focus are unprecedented.

In *Tango Virus* (2005) the Brazilian artist Emiliano Causa and his collaborators connect the movements of viewers dancing with an artificial-life virus that generates changes in the music. (Artificial life, or a-life, is a computing concept referring to software that duplicates elements of biological life by being able to modify itself through 'experience'.) Toni Dove's interactive cinema work *Artificial Changelings* creates an aesthetic metaphor linking a viewer's position with a projected character's narrative – for example, at the closest position the viewer hears the character's inner thoughts (138). Attempting to involve viewers viscerally in his subject, Simon Biggs created *Metropolis*, in which aerial images of New York City and Baghdad projected on the floor and wall got torn apart and shifted between the two places whenever viewers walked about (136).

Linking viewer movement to a fantasy world, the Finnish artist Hanna Haaslahti's *White Square* synthesizes animated shadows, which dance at viewers' feet (140). Norimichi Hirakawa's *DriftNet* invites visitors to access websites by moving in front of a wall-sized abstract projection that portrays the internet as a vast ocean (141). Some artists have made the patterns of movement themselves the focus of their work. In *Pasts and Presents*, for example, Judith Donath, Orkan Telhan and Martin Wattenberg developed an MIT Media Lab project that animates a display showing the history and dynamics of a changing social configuration: people in a café (142).

Surveillance is the shadow side of motion tracking. Who is tracking whom, and for what purpose? Many artists have used surveillance tools to comment on this increasingly problematic social issue. For example, in Rafael Lozano-

Hemmer's *Homographies*, 144 robotic ceiling lights change their rotation pattern to create corridors of light connecting the sensed paths of people moving through a large public space (145). Camera views of Venice's Piazza San Marco provide the focus for David Rokeby's *Seen*. Viewers can inspect the results of four different video analyses such as the extraction of people from context and the freezing of motion (144). Marie Sester's *ACCESS* presents the unnerving experience of a focused audio beam and spotlight tracking people as they move through public spaces (145).

Both researchers and artists are investigating the subtleties of a range of sensorial experience as it relates to the concept of interface. One of these is touch, which is especially interesting in the context of computer-involved artwork because touch is associated with intimacy. Baba Tetsuaki's *Freqtric Drums* networks participants electronically so they become virtual drums activated by other participants' touch. Thus the tapping of someone else's skin is transformed into drumbeats (146).

Several artists have built projects based on the computer's growing capacity to determine where people are looking. They frequently use pupil-tracking, a technology that can pinpoint the direction of a person's gaze by analysing a video feed of the pupil's position in the eye. The German artist Angelika Böck's *Eye2eye* features two monitors showing people's faces opposite one another. The display of each person's eyes (and their focus) is tracked and can be disrupted by viewers walking between the screens (130, 146).

Computers encounter even greater challenges if faces are used as interfaces, which is to say if the visual boundaries of the face, its identity and the emotional content of facial expressions are brought into play. Nicolas Anatol Baginsky's *Public Narcissism II* extracts faces from three video cameras surveying a public space. It then presents large composite portraits that it categorizes by means of a pattern-recognition program (147). Also focusing on facial expressions, Alexa Wright and her researcher-collaborator Alf Linney developed *Alter Ego*. This work provides a strange digital 'mirror' for viewers to look into, in which a computer modifies their faces to represent various emotions (146).

One of the dreams of interface researchers is to make it possible for us to talk to our computers. Although there has been some progress in speech synthesis and recognition, there are still significant challenges to be overcome, and the fantasy that computers might understand strangers' free-form speech and speak flexibly and euphoniously remains just that. Artists, meanwhile, are attracted by the emotional and symbolic possibilities.

Jason Lewis's *Intralocutor* uses video capture to create real-time moving silhouettes of viewers. As they speak, the system recognizes their words, converts them into animated text and then moves them to fill the image of another viewer (142). The aim is to offer a metaphor for the ways in which our words affect others. The enormous robot *Giant Torayan*, created by Kenji Yanobe, only responds to orders issued by children, identified by their voices (149). *n-Cha(n)t* by David Rokeby confronts viewers with a space in which several monitors suspended from the ceiling chant sonorously together, using sophisticated speech algorithms to shape the soundscape. The chanting computers also use speech recognition to listen to viewers and become diverted when they are spoken to (148).

Gestures are more complicated for computers to 'understand' than simple motion as this process involves not only sensing movement but also determining its symbolic meaning. Artists find this challenge intriguing in part because gesture has always been of critical importance in all of the arts both as subject (for example, as captured in a portrait) and as process (the movements made to create a work).

Several hybrid-art projects have attempted to capture the movement of hands drawing or manipulating objects in the air. For example, Zack Booth Simpson's *Calder* invites visitors to move their hands to create virtual, computer-projected mobiles. Their gestures 'form' flat shapes and connecting wires which can then be 'pushed' to initiate movement, thus recalling sculptures by the American Alexander Calder (151). The French visual-music group SSS – Sensors_Sonics_Sights – is a trio that utilizes sensors when they perform. Computers translate their gestures into abstract music and animation (150). Another example, the Quartet project, brought together collaborators from physiology, engineering, music, dance and other media to experiment with gesture-based art, using data from muscle sensors to monitor the movements of musicians and dancers and to control robots and virtual performers (150).

Of course gesture and movement are at the heart of dance and performance. Several dance groups (among them kondition pluriel, Palindrome and Troika Ranch) have become known for integrating experimental technology into their aesthetic. For example, in Troika Ranch's *16 [R]evolutions*, whose subject is human evolution, performers dance with

computer-generated strands of DNA whose shapes and movements respond to sensor signals from their bodies (153). Marnix de Nijs's *Run Motherfucker Run* (2004) confronts viewers with unusual interfaces linking bodily activity with media perception, asking people to run on a treadmill as a way of navigating deserted cityscapes (the 'scapes mix dynamic film and 3-D imagery). A growing number of performance spaces including Arizona State University's Intelligent Stage are integrating experimental technologies such as sensor webs, which 'know' performers' locations, as part of their basic facilities in order to be able to present experimental events.

Interface researchers are also investigating new kinds of outputs, and several artistic research projects have experimented with these unprecedented audio and visual displays. For example, Alvaro Cassinelli's *Khronos Projector* invites visitors to deform a screen to change the information received. When they push on the screen, they can send parts of the image forwards or backwards in time (157).

The emerging field of wearable electronics investigates how sensors and displays can be integrated with clothing and fabric. Seeking to enable artists to experiment in this area, Leah Buechley created an 'e-textile construction kit' consisting of soft patches with embedded microcontrollers and other components that can be configured by ironing them on and by other methods (155). Joanna Berzowska's XS Labs in Montreal is supporting a number of wearable experiments, including *Intimate Memory Dress*, which stores information about when and where it has been touched (155). The *Whisper[s]* project directed by another Canadian artist, Thecla Schiphorst, creates networked wearables that can wirelessly communicate affective states (see 81).

Virtual reality (VR) is one of the most advanced immersive interface technologies currently available. Typically using a mix of head-tracking (a technology that can ascertain which way the head is facing), navigational gloves, stereoscopic goggles and 3-D sound, viewers encounter media experiences that closely simulate the sense experiences of physical reality. Several years ago it was optimistically imagined that VR would revolutionize media and information visualization. Though developers' euphoria has subsided in recognition of the need for heavy instrumentation to make VR possible, significant relevant artistic experimentation is ongoing. For example, Josephine Anstey's *PAAPAB – Pick An Avatar, Pick A Beat* offered visitors a dance-floor environment inhabited by life-size puppets. Visitors in networked VR environments in remote locations could tour the shared floor, animate the puppets and dance with other puppets (156).

Researchers and developers remain optimistic about breaking down the barriers between humans and digital devices so that they can communicate more easily. It remains unclear how far such developments can go. Artists meanwhile are enthusiastic about creating unprecedented interactive works that engage viewers' bodies in innovative ways.

Ken Feingold, *Eros and Thanatos Falling/Flying*, 2006. Ventriloquist dummies use a program to algorithmically generate synthetic speech so that they can speak and sing to each other about their relationship. The dummies are suspended in an ambiguous state between flying and falling as they converse. Reflecting on the theme of ambivalence, their refrains swing from phrases like 'You make me feel so good' to 'You make me crazy' to expressions of erotic desire. The website description notes that 'there is a dysfunction in ... communication which interests Feingold and in his pieces he returns to situations where the communication fails, when words lose their meaning and where the parts go from an engaged conversation to set themselves on "automatic"'.

•••••••••➤

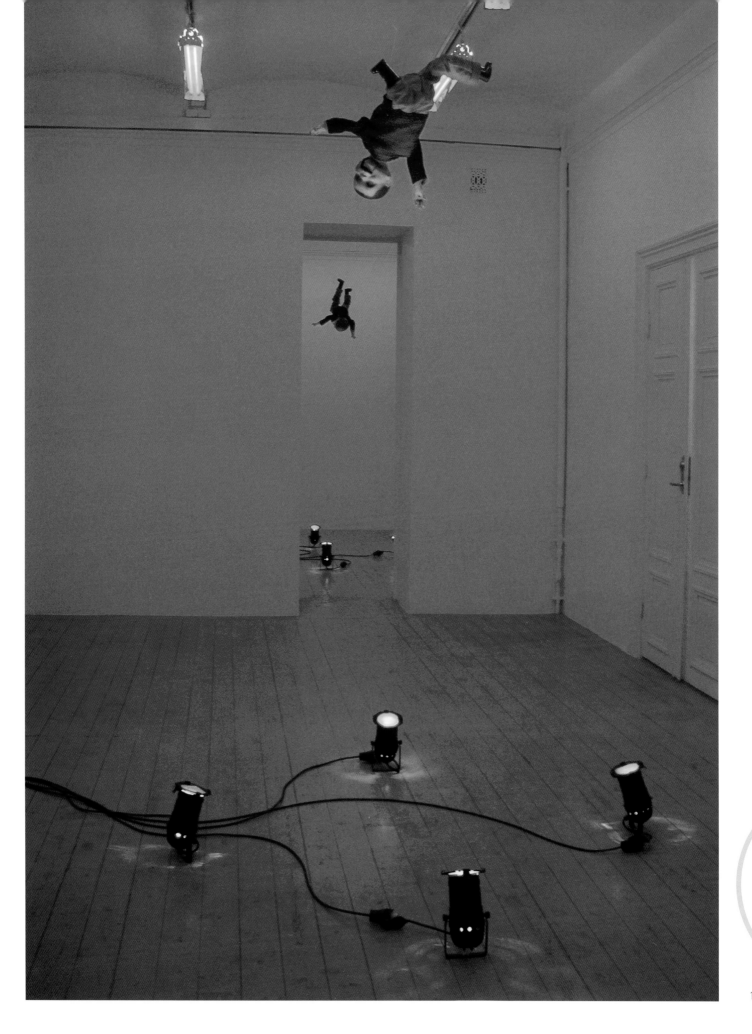

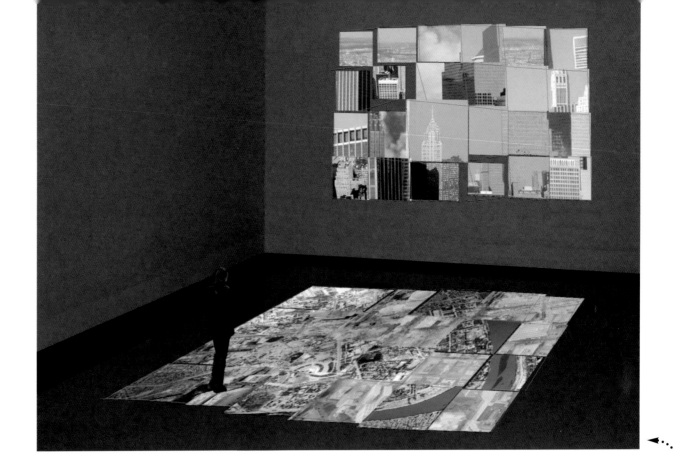

Simon Biggs, *Metropolis,* **2005.** Aerial images of New York City and Baghdad are projected on the floor and wall. Where a viewer interrupts the grid (detected by video tracking), the images are torn apart and exchanged between cities. Biggs wanted to involve viewers viscerally in visual metaphors for events linking the two cities.

Tiffany Sum and Jonathan Minard, *Fingering,* **2005.** A digital video character tracks the movements of viewers and 'shoots' them with a pretend gun if they stay too long. The artists seek to play on the 'satirical tension between sexual sublime and suspended violence' in Hong Kong action movies.

Squidsoup, *Driftnet*, 2007. Viewers 'compose' sound by flapping their arms and moving their bodies in response to this prompt: 'Imagine flying like a bird through a musical composition that surrounds you.' The projection shows an abstract representation of the sound elements the person is activating.

Keith Armstrong, Charlotte Vincent and Guy Webster, *Shifting Intimacies*, 2006. Viewers enter a dark spatialized sound environment in which videos are projected on two circles, one of sand and the other of dust. Motion affects the activities of small a-life graphic-dust forms which eat away at images projected onto the circles. The videos explore themes of birth, decay and death. The artists believe that use of motion detection invites 'states of meditation, exploration, stillness and play, that over time produce a heightened awareness of the body'.

Toni Dove, *Artificial Changelings*, **2001.**
The digital-video installation creates an aesthetic metaphor linking the position of the audience to a projected character's narrative. At the closest position the viewer hears the character's inner thoughts; further away, the character addresses the viewer directly; still further away, the character is in a dream state. Dove works to integrate the storytelling strengths of cinema and theatre with new interactive possibilities; this particular story comments on consumer culture and allows movement back and forth between the present and nineteenth-century Paris. Seeking a more subtle and emotional interface than simple menu choice, Dove has noted: 'I think that there are more complex possibilities for creating a dimensional narrative.'

Gabe Barcia-Colombo, *Animalia Chordata*, **2006.** Mini-video stills of people engaged in the small acts of everyday urban life are projected inside small bottles. The videos come to life when viewers approach. The people seem caught inside the bottles like insect specimens, and the motion-based activation enhances their exotic quality.

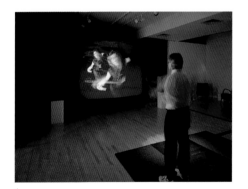

Camille Utterback, *Untitled 5*, **2004.**
A dynamic, abstract, animated image is generated in response to participants' movements and gestures in an installation space monitored by an overhead camera. The traces of past movements become part of the image. As Utterback has explained, 'I hope to refocus attention on the embodied self in an increasingly mediated culture.'

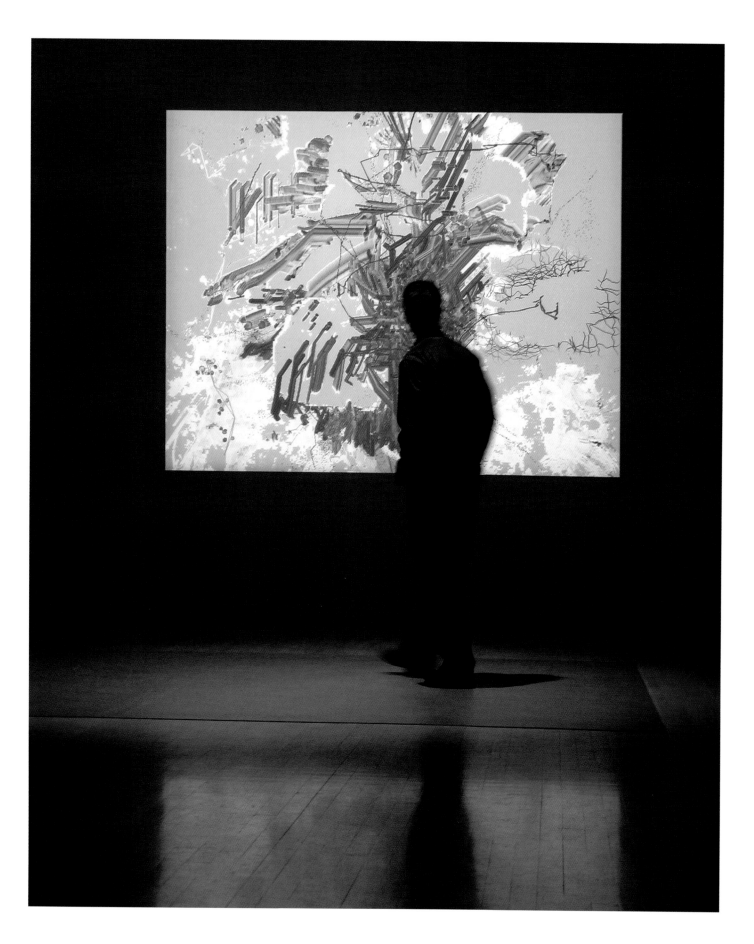

Scott Snibbe, *Shadow Bag*, 2005. The captured shadow of a viewer takes on an animated, independent life, interacting with the viewer, whose position is tracked as she moves. Sometimes the shadow approaches the viewer (as a mirror image), sometimes follows her. The shadow may adopt an earlier action or may even belong to a previous viewer. Snibbe, who often works with shadows, has explained that '[t]he title of the work refers to the Jungian notion of the body's shadow as a "bag" that holds all of our psychic detritus'.

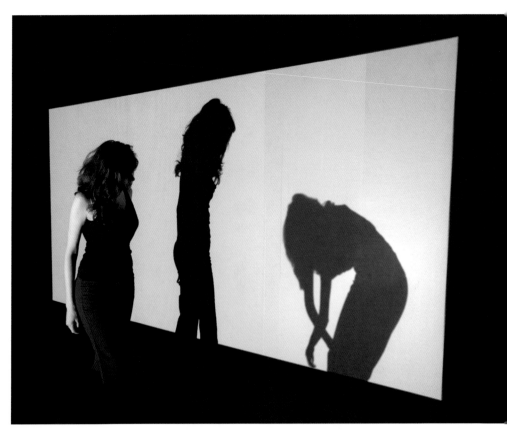

Hanna Haaslahti, *White Square*, 2002. Electronically generated shadows of artificial people cluster at the feet of viewers as they move round the white square projected on the floor. The shadows respond to the viewers' velocity, direction and position. Haaslahti sees the shadows as raising metaphysical questions about alternative realities, saying, 'The shadow is our alter ego, a double mystery that accompanies us throughout our lives.'

Norimichi Hirakawa, *DriftNet*, 2006.
Visitors access internet sites by moving
in front of a wall-sized animated projection
that suggests ocean waves. The image is
shaped by a combination of user motion
and data points from websites. Hirakawa
seeks to present the internet as something
to be contemplated: 'In DriftNet, nobody
has freedom to select [a] link and browse
contents. What we can do is to gaze [at]
the waves absently or to splash the wave
like [we do] in the real surf.'

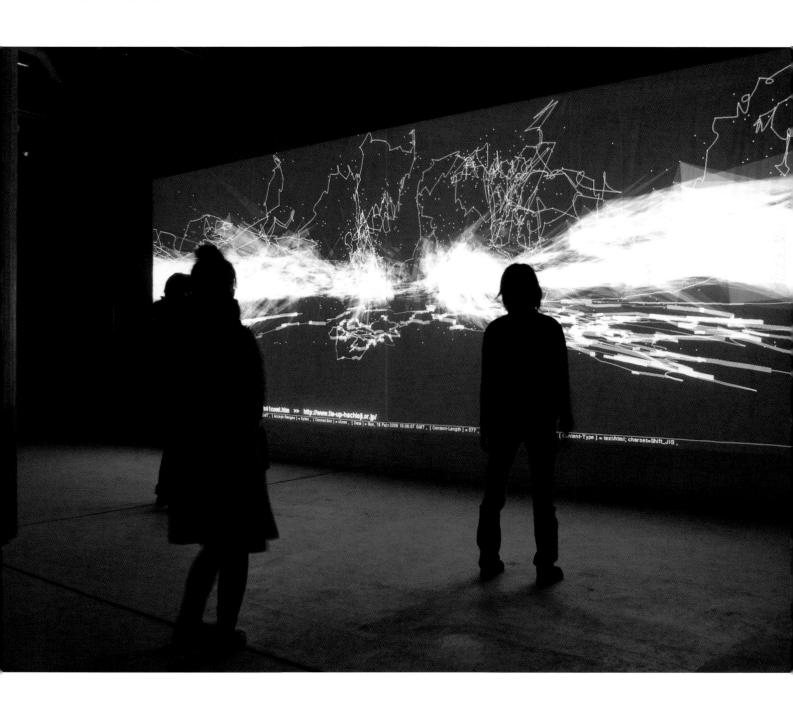

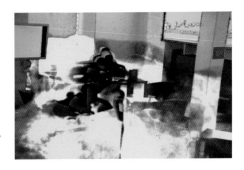

Judith Donath, Orkan Telhan and Martin Wattenberg, *Pasts and Presents*, 2006. In this MIT Media Lab project, live analysis of the topology of current and historical visitor activity in a café is visualized on a display. The intensity and position of the ghost-like red, white and tan shapes present an abstract animation record of people's movements and stillness over time.

Rania Ho, *Ho Fatso*, 2006. In this installation, which resembles a wrestling ring, as soon as anyone moves, everything (including the loose-fitting 'fat suits' people are wearing) inflates to create an absurd wrestling match. When everyone stops, everything deflates. The installation is intended to create a humorous realization of the possibilities of sophisticated technology.

ALTERNATIVE INTERFACES

Jason Lewis, *Intralocutor*, 2006. The installation uses video capture to create real-time moving silhouettes of viewers. As viewers speak, the system recognizes their words, converts them into animated text and then moves them from the speaker's image to fill another viewer's silhouette. This is intended as a metaphor for the way our words enter the consciousness of others. Lewis notes the influence on his work of concrete poetry, which 'treated the visual appearance of text as a principal participant in the production of meaning ... such experimentation grew out of a deeply held belief that traditional forms of written communication, with its clean spacing, rectilinear layout, and sober letterforms, no longer could speak to the cultural schizophrenia of the modern age'.

Jean Dubois and Philippe Jean, *Radicaux Libres*, 2006. Projected letters accumulate at the feet of viewers to form short phrases, spreading out along a path. The artists see this trailing text as a metaphor for walking and thinking, the text 'construct[ing] itself as much from the physical rules that animate the movement of water, as from those belonging to free association in poetry. One can also associate the flow of reading to wandering within a city, to combine the drift of the walk to the delirium of the imaginary, making visible the literary landscape that intimately forms within the spirit of everyone.'

David Rokeby, *Seen*, 2004. A video-analysis system, applied to video captured on the Piazza San Marco in Venice, undertakes four processes: it extracts people and pigeons, produces motion-study loops (short sequences, played repeatedly in a loop), creates composite visuals of streams of action, and separates what moves from what stays still. Some of the wall-sized projections are shown here. The blue wall at the left shows a composite of exposures of people and pigeons collected over time to show their movement and changing positions; the red/yellow image in the centre shows blurred motion studies of their movements; and the image at the right shows the unprocessed video. Rokeby explores surveillance's complexity as both invasion of privacy and 'protective witness'.

Rafael Lozano-Hemmer, *Homographies, Subsculpture 7*, 2006. A motion-tracking system controls 144 robotic fluorescent strip lights, which change their disposition to make corridors of light connecting the paths of people moving through the space. This installation appropriated surveillance technology to create an active, convivial environment, 'an intended contrast to the ... grids that organize most modern architecture'.

Marie Sester, *ACCESS*, 2003. An interactive installation lets web users track anonymous individuals in public places by pursuing them with a robotic spotlight and focused acoustic beam. The installation is set up on the fly, and web users help to determine who is followed. Sester notes that '[t]he structure of ACCESS is intentionally ambiguous, revealing the obsession/ fascination for control, visibility, and vigilance: scary or fun'.

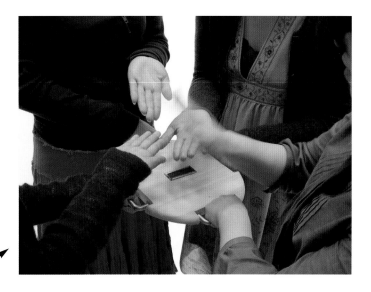

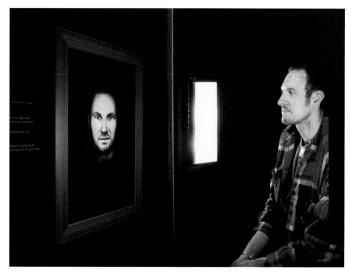

Baba Tetsuaki, *Freqtric Drums,* **2004.** This system electronically hooks people up so they become virtual drums. The person seen at the right (with the blurred hand) creates a drum sound each time he touches the palm of one of the other three people. The board they hold with their other hands enables the completed circuit. Discussing the importance of touch to current artistic research, Tetsuaki's website quotes *The Power of Touch* by Phyllis K. Davis (1999): 'Without touch, a baby dies, the human heart aches, and the soul withers.'

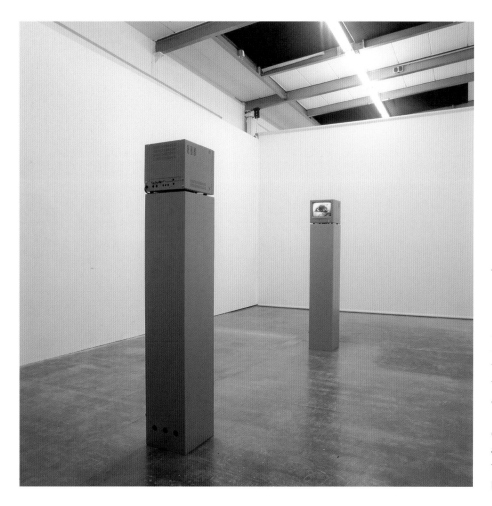

Angelika Böck, *Eye2eye,* **2000.** Two video monitors opposite one another reveal the eye-tracking patterns of the two video 'eyes' watching each other. The close-up shows the path traced by the computerized gaze-tracking system, which determines focus of interest by pupil position relative to its resting position gazing straight ahead. A viewer stepping in between the 'eyes' interrupts the tracking. Böck describes her focus on the process of attention: '[P]erceiving perception becomes the viewer's assignment and enhances his powers of observation.' (See also page 130.)

◄·········•

Alexa Wright and Alf Linney, *Alter Ego*, **2004.** A semi-autonomous, mirror-like computer display reflects a viewer's face modified to express various emotions. The face, previously captured on video, is mapped onto a 3-D theory-based morphing model that 'knows' how to represent emotions. When the viewer pulls a face at the mirror, the mirror reflects the viewer's face expressing other emotions. Drawing on fields such as psychoanalysis and cognitive science, Wright notes that this piece 'investigate[d] the familiar sense of being outside oneself, and play[ed] with the experience of a loss of control over an aspect of the self', simultaneously inviting 'individuals to question the various facets of their own identity'.

Nicolas Anatol Baginsky, *Public Narcissism II*, **2004.** This system extracts faces from videos, categorizes and groups them according to pattern recognition by neural-network software, and composites them in projected portraits. The three bottom displays show live video streams provided by cameras near the displays. The top twelve displays show the results of these analyses, grouped into categories. They blend the relevant sections of new faces into previous analyses.

David Rokeby, *n-Cha(n)t*, 2001. Each member of a chorus of chanting computers deviates from the chant when spoken to. The computers use grammar rules and speech algorithms to shape their chant, and 'listen' to viewers via voice recognition. When a computer is spoken to, it falls away from the community chant to respond to the viewer's words. Rokeby aims to show 'how the power of the spoken word creates community, a sense of togetherness and belonging, and how that very system of sociability goes awry when interrupted by a strange voice'.

Kenji Yanobe, *Giant Torayan*, 2005. This giant singing, dancing and fire-breathing robot responds only to children's voices (determined by voice tone) and periodically sounds the massive ship's horn mounted on its shoulder, which can be heard for miles. Yanobe has proclaimed that *Torayan* is the ultimate child's weapon; children see it as a powerful but friendly companion.

Golan Levin and Zachary Lieberman with Jaap Blonk and Joan La Barbara, *Messa di Voce*, 2003–4. Performers' utterances are analysed by a computer and used to generate animated graphics, which appear to emerge from the performers' silhouetted bodies. The installation uses a video tracking system to create the silhouettes, which move with the performers. Voice-recognition and sound-analysis software are used to interpret the speech, shouts and songs produced by the sound artists and to animate corresponding visual displays. The artists note that the 'performance touche[d] on themes of abstract communication, synaesthetic relationships, cartoon language, and writing and scoring systems'.

Sponge and FoAM, *TGarden*, **2001.** This 'Gestural Media' project links visitors' gestures to evolving sound textures and computer-synthesized video displays. Participants are shown wearing clothing embedded with sensors; their movements cause interaction with sensors in the large spheres and walls, and this interaction generates responses in the form of sound and projected graphics. The project investigates 'subjectivation, agency and materiality' via experiments in wearable computing and activated architecture.

SSS – Sensors_Sonics_Sights (Cécile Babiole, Laurent Dailleau and Atau Tanaka), 2004. Performers work with computers and a variety of sensors which let them use gesture and movement to create sound and 'visual music' events. The sensors (theremin, ultrasound motion detector, biomuse muscle reader) detect hand movements and angles which generate data to feed into a computer. Tanaka's career illustrates the kinds of crossover fertilization possible between art and science. In addition to developing experimental music, he is also a researcher for Sony, studying the use of muscle bio-signals to enable computers to use arm gestures as an interface.

Quartet (Margie Medlin, Stevie Wishart, Nick Rothwell, Todor Todoroff, Gerald Thompson, Glenn Anderson, Holger Deuter and Michael Koch), 2007. Detailed monitoring of musicians' and dancers' gestures is used to control live and virtual dancers and robots. The promotional image shows the project's focus on interweaving the physical and virtual to break new ground in gesture-based art, including tracking hand, arm and body movements. Team collaborators come from physiology, engineering, music, dance and the media (see page 205 for a full list of collaborators).

Zack Booth Simpson, *Calder*, 2004. An infrared gesture-detection system lets visitors manipulate Calder-like virtual mobiles. Movement of the hands and arms causes part of the virtual mobile to rotate in accordance with laws governing real objects. Simpson, who is also a game developer and molecular biologist, has created several other gesture-based installations, including *RNA Folding* (2005), which lets viewers manipulate protein models, and *Interference* (2004), which creates a light show activated by gestures.

Isabel Rocamora, *Memory Release*, 2003. This interactive video performance is influenced by a dancer's movements. The image above shows the suspended dancer, who is wired with motion-capture sensors; her movements are analysed by computer, which abstracts the changing locations of key body points (right), and also control the sections of a biographical video that are projected as part of the performance. Rocamora has noted that suspension can free the body to release tightly held memories.

Troika Ranch (Dawn Stoppiello and Mark Coniglio), *16 [R]evolutions*, 2006. Dancers move in front of animated strands of virtual DNA, whose motion is itself influenced by sensing systems that track their movements. The group uses a variety of sensors, including a 'midisuit' with plastic fibres, which measures the flex of major muscle groups, and the Isadora video-based motion-capture system, which tracks the relative positions of twelve key body points.

Alternating Active Elements

Blue Active Elements

Yellow Active Elements

Leah Buechley, *LilyPad Arduino*, **2007.** A set of stitchable controllers, sensors and actuators enables novices to build their own electronic textiles. The image shows a microcontroller pad that can be sewn into a garment. The black chip in the centre is an Arduino microcontroller (see page 120), capable of reading sensors, processing information and activating electronics; the holes round the edge allow components to be linked via conductive thread. This is part of an e-textile construction kit. Buechley, who maintains that 'high tech doesn't have to be hard-edged' and '[f]unctional doesn't have to be impersonal', has created various wearable displays including beaded LED bracelets, LED tops and a PDA-controllable skirt display.

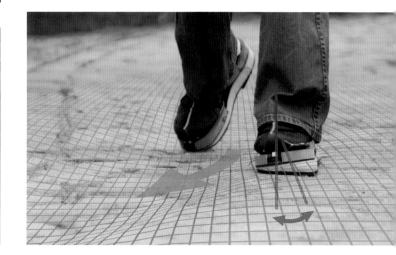

Maggie Orth, *Running Plaid*, **2007.**
Electronics and software-controlled conductive and resistive yarn are used in hand-woven fabrics. Different signal patterns cause the yarns to heat up and change colours via hand-printed thermochromic dyes. Orth is known for her pioneering experimentation with clothing as part of her International Fashion Machine project. *Firefly Dress* (1998) has embedded LEDs which light up in response to the swaying of the fabric.

Martin Frey, *CabBoots*, **2005.**
These boots, with integrated positional navigational systems (such as GPS), change shape to signal to the wearer that he is walking in the wrong direction. The green grid displays the forces that indicate the target path – an incline towards the left – which is set by pre-programmed navigational information. The footfalls of the wearer trigger an electromechanical system that subtly adjusts the soles of the boots so that they slant in the desired direction.

Manel Torres, *Fabrican*, **2006.**
This foam-based system turns into interlocking fabric when sprayed on the body. It was developed through interdisciplinary research in engineering, material science and design, and illustrates unprecedented ways of thinking about clothing and technology.

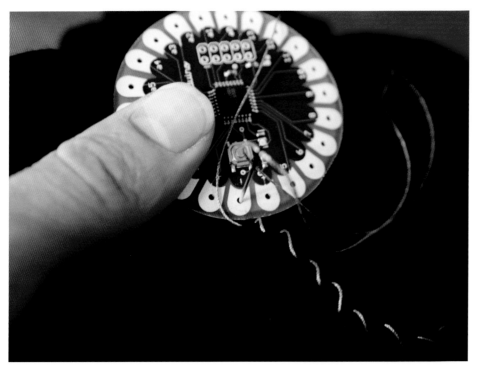

Joanna Berzowska, *Intimate Memory Dress*, 2005. The dress records details about when the wearer has been touched. Fabric-based pressure sensors are linked to LEDs, which illuminate the embroidery and fade as time passes. Berzowska directs XS Labs, which investigates the possibilities of dynamic clothing: 'We develop projects that focus on aesthetics, personal expression, and the idea of play, as opposed to the prevalent utilitarian focus of wearable technology design on universal connectivity and productivity applications.'

Sheldon Brown, *Scalable City*, 2007.
A semi-immersive VR visualization of a suburban environment is built up from a combination of real data and an elaboration of that data by an autonomous algorithm. In the world that viewers encounter, 3-D graphic conventions are subverted in a manner both humorous and disturbing. For example, houses float and roads do not quite connect. A self-organizing expanding element 'builds upon the previous, amplifying exaggerations, artifacts and the patterns of algorithmic process'. Brown wanted viewers to think about the underlying logic of suburban design.

F.A.B.R.I.CATORS (Franz Fischnaller), *City Cluster*, 2003. A shared networked VR environment allows viewers to modify representations of Florence and Chicago. The illustration shows an interweaving of buildings and sculptures constructed by people using the system. As a press release notes, 'visitors, with their own creativity and communicative skills, can become protagonist and/or free citizen: navigate, interact, intervene, exchange buildings, objects, ideas and/or create their own ideal city'.

F.A.B.R.I.CATORS have created many VR environments, including one that allowed viewers to navigate a 3-D representation of Leonardo da Vinci's *Last Supper*.

Josephine Anstey, Dave Pape and Dan Neveu, *PAAPAB – Pick An Avatar, Pick A Beat*, 2003. A VR dance-floor (above), is inhabited by life-size puppets animated by the movements of users at remote locations. A woman wearing VR goggles and tracking sensors on her hands (below) controls one of the puppets.

Luc Courchesne, *Panoscope 360*, 2001– . The viewer is surrounded by a navigable hemispheric 360-degree immersive 3-D sound and visual display, created with a special lens and projection surface. The illustration shows a viewer navigating a virtual world using a three-axis pointer. The system has also been used for experimental telecommunications and games events.

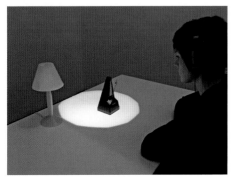

Akitsugu Maebayashi, *Metronome Piece*, 2003–7. This 3-D sound installation consists of recorded sounds from an urban environment and the clicking of a metronome. As Maebayashi took a series of walks through urban spaces he recorded ambient sounds by means of microphones placed in his ears (to get the 3-D separation) and also the ticking of a metronome that he carried with him. In the installation these sounds are combined with the ticking of a real metronome in front of the viewer to create an uncanny layered 3-D soundscape. The metronome clicks act as what Maebayashi calls a 'sonar' marker to provide a spatial sonic signature.

Alvaro Cassinelli, *Khronos Projector*, 2005. In this innovative system, the viewer can manipulate a deformable screen to move sections of a projected image back or forwards in time. In this computer visualization of how the innovative system works, the screen has been pushed inwards, causing the depressed segment to show the scene as it was in the past – in the illustration, at night. Cassinelli calls the *Projector* a 'video time-warping machine' and sees viewers using the display as 'sculpting the space-time "substance"'.

Life Writer © 2006, Laurent Mignonneau & Christa Sommerer

Christa Sommerer and Laurent Mignonneau, *Life Writer: an Interactive Typewriter*, 2006. Text typed on a typewriter is transformed into animated a-life creatures. According to the sequence of words and the complexity of the text, the system changes various parameters of the life forms. Once the carriage return is pushed, the text 'projected' on the paper appears to become animated into floating forms which interact with each other and the viewer.

ALGORITHMS

What goes on inside computers is opaque to most users, who simply depend on them to work efficiently and quickly. Meanwhile the electronic 'brains' inside the machines are working overtime. They read sensors; organize, manipulate and interpret information; display results; control devices; and manage communications networks. To do this, they rely on sets of detailed instructions (variously called programs, code and algorithms) to guide their actions. Extrapolating from the success of computer code, it might be the case that the wider world can be understood by consolidating the intricacies of fields such as biology and economics down to a series of encapsulating algorithms. On the other hand sceptics note that reducing all phenomena to the status of data ignores the critical features of life.

Intrigued by these issues, artists have explored code and its cultural implications in many ways, investigating automated algorithms (step-by-step procedures for solving problems and, in computer science, the conceptual structure guiding software) to create images, sounds, animation and interactions, as well as increasing code's 'intelligence' so that computer-controlled devices can simulate life (artificial life) and human intelligence (artificial intelligence).

In the early days of computer art, practitioners sought to emulate the representational qualities of photography and drawing. Some pioneers such as Herbert Franke and Paul Brown suggested that these efforts were misguided, seeing programmability as one of the most interesting aspects of computers and a critical area for inquiry. Artists, they felt, should focus their creative energy on developing algorithms that could then create artworks. Code itself could be considered as a major aesthetic component, as the 'families' of work it could produce were often more important than any single production. Critics of these ideas believe that the aesthetic credentials of art produced primarily by code is somewhat suspect.

Artists' interests in algorithms and code include the intellectual challenge of working with symbols that represent complex, dynamic processes; the puzzle of developing code, which then creates aesthetically strong sonic, interactive and visual art; the connection of code with Modernism's thrust towards abstraction and identification of underlying formal structures; and the possibility of exploring postmodern questions about the elusiveness of authorship. For example, the American code artist C. E. B. Reas has urged that artists become involved in programming because of its critical role in technology-based culture. To help make this possible, he and his colleague Ben Fry developed the Processing computer language, which, being optimized for artistic experimentation, won an Ars Electronica prize. Reas's code-based work such as *TI* focuses on dynamic processes and the integration of sketching and editing along with algorithmic generation (167).

Other artists also stress the interplay of algorithm and intervention. The Austrian group @c + Lia create live events in which they improvise with code-generated sound and abstract image projections (164). The poet Jim Andrews creates web events in which viewers interact with code-generated sound and animations (165). Other artists take a less interactive approach. For example, Shirley Shor creates 'architectural algorithmic art' in which program-generated animations interact with a range of features of architectural spaces (167).

Some artists' groups see involvement with code as critical to what they are trying to achieve. For example, the website of the Norwegian art group Generator.x, which has produced several shows, proclaims: 'Intrigued by the power of computation and the realization that all digital media are in fact software, a new generation of artists and designers are turning to code as a means of new expression and a way to better control their medium.' Also stressing empowerment, the Runme organization produced the Helsinki 2003 Read_me festivals as well as ongoing online repositories which

encourage exchange and critical dialogue between the software-art and programming communities.

The USA-based curator Christiane Paul organized a pair of related process-oriented shows, both called *CODeDOC*, at the Whitney Museum of American Art in New York (2002) and at Ars Electronica (2003) to explore the conceptual and aesthetic intricacies of code-based art (166). Artists in each exhibition were given a common challenge (for example, to animate three circles connected by lines) and then invited to generate code-based responses. Paul explained her motivations this way in the online catalogue of the Ars Electronica show:

> I wanted to raise questions about software art as artistic practice.... One intent of the [*CODeDOC II* show for Ars Electronica] project certainly was to demystify the notion of code as a 'mysterious,' hidden driving force and to reveal the code to the viewer. Among the questions that seemed important to address or clarify were the following.... Do 'signature,' 'voice,' and aesthetics of an artist manifest themselves equally in the written code and its executed results? Will reading the source code enhance the perception of the work? Does it in fact add anything at all or just create an emphasis on 'technicalities' that is unnecessary, alienating, and obscures the work?

Evolution is one of the processes that continue to attract the interest of artists who find the principles of adaptation and increasing complexity particularly intriguing. Several visual and sonic specialists have experimented with programming genetic and evolutionary systems. Borrowing biological concepts such as breeding, mutation and natural selection, these systems typically use algorithms to generate sets of images or sounds that might serve as 'parents' for new generations. Judgements are then made about the relative desirability of the members of the set. These judgements can be applied automatically, via computer application of fitness criteria, or can be made by artists or viewers. At each generation, those forms judged most fit are 'bred' such that the next generations are more likely to incorporate the parents' underlying design tendencies.

Today genetic art has an active following supported by yearly conferences and websites. Involving many people as evolutionary selectors, Scott (Spot) Draves's *Electric Sheep* is a screensaver that exploits the participants' unused computer cycles to further genetic image evolution (169). The system displays new candidates for breeding to internet users all over the world and amalgamates their votes. In *E-volver*, the Dutch artists Erwin Driessens and Maria Verstappen created an evolutionary art installation on flat screens placed throughout a biological research laboratory. Researchers could 'vote' for their evolutionary choices among each generation's images (168).

Researchers have even greater ambitions than merely modelling evolution, however. Artificial-life (a-life) advocates believe they can develop algorithms to simulate the panoply of life processes, creating artificial entities that learn, modify their own code, evolve and respond with subtlety to their environments. Some even claim that one might call these entities true life forms. There is considerable research interest in such investigations, for both theoretical purposes (understanding life) and practical purposes (making flexible, adaptive programs and devices, for example).

Artists have also become intrigued by the notion of creating works that are autonomous, that change over time and have multilayered interactions with viewers. They have developed complex screen-based animated worlds populated with autonomous creatures, constructed interactive sculptures that seem life-like, and composed music with a-life generational agents as well as performances in which humans and artificial agents collaborate. Spain's Vida international artificial-life competition considers a range of work including (to quote from their website) 'projects using autonomous robots, avatars, recursive chaotic algorithms, knowbots, cellular automata, computer viruses, virtual ecologies that evolve with user participation, and works that highlight the social side of Artificial Life'.

Building on his research to model the development of cells, the Australian Jon McCormack generates still and animated visions of artificial life. For example, the advertising-hoarding-sized *Bloom* project presents graphics of mutated forms of Australian plant life (170–71). Infusing virtual game-like worlds with a-life-generated behaviour, Troy Innocent creates unprecedented environments like Ludea which comment on complex themes ranging from urban life to the nature of language (201).

As part of his research into what he called *Hyperzoologie* (life as it could be), the French artist Louis Bec was a pioneer in the area of artificial life. A long-time champion of a hybrid approach that questions the separation of the arts and the sciences, Bec is currently working on the Arapuca project together with the EU-funded Alterne research consortium.

This project studies how virtual reality might enhance investigations of a-life, for example by allowing immersive environments to manipulate computer-generated a-life forms (173). Christa Sommerer and Laurent Mignonneau's *Life Writer* invites viewers to create such forms by keying messages on a typewriter. Their system then 'projects' animated-text a-life forms on paper influenced by the sequencing and complexity of the typewritten messages (158).

Robotics artists have been attracted to a-life because of the richness that its techniques can contribute to behaviours and interactions, and because mimesis of life has long been a focus of robotics. Adam Brown and Andrew Fagg's *Bion* is an installation composed of hundreds of small a-life programmed modules suspended on cables which adjust their activities based on 'experience' (172). Ken Rinaldo's and Bill Vorn's long-standing efforts to apply a-life to robotics (respectively 129, 128) are also relevant here.

Although famous for their 'intelligence', computers are actually too stupid to master the everyday tasks that humans take for granted. For example, computers cannot understand free-form children's stories sufficiently to answer simple questions about them. While Ray Kurzweil (in his 1999 book *Age of Spiritual Machines*) predicted that computers would exceed humans in all realms of mental functioning by 2050, other commentators are sceptical. Both researchers and artists round the world are eager to test the hypothesized limits, wondering, among other things, when computers will be able to be programmed to create works that might be judged to be aesthetically interesting. Paul Brown, for example, is working with an interdisciplinary team to create *DrawBots*, which test the limits of artificially generated creative activity (175). The performance troop known as Open Ended Group integrates research in artificial intelligence (AI) with art, dance and music. For example, *How Long* utilizes AI algorithms to analyse real-time motion-capture data of dancers, generating 3-D figures on a scrim with whom the dancers improvise on stage (176).

SVEN (Surveillance Video Entertainment Network) by Amy Alexander and her collaborators demystifies security systems by humorously turning surveillance videos into MTV-like sequences based on AI analysis of people's movements and characteristics (176). Christian Moeller's *Cheese* monitors videos of actresses trying to maintain forced smiles for long periods with an emotional-expression-recognition system. The system sounds alerts when it judges that smiles are falling below its recognition threshold (177).

The development of artificial characters is another grand challenge of AI. Both artists and research labs such as MIT Media Lab's Synthetic Characters Group are asking how we can program computers to simulate interesting fictional entities. In *Agent Ruby*, Lynn Hershman Leeson hints at what interacting with artificial characters with attitude and a strong sense of self might be like by offering a female chatbot (an AI program that maintains a conversation by extracting meaning from received text and then typing believable responses) who is able to have free-form conversations with web visitors (163).

Other research groups are pursuing the related topics of artificial narrative and affective computing, which focuses on reading users' emotions and generating appropriate synthetic ones. As part of an investigation of emotions not of interest to commercial developers, Marc Böhlen's *Amy & Klara* are two tabletop robots that constantly monitor the Salon.com website for topics of interest. They use AI, speech synthesis and speech recognition to express their opinions verbally, to interpret what the other is saying and to get into arguments (179).

For some artists, code is the ultimate abstract art – events, images, sounds reduced to data and a set of instructions. The challenges are significant for those who are prepared to push further on the frontiers of a-life and AI.

Lynn Hershman Leeson, *Agent Ruby*, **2002.** A web-based 'chatbot' named Ruby engages in dialogue with visitors to the website. The image shows a composite of some of Ruby's facial expressions. The website explains the attempt to model sophisticated intelligence: 'At any given moment, Ruby might dodge your question by turning it back on you rhetorically, jumping from one topic to another... Agent Ruby generates dialectic, potent tension between human and computer, symbolic and imaginary, real and virtual. At times intelligent and cunning, at other times sensitive and funny, Ruby surprises us with her post-human vulnerability. She is the next generation confidante.'

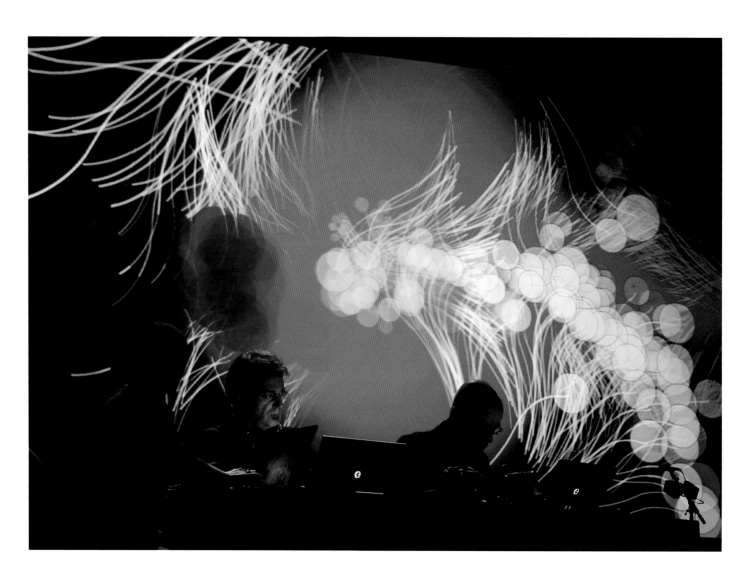

@c + Lia, *Generative Audiovisual Performance,* **2007.** The group developed algorithms to generate animated graphics and sound. The illustration shows one of their performances during which they improvise in response to their code-generated sounds and images.

Jim Andrews, *Nio,* **2001.** Influenced by concrete poetry and abstract sound art, Nio has created an interactive website where visitors can improvise with animations and sound generated by computer code. The letters visitors type on their keyboards unleash abstract animations like those in this screenshot. Andrews's paper 'Poetry and Programming' claims that programming is part of a larger cultural enterprise and sees computers as critical 'language machines'. He further asserts that artists must learn programming so they can 'inform the vision of where computing is going'.

Software art produced for *CODeDOC* shows, 2003. As part of shows exploring code-based art at Ars Electronica and the Whitney Biennial in New York, twenty artists were invited to respond to the curator's challenge to create code to 'connect and move three points in space'. John F. Simon Jr.'s *CodedocII* (above) presented a ten-by-six grid of three dots and connecting lines which animated themselves into various configurations. In Antoine Schmitt's *Threesome* (below), software animated three shaded spheres, whose movements generated many different images, exploring 'the realm of ... attraction/repulsion/indifference relationships'.

C.E.B. Reas, *TI*, 2004. The image projected on each of a number of discs, suspended to hover above the floor, is created by a software process in which the organic-looking forms seem to grow. Shown here is a still, capturing a moment in that process.

Reas, who programmed an environment in which the images emerge 'from the results of thousands of local interactions between autonomous elements', is fascinated by the dynamic processes of code: 'Core expressions of software including dynamic form, gesture, behavior, simulation, self-organization, and adaptation emerge from these processes.... The design of software is ... increasingly becoming a basis for our reality.'

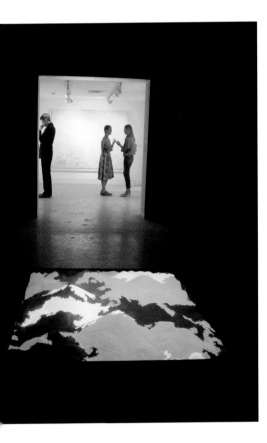

Shirley Shor, *Landslide*, 2004. A large grid of coloured shapes is projected onto a pile of sand. A computer algorithm uses a combination of randomness and rules to create abstract battles in which colours attempt to 'conquer' neighbouring colours until one dominates the others. The computer endlessly cycles the algorithms, generating a new progression each time. The installation refers to territorial fighting in the Middle East.

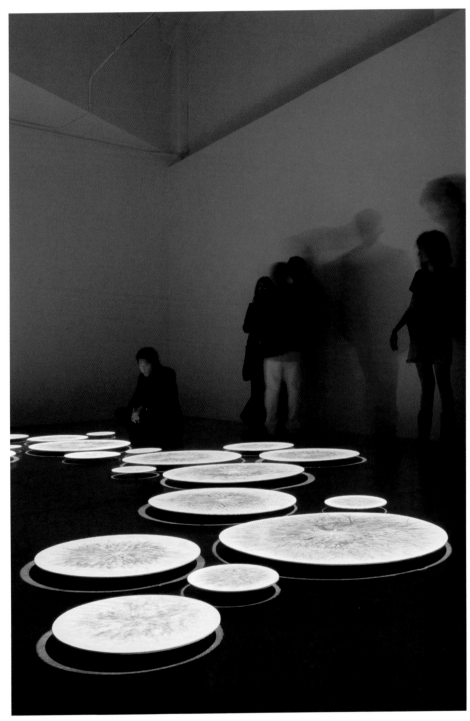

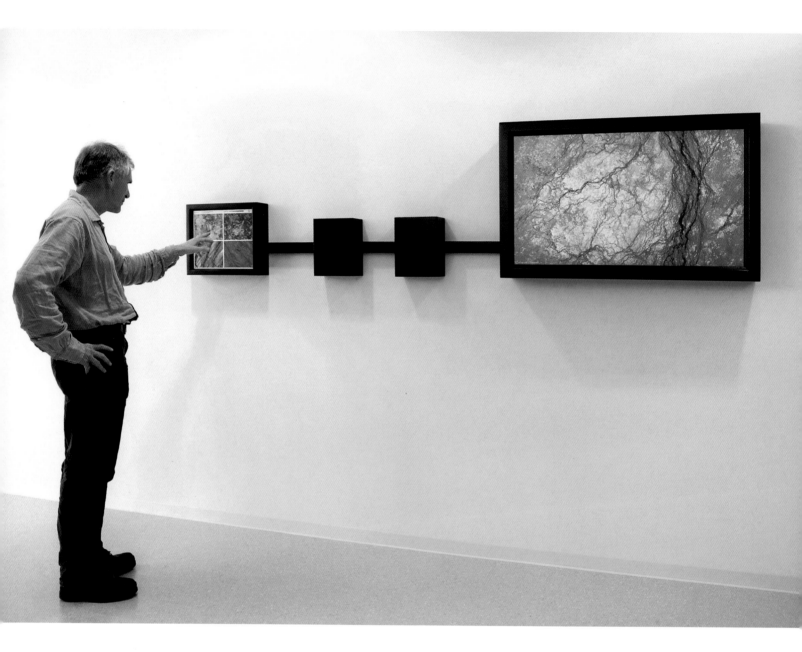

Erwin Driessens and Maria Verstappen, *E-volver*, **2006.**
An evolutionary art system breeds new digital organisms,
taking account of viewer votes. Touch screens distributed
throughout a biological research laboratory offer passers-
by the chance to indicate their preferred organic forms.
The generative software in the 'image cultivating machine'
installed in the space then extracts qualities of the most
popular images to use in the next generation of organisms.

Jeffrey Ventrella, *Gene Pool*, **2006.** Viewers can breed a computer-generated colony of 'swimbots' to explore concepts of artificial evolution. Ventrella used a-life programming techniques to create this dynamic set of interacting creatures. The colony evolves as some swimbots, influenced by differential attractiveness and ability to swim, reproduce more often than others. Variations in structure and colour affect both attractiveness and feeding/mating ability. Users can affect the path of evolution via the menus at the top by helping creatures to mate or eat. For example, the love menu lets the user set what qualities constitute attractiveness in the colony.

Scott (Spot) Draves, *Electric Sheep*, **2006.** Engaging with this evolutionary art program, viewers vote on which images in a set should serve as parents, from which the next generation of images evolve. *Sheep* uses the internet to involve an international community in the distributed evolutionary process. Draves notes that this work 'validates the premise of artificial life: that beauty and life can spring from iteration of simple mechanical rules. That you can get out more than … you put in.'

Chu-Yin Chen, *Quorum Sensing***, 2002.** Projected a-life creatures evolve and swarm at the feet of viewers. The installation takes its name from the biological phenomenon of bacteria colonies sending chemical signals to each other in order to coordinate their behaviour. The graphics, generated by a semi-autonomous genetic algorithm, are projected on the floor; the creatures' swarming behaviour, their metabolism and the sounds they make vary according to the number of visitors and their changing positions.

Jon McCormack, *Bloom***, 2006.** This advertising hoarding shows computer-generated variations of native Australian plant species resulting from programmed algorithms simulating the effects of evolution and the environment. Building on McCormack's research to model cell development, *Bloom* presents 'mutated and crossbred representations'.

••••••••••▶

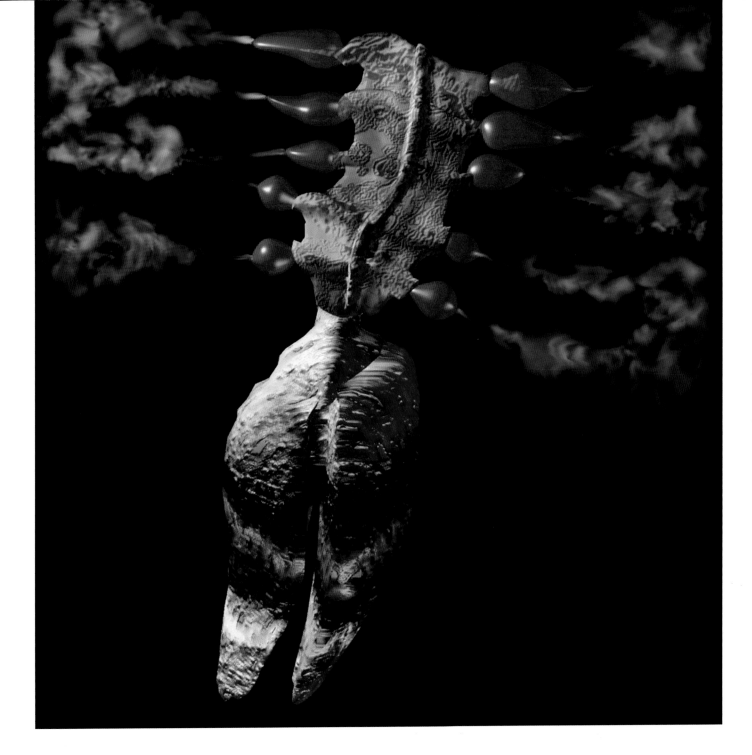

Adam Brown and Andrew Fagg, *Bion*, 2006. Hundreds of small modules suspended on cables are programmed with a-life techniques to produce dynamically changing light and sound behaviour. Proximity sensors cause the 'bions' to interrupt their constantly morphing patterns of light and sound only when viewers appear. Learning from these experiences, the bions communicate their reactions throughout the group.

Project Alterne//Arapuca: Louis Bec, *The Protospone Mex*, 2005. This a-life creature is a semi-autonomous software entity that can interact with other creatures and its environment. Bec, a biologist and artist, was invited to work in the EU-funded interdisciplinary Alterne research consortium to test the use of immersive VR environments to develop a-life. He believes that the complex environmental interactions of a-life forms with VR can be provocative in furthering research.

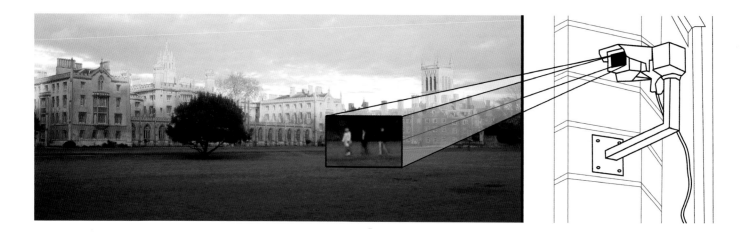

James Coupe, *(Re)collector*, **2007.** Using a city-wide network of surveillance cameras, an AI-based system attempts automatically to recognize and capture 'cinematic moments' from everyday activities and recombine them into feature films. It then projects a video of 'farewell scenes, meetings, escape scenes, chases, love scenes, etc' which it has identified. The promotional illustration shows a drawing of a typical surveillance camera and an image of one of the captured activities superimposed on a view of Cambridge, England.

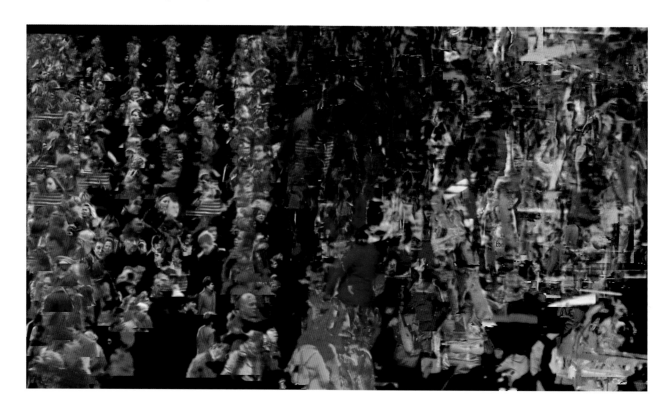

David Rokeby, *Sorting Daemon*, **2003.**
A surveillance camera pans, tilts and zooms as it surveys a street scene, looking for elements that could be people. The visually intelligent program then extracts the people and their actions and creates real-time composite displays, sorted by visual characteristics such as colour. The wall-sized projection sorts extracted video by colour horizontally and by intensity vertically. Rokeby has explained that the system is based on his concern that the 'war on terrorism' is using automated video-scene analysis systems to profile people.

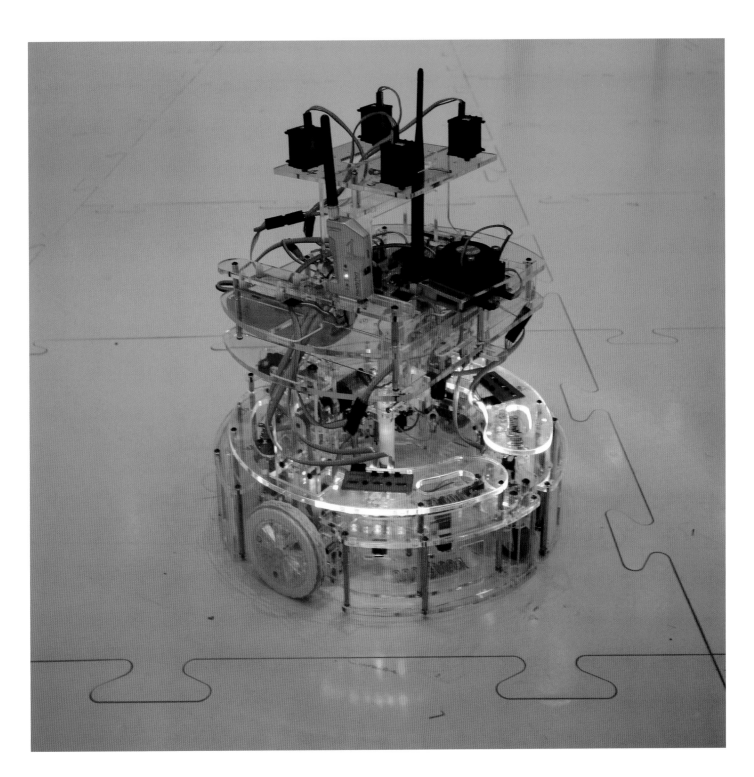

Paul Brown, Bill Bigge, Jon Bird, Dustin Stokes, Maggie Boden and Phil Husbands, *DrawBots*, **2005–8.** As part of a larger research project, an interdisciplinary team applied evolutionary robotics methods to the enterprise of building an embodied robot that could manifest autonomous creative behaviour. The form of creativity the team chose was the ability to make marks or draw in the most general sense; the 'drawbot' in the picture is fulfilling this function by drawing on the floor. The artists, engineers, AI researchers, cognitive scientists, philosophers and art theorists worked together on an inquiry titled 'Computational Intelligence, Creativity and Cognition' to investigate the theoretical bases of 'AI, Alife, philosophy, creativity and cognition'.

Open Ended Group (Paul Kaiser, Marc Downie and Shelley Eshkar), *How Long Does the Subject Linger on the Edge of the Volume*, 2005. This AI program responds in real time to the underlying structures of dancers' movements by generating graphic agents on a translucent screen. Using AI algorithms to analyse motion-capture data, *How Long* generates 3-D figures, which function as 'abstract agents ... akin to intelligent and responsive diagrams'. The dancers can improvise in relation to these evolving animations, which also offer the audience a new kind of abstract information to enrich their appreciation.

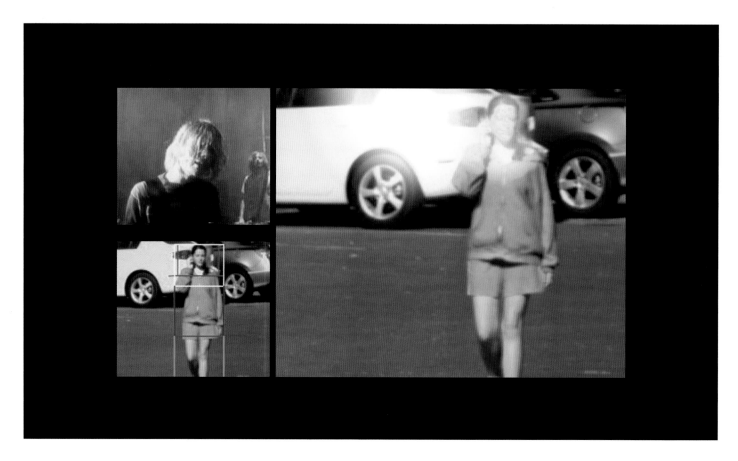

Amy Alexander, Wojciech Kosma and Vincent Rabaud, with Nikhil Rasiwasia, Jesse Gilbert and Marilia Maschion, *SVEN* (Surveillance Video Entertainment Network aka 'AI to the People'), 2007. Image-analysis software tracks pedestrians and converts the surveillance video to special-effects MTV treatments. The bottom left image shows segmentation analysis of the live video image, while the top left one shows a rock video used as a source for effects. The large image shows the adding of effects to the live video. This process seeks to 'demystify concerns about surveillance and computer systems' not by questioning the fact of our being watched but by examining 'how the watching is being done – and how else it might be done if other people were at the wheel'.

Christian Moeller, *Cheese,* **2003.** This installation uses a facial expression-recognition system which sounds an alert when an actress's forced smile deviates from acceptable levels of sincerity. Shown are digital video recordings of five people who were trying to maintain smiles while interacting with the system.

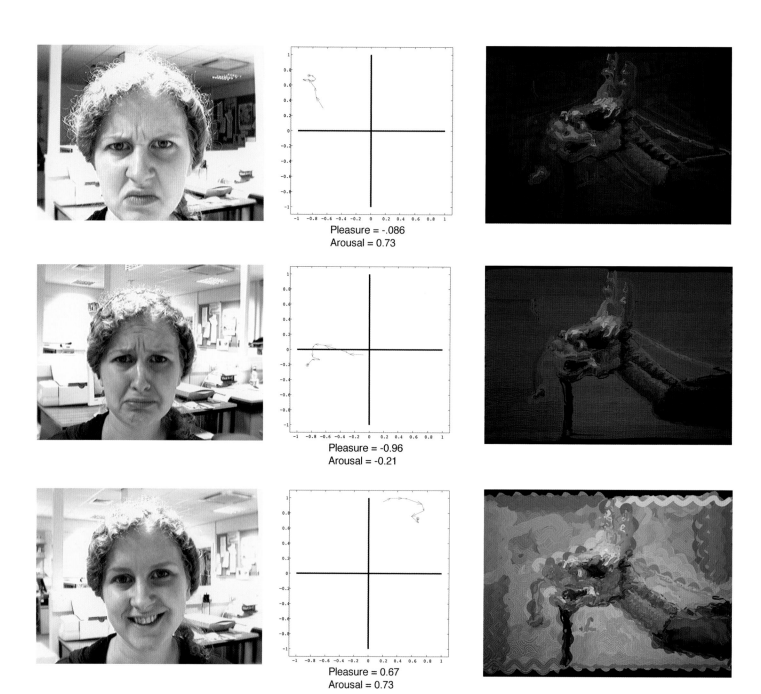

Pleasure = -.086
Arousal = 0.73

Pleasure = -0.96
Arousal = -0.21

Pleasure = 0.67
Arousal = 0.73

Maria Shugrina, Margrit Betke and John P. Collomosse, *Empathic Painting: Interactive Stylization through Observed Emotional State,* **2006.** This system attempts to read the emotional expression of the computer user's face for dimensions of pleasure and arousal. It continuously monitors twenty 'facial action units' (e.g. eyes, brows, mouth) and modifies its display of paintings to represent the emotions it has detected. Shown are original expressions, graphs of how the system interprets them, and pictures of a dragon automatically selected to indicate the prevailing mood.

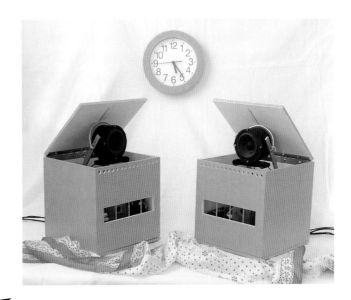

Jessica Field, *Semiotic Investigation into Cybernetic Behaviour*, 2003. Two decision-making machines debate their understandings of viewers' behaviour and show their chain of reasoning via text displays and sound. The machines, called Alan and Clara, have different sensors, thus giving them different abilities. One can only sense movement over time, the other only movement in space. Field was here seeking to simulate 'the social complexity of having an opinion'.

Marc Böhlen, *Amy & Klara*, 2006. Tabletop robots use AI, speech synthesis and speech recognition to get into arguments and swearing matches about what they read on the web. They rise out of their boxes for discussion and arguments, and use AI analysis to interpret utterances and devise responses. The illustration shows the bots in listening mode. Böhlen believes that artists should investigate ignored research areas, observing that the 'language of synthetic speech recognition and synthesis systems is a highly selective subset of the full, rich and messy body of linguistic corpora that comprise our oral and written languages'.

Michael Mateas and Andrew Stern, *Façade*, 2005. An AI-driven virtual world lets viewers interact with characters experiencing marital problems. The program generates a 'real-time 3-D virtual world inhabited by computer-controlled characters, in which the player experiences a story from a first-person perspective'.

Hasan Elahi, *Tracking Transience*, **2006.**
A series of self-surveillance projects
documents location in real time and
everyday activities. Shown is one project
in which Elahi photographed all the meals
he ate on aeroplanes. To illustrate a darker
side of databases, Elahi responded to
repeated questioning by US Homeland
Security personnel by creating works
that take surveillance to an absurd
extreme, noting that he 'prefer[s] to
investigate the acceptance of technology
rather than technology itself'.

INFORMATION

We have in recent years come to depend on the efficient storage, management, retrieval and analysis of databases in almost all areas of life. (A database is an ordered collection of data elements.) The World Wide Web has accelerated this process because online activities, including informal elements of personal life, can easily be converted into database information. Databases now include media as well as text, as for instance on YouTube. New technologies such as Radio Frequency Identification Chips (RFID) allow physical objects to be tracked. Sophisticated data-mining, analysis and visualization methods extract unprecedented information from rich databases. Examples of this activity include Amazon.com's ability to recommend books by analysing buyers' purchase records, or the FBI's ability to identify potential terrorists on the basis of patterns of times, places, and people called extracted from telephone records.

These developments may well be increasing overall efficiency and enriching life in general. Microsoft Research, for example, has a project called MyLifeBits in which researchers continuously document all details of their everyday existence via automatic cameras, GPS locators, email, voice communications and so on to understand how this kind of self-documentation might be useful in the future. Of course it may be that databases' increasing reach will resolve into exploitation and a threat to individuals' privacy. More profoundly, perhaps, it might warp perceptions of identity. The Critical Art Ensemble, famous for its critiques of electronic culture, has suggested that political authorities are beginning to view people merely as 'databodies' – collections of information items (for example, credit-card and web records) to be panoptically tracked, exploited and controlled.

Showing that database concepts have an impact even in cultural practice, the art theorist Lev Manovich has explained that databases represent major transformations in thought processes and new ways of organizing art/media experiences. Manovich sees these changes as essential to the development of the 'poetics, aesthetics, and ethics' of database-engaged media. As he put it in his 1997 essay 'Database as a Genre of New Media':

> After the novel, and subsequently cinema privileged narrative as the key form of cultural expression of the modern age, the computer age introduces its correlate – database. Many new media objects do not tell stories; they don't have beginning or end; in fact, they don't have any development, thematically, formally or otherwise which would organize their elements into a sequence. Instead, they are collections of individual items, where every item has the same significance as any other.

Artists are drawn in a love/hate way to these developments, both commenting on their dangers and exploring the potential deriving from the construction and analysis of databases. Some construct databases themselves; others develop information-visualization methods, create cinema derived from database processes, explore the possibilities of barcode and RFID information systems, reflect on surveillance, and invent methods to subvert and question information systems. Artists bring unconventional perspectives to the design of databases, inventing unusual focuses, developing innovative ways in which to orchestrate wide participation in amassing data, finding engaging ways to visualize that data, and subjecting it to unprecedented kinds of analysis.

Artists often use the web because it enables international participation and allows for wide dissemination and usage. For example, Karen O'Rourke's *A Map Larger Than the Territory* invites web participants to represent their paths across any of several cities using images, texts and sounds in a geographically indexed system (186). Other practitioners

take a tactical approach, offering critical commentary on mainstream governmental and commercial institutions by gathering and presenting information that authorities might prefer remained unavailable. For example, Christoph Wachter and Mathias Jud's *Zone*Interdite* invites international web users to contribute location and other information about restricted military areas to an online atlas (186).

Some artists build databases infused with unconventional perspectives, media treatments or unusual subjects. The Austrian artist Michael Aschauer's *Danube Panorama Project* creates a searchable visual database documenting both shores of the Danube via an automatic camera that takes continuous panoramic photographs (187). Illustrating both the formation of unusual databases and research into retrieval methods, George Legrady's *Pockets Full of Memories II* (2003–7) installation asks viewers to digitally scan any object they are carrying and then add descriptive keywords and ratings. A computer uses semantic-analysis algorithms that extract conceptual relationships from a set of words to cluster items visually in computer displays.

Artists are also reflecting on the increase of video surveillance in public spaces, of snooping on communication networks, and of the use of smart-card/RFID tracking technologies. Their obvious concern is the loss of privacy and identity. Hasan Elahi, an Arab-American artist, responded to repeated instances of questioning by US Homeland Security personnel by creating a set of works entitled *Tracking Transience* that take surveillance to an absurd extreme. Using technologies such as GPS and web maps, Elahi created a system that continuously updates his own actual location on the web (180). Michelle Teran's *Friluftskino* is one of a series of performances in which Teran herself snoops on the snoopers by intercepting and making visible images being picked up by wireless security cameras in public spaces (188–9).

Some artists have built gallery installations featuring provocative devices to explore the omnipresence of surveillance. For example, Seiko Mikami's *Desire of Codes* creates a wall of sixty coordinated robotic camera/light devices that track their viewers (190). The controversial software Carnivore, concocted by the FBI to continuously monitor all electronic communication for suspicious activity, has inspired a range of responses, with the artists' group Rhizome sponsoring projects to comment on it. For instance, Jonah Brucker-Cohen's *Police State* converted the flow of internet words referring to terrorism to instructions to control twenty radio-controlled toy police cars (190).

The growth of surveillance technologies has greatly increased our capability to track both objects and persons. Perhaps it will become possible to maintain databases to monitor all objects from manufacture to disposal, but this might be a growing nightmare, as artists are well aware. James Patten's *Corporate Fallout Detector* is a device that allows consumers to scan barcodes of various items to access unusual information – for example, a display of manufacturers' records on pollution and ethics (192). Embedding personal RFIDs in visitors' shoes, Evan Karatzas's *Proximity Lab* employs a sensor-enabled floor surface to customize projected sounds and images to the locations where particular individuals are standing (193). Ryota Kimura's *S.U.I. – Smart Urban Intelligence* reads Tokyo smartcard railway tickets and projects videos and route maps extracted from the records of trips encoded in the cards, as well as portraying a fictitious 'agent' who comments on the users' records (192).

Databases offer intriguing parallels with concepts underlying contemporary media art. Both focus on non-linearity (the idea that information can be input and output in non-sequential flexible ways) and on distributed authorship (the notion that many people contribute to the creation and organization of information – both database and cultural). As part of the Synthetic/Computational Cinema movement, artists have undertaken experiments using database concepts and techniques to approach digital cinema, for example viewing films as sets of shots and themes to be sequenced dynamically based on viewers' interests. Lev Manovich's *Soft Cinema*, for example, implements algorithmic cinema in which custom software 'edits' compositions on the fly based on rules devised by the system's creator. A database of clips is tagged both semantically and formally according (among other things) to location, subject matter, movement direction and brightness (185). Chris Ziegler's *66movingimages* is a video documentation of a road trip on Route 66 across the American southwest. Visitors manipulate a motorized screen on an 11-metre (12-yard) track along which the relative position of the screen correlates the video with the same relative position along the USA's most famous highway (185).

The field of Information Visualization combines design, computer science, psychology and other disciplines in the development of methods to display complex information from many fields as a way of enhancing interpretation. A related technique, Sonification, represents information through sound. Typical visualization research focuses on issues of

utility, such as how data display can be used to enhance action or advance scientific understanding. A growing movement sees the collection of data and development of ingenious methods to visualize it as potential cultural events, however. There is even an Information Aesthetics website that showcases compelling examples of information displays. As the site explains,

> [I]nformation visualization can be enriched with the principles of creative design and art, to develop valuable data representations that address the emotional experience of users.... [I]nstead of evaluating such information applications by measuring task performance and comprehension effectiveness, one should consider to determine user interest, attention, focus, enjoyment and curiousity [*sic*].

In this spirit, artist-researchers have developed numerous information visualization-related projects. And some are focusing on related political issues (noting that there is no 'correct' way to visualize data) or picking topics and methods of emphasis that might be ignored or devalued by the mainstream.

Donna Cox has been an artist/scientist at the US National Center for Supercomputing Applications (NCSA) for many years, helping other researchers to visualize astronomical, atmospheric, network and biological data. Her *Black Holes: The Other Side of Infinity* visualized two colliding galaxies (197). Commenting on international financial systems, John Klima's *Ecosystem* presents an animated real-time visualization of world financial markets. Flocks of birds constantly change their numbers to represent currency values in particular countries; the changing numbers of branches on the trees they fly by represents countries' stock-market-index fluctuations (199).

Other projects have extracted analytical information about media sources such as television and the internet. Osman Khan and Daniel Sauter's *We Interrupt your Regularly Scheduled Program* processes and abstracts the flow of TV broadcasts by collapsing each video frame into a single line representing the colours and intensity of that image. The accumulation over time makes visible the flow of zooms and scene changes (197). Marcos Weskamp and Dan Albritton's *Newsmap* presents an abstract visualization of relationships between internet news items that illustrates their bias. Rectangle size indicates the number of stories

focused on particular topics, colour indicates news categories, and saturation denotes the ages of particular items (195). Considered a classic of the genre by many, *Listening Post* by Ben Rubin and Mark Hansen presents a hall-sized sculptural installation made up of a grid of small digital text displays. It continuously monitors chat rooms on the internet and displays the flow of interpersonal communication via text moving through the array and speech synthesizers speaking the words (198–9).

Trying to envision a dynamic future in which the architecture, social, political and commercial life, and network data flow of a city will all be integrated, a number of artists have developed prototype visualization systems. George Legrady's *Making Visible the Invisible* converts the mundane activities of a public library's flow of books into fascinating info-aesthetic events. One of these, tied to book circulation, shows a digital display of titles floating 'in' and 'out'; another shows coloured digital rain representing the volume of activity in all Dewey decimal categories (199).

Finally, even art and literature can be subjected to meta-analysis via visualization. Ben Fry's *Valence* visualizes the structure of texts in three dimensions. As the words in a book stream into the program, an animated multilayered orbital diagram is constantly readjusted, with related words clustering near each other and spokes connecting clusters to show additional relationships (196).

If the predictions are true, every corner of life will be captured in databases at some point in the future. Artists will help address the challenge of how to make use of this data and how to think about its negative aspects, even its dangers. Even more importantly, they will indicate ways to move beyond utility, transforming data-derived information into novel aesthetic forms.

Marc Lafia and Fang-Yu Lin, *The Battle of Algiers*, **2006.**
The classic 1965 film by Gillo Pontecorvo is broken into segments and algorithmically recomposed, using themes such as location on screen and image size. This digital event 'uses computation to re-present the logic of the [Algerian] nationalists tactics' in the way the film material is restructured. A large grid of small stills is constantly changing: larger rectangles appear and disappear in various locations, with corresponding sound-balance changes to represent different themes.

Chris Ziegler, *66movingimages*, **2002.**
Access to video documentation of a road trip on US Highway 66 is correlated to the position of a movable screen on a track. For example, pushing the screen to the middle of the track calls up video from the middle of the actual journey.

Lev Manovich, *Soft Cinema*, **2002–5.**
Custom software creates digital cinema sequences by selecting clips from a database. The clips are categorized according to both semantic and formal criteria (such as location, subject matter, movement direction and brightness). The sample thumbnail images (top) represent the contents of the database; the generator program (bottom) selects videos according to parameters of form and content, using graphic-interface sliders. All the elements of the resulting sequence are subject to change at every viewing.

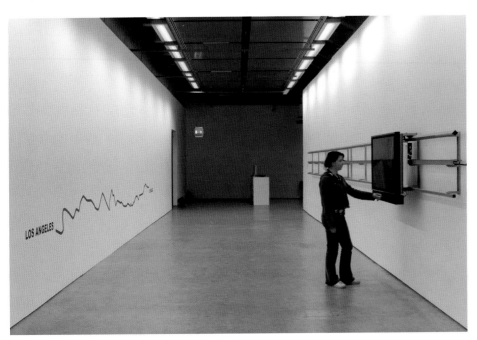

Christoph Wachter and Mathias Jud, *Zone*Interdite*, 2006.
The project invites web viewers to contribute information about restricted military and other areas to an atlas. A second part of the project creates virtual 3-D walk-through models of some locations (e.g. Camp Delta, Guantanamo Bay, Cuba). Visitors can navigate the database via various categories, such as government or type of installation. The artists, who feel it is important to resist access restrictions, have noted that 'imagination and the joy of discovering occurs ... replacing the patriotic and pacifistic duty of a knee-jerk avowal, and undermining censorship'.

Karen O'Rourke, *A Map Larger Than the Territory*, 2001–4.
This geographically oriented web database contains images, sounds and text contributed as people travelled across several cities. The top part of the illustration shows a grid of sample images, while the bottom one shows trajectories of trips across Paris. Viewers can interrogate the system by means of various indexing schemes such as location, trajectory, person and time.

Michael Aschauer, *Danube Panorama Project*, 2006. An automated slit-scan camera takes coordinated pictures of both banks of the Danube, which flows through several European countries. The camera uses GPS control to maintain a constant rate of picture-taking. The illustration shows sixteen thumbnails constructed by the system as a boat travelled through Austria. The visual database enables search by space or time, offering animations of the trip or still panoramas.

Michelle Teran, *Friluftskino: Experiments in Open Air Surveillance Cinema*, 2007. Live surveillance intercepted from wireless CCTV cameras is captured and then broadcast on city walls. The illustration shows projections 'hijacked' from a car wash. Teran's website explains that she is interested in both the dangers of, and new opportunities for, the private use of surveillance in the city: 'What are people watching? In which ways are they being used? ... The action of walking through the city and intercepting wireless surveillance feeds becomes a journey narrative of transient states, intertwinings between place and non-place, between the visible and the invisible, as one moves through and inhabits both the physical and the mediated.'

Seiko Mikami, *Desire of Codes*, **2007.**
Sixty wall-mounted robotic structures orient themselves to visitors' movements. Parodying our obsession with surveillance, the mechanisms include lights, cameras and microphones; wall projections are fed from the cameras. Mikami called the work *Desire of Codes* because the installation tracks and codes visitors' choices as they move.

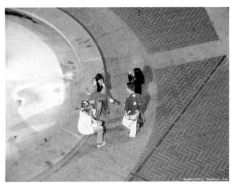

Björn Schülke, *Observer*, 2001. Schuelke creates ominous surveillance robots like this one to watch viewers from walls and ceilings. The devices include solar cells, heat sensors, propellers, video chips and flat-screen monitors. Straddling the organic and the high-tech worlds, the works suggest situations in which people are being watched by aliens.

Jonah Brucker-Cohen, *Police State*, 2003. Analysis of internet data referring to terrorism is used to control an installation of twenty radio-controlled toy police cars. Data is converted into police codes, which are then turned into movement instructions to the cars. CarnivorePE, the software that runs the installation, was written by the Radical Software Group, which invited artists to create work that used it. The project was created in response to the public debate about the FBI's implementation of Carnivore to electronically monitor the communications of large numbers of American citizens.

Ken Goldberg, *Demonstrate*, 2004. During the fortieth anniversary of the Free Speech Movement, which expanded citizens' rights to freedom of political and cultural expression, a state-of-the-art tele-robotic web camera was installed over Sproul Plaza at the University of California Berkeley, where the movement began – a significant and poignant location for a surveillance system. Web viewers could control the robotic zoom/pan camera all day every day for six weeks.

Ryota Kimura, *S.U.I. – Smart Urban Intelligence*, **2006.** The installation features a fictional railway agent who uses AI techniques to interpret the data on participants' Tokyo railway smartcards. One illustration shows the agent's face overlaid with an abstract graphic of trips taken. While waiting for visitors, the system projects general information about travels. Once a user swipes a card, as in the other illustration, the system starts projecting motion video and route maps. Offering a caricature of the data-dominated future, the agent 'analyses, interprets and evaluates the data according to 'his arbitrary and biased view'.

James Patten, *Corporate Fallout Detector*, 2005. A barcode-scanning device emits a clicking signal, the loudness of which is correlated with the corporate responsibility record (pollution and ethics) of the manufacturer of the coded product. Patten has noted why he picked a Geiger counter-like sound: 'These aspects of products are invisible and difficult to understand. In this sense, [they] are like nuclear radiation (invisible, dangerous, complex).'

◀·················

Evan Karatzas, *Proximity Lab*, 2006. A surface with embedded sensors reads signals from RFID (radio frequency identification) chips in the shoes of walkers and sends data to a computer, which responds by creating customized images and sound based on the participant's location and proximity to others. RFID is an identification technology that requires no visible markings, but transmits a unique serial number via wireless low-powered radio waves. Its proponents believe that most manufactured items will eventually have embedded RFID chips to enable tracking.

Ingo Günther, *Worldprocessor*, 1988– .
Illuminated globes on stands visualize
various sociological, political, economic,
ecological and scientific phenomena.
Günther has created more than three
hundred such globes, which focus on
themes like ocean currents, income
disparities, pollution levels, TV ownership,
energy consumption and infant mortality
rates. The installations are overwhelming
in their luminous beauty and richness of
information. Günther proclaims the critical
importance of information visualization this
way: 'Today, we as individuals can only hope

to know a fraction of human learning.
As a result, interfaces, symbols, and
navigational tools have become critical
to establishing our sense of place in the
world – intellectually, physically, and
ultimately emotionally.'

Stanza, *Sensity*, 2003. A wireless network of
sensors set up in the artist's neighbourhood
sends readings about urban activity, which
are visualized on a large globe projection.
The green circles represent activity levels
at the sensors, which monitor temperature,
sound, light, vibration, humidity and GPS.
Sensity is part a larger project, *The Central
City*, which combines prerecorded video
and sound with output from live web
cameras and other sensors to create
constantly morphing visual environments
'explod[ing] with ideas from art,
architecture, design and urbanism'.

◄ ● ● ● ● ● ● ● ● ●

Marcos Weskamp and Dan Albritton, *Newsmap*, 2003. This system automatically scans Google's news site and prepares a dynamic collage of rectangles symbolizing relationships between news items. The visual qualities of the display try to 'ironically accentuate' its bias; for example, the size of boxes is proportional to how many news items focus on various topics. The screenshot shows the system's analysis of news presented on 2 December 2007.

Ben Fry, *Valence*, 1999–2002. The structural relationships embedded in the text of Mark Twain's novel *Innocents Abroad* (1869) are visualized as a dynamic 3-D orbital animation. As the text streams into the program, the 3-D structure of the relationships of words is adjusted, giving the reader a feel for their dynamic flux. As Fry explains, 'The more frequently particular words are found, they make their way towards the outside (so that they can be more easily seen), subsequently pushing less commonly used words to the centre. Each time two words are found adjacent in the text, they experience a force of attraction that moves them closer together in the visual model.'

Lisa Jevbratt, *Migration*, 2002–5. This visualization of internet evolution shows (as coloured areas) which IP (Internet Protocol) addresses contain web servers. Seeking to extract hidden information, Jevbratt sends a crawler (an automatic program that accesses addresses) to search every IP numerical address and then treats the resulting set as an abstract exploratory space. In *Migration*, coloured blobs indicate the presence of web servers at various IP addresses, blob size shows the number of servers at each address, and white areas indicate the absence of web servers at those locations.

Donna Cox, Robert Patterson and Stuart Levy (visualization); Brant Robertson, Lars Hernquist and T. J. Cox, Harvard University (simulation), *Black Holes: The Other Side of Infinity*, 2006. Screenshot from a digital planetarium show, in which a scientific simulation of two galaxies colliding is presented through computer animation. In her position as artist/scientist at the National Center for Supercomputing Applications in Illinois, Cox helped scientists to visualize astronomical, atmospheric, network and biological data. She believes that artists can play a critical role in increasing public literacy and curiosity.

Osman Khan and Daniel Sauter, *We Interrupt your Regularly Scheduled Program*, 2003. This system creates a display that collapses the colours of each frame into a single line. The artists note that 'features such as cinematic cuts, zooms, and flashy graphics, which might be missed in the mind numbing flow of TV, become quite clear'. The illustration shows a TV facing a wall and the band of imagery (coming from a projector) that is the accumulation of the single lines of pixels abstracted from the broadcast flow.

Ben Rubin and Mark Hansen, *Listening Post,* **2002–5.** A sculptural installation presenting animated digital-text displays and synthesized speech derived from monitoring real-time communication on internet chat rooms, *Listening Post,* which has won many international awards, has a momentous presence: the effect is like being in a cathedral listening to chanting. Rubin explains: 'Once Mark and I started listening, at first to statistical representations of web sites, and then to actual language from chat rooms, a kind of music began to emerge... Every word that enters our system was typed only seconds before by someone, somewhere.'

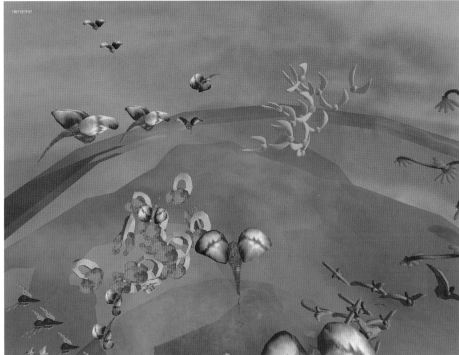

George Legrady, *Making Visible the Invisible*, 2005. Animated displays, on six linked plasma screens positioned behind the librarians, visualize real-time library borrowing, showing the flow of book titles in and out and the relative popularity of different Dewey decimal categories. The event shown is *KeyWord Map Attack;* words from the titles checked out in the previous hour are positioned in the visual space in accordance with their Dewey decimal numbers.

John Klima, *Ecosystem*, 2000–2002. In this system to visualize world financial markets in real time, flocks of birds constantly grow and decline in number to represent currency values. The flocks also reflect currency volatility, flying gracefully over large territories when it is stable and excitedly within a restricted range when there is a lot of market volatility.

CULTURAL CHALLENGES IN A TECHNO-SCIENTIFIC AGE

Science and technology are major engines of change in our lives. But their impact does not stop at the laboratory door. Advances in both areas are changing every aspect of contemporary life, from daily ephemera to philosophical notions about time, space and the nature of existence. It is a critical error for both science and art to segregate such research.

Investigations into the origin of the universe, the movements of the winds, the life cycles of insects and the function of the brain must be appreciated not only within the disciplines of science, but as part of a universal humanistic impulse to question and understand phenomena generally. A techno-cultural society that does not understand this is in trouble. Scientists cannot proceed successfully for long without the broad interest and support of the culture at large. In a practical sense, they will not get the funding they require nor the public's acquiescence to their ethics and research agendas. In a more global sense, they will miss out on the external revitalization necessary to keep their thinking fresh. Coming generations enthusiastic to pursue the disciplines of science and to find answers to broader questions will be excluded.

Artists also cannot thrive in isolation, and in a techno-cultural society it is simply suicidal for them to ignore the momentous developments in science. They must find robust ways in which to engage the broader humanistic implications of this research if they are to help the larger culture understand and take on the transformations it proposes. To accomplish this in any kind of profound way, artistic practitioners must be prepared to abandon the comforts of traditionally sanctioned forms and contexts and educate themselves in the worldviews, techniques and knowledge base of the sciences. Even further, they must be bold enough to work at frontiers where even researchers may feel unsure of their paths. And they must take what they learn to the places artists know best, creating engaging works of provocation, commentary and expression.

The artists featured in this book have accepted this challenge in many different ways, focusing on the poetry of the subject matter and processes of science; finding intriguing new modes through which to visualize scientific discoveries; and transforming research processes into engaging performances. Others have revealed unacknowledged ethical and political issues; invented community-based interventions; pursued independent research agendas; and developed innovative technologies without concern for market or utilitarian value.

It is clear that these hybrid arts are vibrant; they are also young, and their aesthetic is still developing. Which works have been most successful? How does one judge success? Should the criteria perhaps resemble those applied to Conceptual art, which is judged by its ability to challenge and open up thought? Or should they

focus on visual power or performative engagement? Should a new standard perhaps be developed that is more suited to the hybrid aspirations of science-based and -inspired art? And how much should viewers be required to know about the science that informs a particular work to appreciate it in an artistic context or setting? For example, how can one understand the craft, leap of imagination and conceptual richness of an artwork focused on robot motion without knowing a bit about the challenges researchers face in this area?

In the coming decades we will see astonishing and provocative developments in science and technology. Artists will be there, ready to ponder, celebrate and critique. Consider some of what we may confront: invention of new species; advances in cloning techniques; 'post-human' enhancements to human bodies and brains; access to the insides of brains; worldwide monitoring of the health of the oceans and skies; computers that can read gestures, speech and thoughts; autonomous, intelligent everyday objects; robot companions; construction

Troy Innocent, *Home Base*, 2006. Three species of artificial life from a fictional world called Ludea compete for territory in a game-like urban environment. The screen grab shows four blue a-life forms moving about the city looking for action; the signs show artificial language related to their culture. The a-life programming results in changing scenarios as the semi-autonomous entities interact.

of materials atom by atom; visits to other planets; and deepening probes into the origins of the universe. Imagine what kind of art will answer these challenges. Like science, it too will be revolutionary and experimental, daring to venture into unexplored terrain.

While this book has surveyed a few members of the first generation of practitioners opening these new chapters in the history of art, many more await study and evaluation. This is, then, the first step in what will doubtless become unimagined new directions. May it lead to more than just new kinds of art, helping to shape a truly hybrid culture in which scientists and artists are vitally inspired by each other's work.

FURTHER READING & BROWSING

The books, journals and websites in this list are intended to provide the reader with research materials, including theory, history, and website links to additional information about artists and art works such as those described in the book.

Analysis and Theory

Bulatov, Dmitry, *Biomediale: Contemporary Society and Genomic Culture*, Kaliningrad: National Publishing House Yantarny Skaz, 2004

Clarke, Andy, and Grethe Mitchell, *Videogames and Art*, Bristol: Intellect Books, 2007

da Costa, Beatriz, and Kavita Philip (eds), *Tactical Biopolitics: Art, Activism, and Technoscience*, Cambridge, MA: MIT Press, 2008

Daston, Lorraine (ed.), *Things That Talk: Object Lessons from Art and Science*, Cambridge, MA: MIT Press, 2007

Ede, Siân, *Art and Science*, London: I. B. Tauris, 2005

Emmer, Michele, *Visual Mind II*, Cambridge, MA: MIT Press, 2005

Fishwick, Paul A., *Aesthetic Computing*, Cambridge, MA: MIT Press, 2006

Flanagan, Mary, and Austin Booth (eds), *re:Skin*, Cambridge, MA: MIT Press, 2007

Frieling, Rudolf, and Dieter Daniels, *Medien Kunst Netz / Media Art Net2*, New York: Springer, 2006

Fuller, Matthew (ed.), *Software Studies: A Lexicon*, Cambridge, MA: MIT Press, 2008

Galison, Peter, and Caroline Jones (eds), *Picturing Science, Producing Art*, London: Routledge, 1988

Goldberg, Ken, *The Robot in the Garden: Telerobotics and Telepistemology on the Internet*, Cambridge, MA: MIT Press, 2000

Goriunova, Olga, and Alexei Shulgin (eds), *read_me: Software Art & Cultures*, Helsinki: Aarhus, 2004

Gould, Stephen Jay, and Rosamond Purcell, *Crossing Over: Where Art and Science Meet*, New York: Three Rivers Press, 2000

Grau, Oliver, *Virtual Art: From Illusion to Immersion*, Cambridge, MA: MIT Press, 2003

Haraway, Donna, *The Haraway Reader*, London: Routledge, 2003

Harris, Craig, *Art & Innovation*, Cambridge, MA: MIT Press, 1999

Hayles, N. Katherine. *How We Became Posthuman: Virtual Bodies in Cybernetics, Literature, and Informatics* (Chicago: University of Chicago Press, 1999)

Henderson, Linda Dalrymple, *The Fourth Dimension and Non-Euclidean Geometry in Modern Art*, Princeton: Princeton University Press, 1983; new edn, Cambridge, MA: MIT Press, 2009

Jones, Caroline (ed.), *Sensorium: Embodied Experience, Technology and Contemporary Art*, Cambridge, MA: MIT Press, 2006

Kac, Eduardo, *Signs of Life: Bio Art and Beyond*, Cambridge, MA: MIT Press, 2007

Lovink, Geert, *Uncanny Networks: Dialogues with the Virtual Intelligentsia*, Cambridge, MA: MIT Press, 2002

Luenfield, Peter, *Snap to Grid*, Cambridge, MA: MIT Press, 2001

Kahn, Douglas, *Noise, Water, Meat: A History of Sound in the Arts*, Cambridge, MA: MIT Press, 2001

Kemp, Martin, and Marina Wallace (eds), *Spectacular Bodies: The Art and Science of the Human Body from Leonardo to Now*, Berkeley, Los Angeles and London: University of California Press, 2001

Kepes, Gyorgy, *New Landscape in Art & Science*, Chicago: P. Theobald, 1956

Latour, Bruno, *Science in Action*, Cambridge, MA: Harvard University Press, 1987

— , and Peter Weibel, *Iconoclash: Beyond the Image Wars in Science, Religion, and Art*, Cambridge, MA: MIT Press, 2002

Malloy, Judy (ed.), *Women, Art, and Technology*, Cambridge, MA: MIT Press, 2003

Manovich, Lev, *The Language of New Media*, Cambridge, MA: MIT Press, 2001

O'Sullivan, Dan, and Tom Igoe, *Physical Computing*, Boston: Thompson Publishers, 2004

Schlain, Leonard, *Art and Physics*, New York: Morrow, 1991

Scott, Jill (ed.), *Artists in the Lab*, New York: Springer, 2006

Shanken, Edward A., *Telematic Embrace: Visionary Theories of Art Technology and Consciousness*, Berkeley: University of California Press, 2003

Shaw, Jeffrey, and Peter Weibel (eds), *Future Cinema: The Cinematic Imaginary after Film*, Cambridge, MA: MIT Press, 2003

Smelik, Anneke, and Nina Lykke (eds), *Bits of Life: Feminism at the Intersections of Media, Bioscience, and Technology*, Seattle: University of Washington Press, 2008

Sommerer, Christa, and Laurent Mignonneau (eds), *Art @ Science*, New York: Springer, 1998

Spaid, Sue (ed.), *Ecovention: Current Art to Transform Ecologies*, Cincinnati: Contemporary Arts Center, 2002

Thacker, Eugene, *The Global Genome, Biotechnology, Politics and Culture*, Cambridge, MA: MIT Press, 2005

Turkle, Sherry, *Inner History of Devices*, Cambridge: MIT Press, 2008

Vesna, Victoria, *Database Aesthetics: Art in the Age of Information Overflow*, Minneapolis: University of Minnesota Press, 2007

Wardrip-Fruin, Noah, and Nick Montfort (eds), *The New Media Reader*, Cambridge, MA: MIT Press, 2003

Weibel, Peter, and Timothy Druckrey (eds), *Net_Condition: Art and Global Media*, Cambridge, MA: MIT Press, 2001

Wellcome Trust, *Experiment: Conversations in Art and Science*, London: Wellcome Trust, 2005 (other monographs include *Talking Back to Science* and *Head On*)

Whitelaw, Mitchell, *Metacreation: Art and Artificial Life*, Cambridge, MA: MIT Press, 2004

Wilson, Stephen, *Information Arts: Intersections of Art, Science, and Technology*, Cambridge, MA: MIT Press, 2002

Surveys and Histories

Benthall, Jonathan, *Science and Technology in Art Today*, New York: Praeger, 1972

Cohen, Harold, with Pamela McCorduck, *Aaron's Code: Meta-Art, Artificial Intelligence, and the Work of Harold Cohen*, New York: W. H. Freeman, 1990

Davis, Douglas, *Art and the Future: A History/Prophecy of the Collaboration between Science, Technology, and Art*, New York: Praeger, 1973

Dixon, Steve, *Digital Performance: A History of New Media in Theater, Dance, Performance Art, and Installation*, Cambridge, MA: MIT Press, 2007

Druckrey, Timothy (ed.), *Ars Electronica: Facing the Future: A Survey of Two Decades*, Cambridge, MA: MIT Press, 1999

Dunne, Anthony, and Fiona Raby, *Design Noir: The Secret Life of Electronic Objects*, Princeton: Princeton Architectural Press, 2001

Greene, Rachel, *Internet Art*, London: Thames & Hudson, 2004

Ippolito, Jon, and Joline Blais, *At the Edge of Art*, London: Thames & Hudson, 2006

Jana, Reena, and Mark Tribe, *New Media Art*, New York: Taschen, 2006

Kluver, Billy, J. Martin and B. Rose (eds), *Pavilion: Experiments in Art and Technology*, New York: E. P. Dutton, 1972

Kranz, Stewart, *Science and Technology in the Arts: A Tour Through the Realm of Science/Art*, New York: Van Nostrand Reinhold Co., 1974

Leonardo: International Journal of Art, Science and Technology, Cambridge, MA: MIT Press, published six times a year

Leopoldseder, Hannes, and Christine Schopf, *CyberArts 2001*, New York: Springer, 2001 (documentation of Ars Electronica Prix competitions; other years are also available)

Maeda, John, *Creative Code*, London: Thames & Hudson, 2004

Mulder, Arjen, and Maaike Post, *Book for the Electronic Arts*, Rotterdam: V2, 2001

Paul, Christiane, *Digital Art*, London: Thames & Hudson, 2003; new edn 2008

Popper, Frank, *Art of the Electronic Age*, London: Thames & Hudson, 1993

— , *From Technological to Virtual Art*, Cambridge, MA: MIT Press, 2005

Wands, Bruce, *Art of the Digital Age*, London: Thames & Hudson, 2006

ONLINE RESOURCES

The author's companion website to this book offers comprehensive links to relevant artists, organizations, blogs, festivals, books, essays, etc., as well as a live links version of these online resources: http://userwww.sfsu.edu/~infoarts/links/wilson.thames.html

Educational Programmes Supporting Hybrid and Cross-disciplinary Arts

Academy of Media Arts, Cologne, Germany; www.khm.de

Arizona State University, Institute for the Arts, Tempe, USA; ame.asu.edu

Art Academy of Trondheim – KIT, Norway; www.kit.ntnu.no/galleri_kit/program/navn/Network_Baltic_text.htm

Arts and Genomics Centre, Leiden, Netherlands; www.artsgenomics.org

Brunel University, London, UK; www.brunel.ac.uk

CADRE, San Jose State University, California, USA; cadre.sjsu.edu

Carnegie Mellon University Art Department, Pittsburgh, Pennsylvania, USA; www.art.cfa.cmu.edu

CAST (Cultures of Arts, Science, and Technology), Universiteit Maastricht, Netherlands; www.maastrichtuniversity.nl/web/show/id=356505/langid=42

CAVS (Center for Advanced Visual Studies), Massachusetts Institute of Technology, Cambridge, USA; cavs.mit.edu

College of Fine Arts in Umeå, Sweden; www.umu.se/art

Conceptual/Information Arts, San Francisco State University, California, USA; userwww.sfsu.edu/~infoarts

Concordia University, Montreal, Canada; finearts.concordia.ca/HTML/index.htm

Connecticut College Center for Art & Technology, New London, USA; cat.conncoll.edu

Crucible Studios, Helsinki School of Art and Design, Finland; crucible.lume.fi

Digital Worlds Program, University of Florida, Gainesville, USA; www.digitalworlds.ufl.edu

DXArts, University of Washington, Seattle, USA; www.washington.edu/dxarts

Electronic Visualization Lab, University of Illinois, Chicago, USA; www.evl.uic.edu

Emily Carr College – IntegratMedia, Vancouver, Canada; www.ecuad.ca/programs/courses/IMED

European Graduate School (EGS), Saas-Fee, Switzerland; www.egs.edu

Georgia Institute of Technology, Literature Communication and Culture, Atlanta, USA; dm.lcc.gatech.edu

Hunter College, Integrated Media, New York, USA; filmmedia.hunter.cuny.edu

IAMAS (International Academy of Media Arts and Sciences), Ogaki City, Japan; www.iamas.ac.jp

ICinema, University of New South Wales, Sydney, Australia; www.icinema.unsw.edu.au/index.html

Interdisciplinary Art, Science and Technology, Netanya, Israel; future-of-art.blogspot.com/2006/06/new-school-of-art-and-multimedia.html

ITP (Interactive Telecommunications Program), Tisch School of Arts, New York University, USA; www.itp.nyu.edu

Le Fresnoy Studio National des Arts Contemporains, Tourcoing, France; www.lefresnoy.net

Massachusetts Institute of Technology Media Lab, Cambridge, USA; www.media.mit.edu

Mills College, Interdisciplinary Computer Science, Oakland, USA; ics.mills.edu

Ohio State University, Art and Technology Program, Columbus, USA; artandtech.osu.edu

Parsons College of Art, Design and Technology Program, New York, USA; dt.parsons.edu

Planetary Collegium, Consciousness Reframed Conference, Plymouth, UK; www.planetary-collegium.net

Pratt Institute, Emerging Arts, Brooklyn, NY, USA; dda.pratt.edu/cur_emerging.php#emmfa

Rensselaer Polytechnic Institute, iEAR (IntegratElectronic Arts), Troy, New York, USA; www.arts.rpi.edu

Rhode Island School of Design, Digital Media, Providence, USA; digitalmedia.risd.edu

Royal College of Art, Design Interactions, London, UK; www.interaction.rca.ac.uk

School of the Art Institute of Chicago Art and Technology Studies Program, Illinois, USA; www.saic.edu

State University of New York at Buffalo, Media Studies, USA; mediastudy.buffalo.edu

Swinborne University of Technology, Australia; www.swin.edu.au

Transart Institute, Donau University, Linz, Austria; www.transartinstitute.org

University of California at Davis, Technoculture Program, USA; technoculture.ucdavis.edu

University of California at Irvine, Arts Computation Engineering (ACE), USA; www.ace.uci.edu

University of California at Los Angeles, Design and Media, USA; www.design.ucla.edu

University of California at San Diego, Center for Research in Computers and the Arts, USA; www.crca.ucsd.edu

University of California at Santa Barbara, Media, Art & Technology (MAT), USA; www.mat.ucsb.edu

University of California at Santa Cruz, USA; arts.ucsc.edu

University of Michigan Art Department, Ann Arbor, USA; www.art-design.umich.edu

University of Oslo, Intermedia, Norway; www.intermedia.uio.no

University of Plymouth, Interactive Systems, UK; www.plymouth.ac.uk/pages/view.asp?page=7491

University of Southern California, Interactive Media Program, Los Angeles, USA; interactive.usc.edu

University of Westminster, Centre for Arts, Research, Technology and Education (CARTE), London, UK; www.wmin.ac.uk/sshl/page-667

Directory of Art & Technology Education Programs (Michael Naimark and Mark Tribe, eds); wiki.brown.edu/confluence/pages/viewpage.action?pageId=13017

Recurring Festivals, Shows and Conferences

Ars Electronica, Austria; www.aec.at

Art Futura, Spain; www.artfutura.org/english/index_intro.php

BEAP – Biennale of Electronic Art Perth, Australia; www.beap.org

Cyberart Festival, USA; bostoncyberarts.org

File, Brazil; www.file.org.br

ISEA – International Symposium of Electronic Arts; www.isea-web.org

Japan Media Art Festival, Japan; plaza.bunka.go.jp/english/festival

Refresh Conference – Histories of Media Art, Science and Technology; www.mediaarthistory.org

Siggraph Art Shows, USA; www.siggraph.org/artdesign

Subtle Technologies Festival, Canada; www.subtletechnologies.com

Transmediale, Germany; www.transmediale.de

V2 – DEAF – Dutch Electronic Art Festival, the Netherlands; www.v2.nl

VIDA – Art & Artificial Life Competitions, Spain; www.fundacion.telefonica.com/at/vida/telefonica-05-en.shtml

WRO, Poland; wro09.wrocenter.pl/entry/index.php

Museums, Galleries, Research Opportunities and Organizations

ANAT – Australian Network for Art and Technology, Australia; www.anat.org.au

Ars Electronica, Austria; www.aec.at

Art + Com, Germany; www.artcom.de

Artciencia, Portugal; www.artciencia.com

aRT+sCIENCE, France; artplusscience.free.fr/ENG/homeFR.htm

Art Science Group, USA; www.artscience.org

Art Science Research Lab, USA; www.artscienceresearchlab.org

Arts Catalyst, UK; www.artscatalyst.org

Arts Council, Interdisciplinary Arts, UK; www.artscouncil.org.uk/subjects/homepage.php?sid=25

Artists in Labs, Switzerland; artistsinlabs.ch

ASCI – Art & Science Collaborations, USA; www.asci.org/artikel501.html

Banff Center, Canada; www.banffcentre.ca

Bitforms, USA; www.bitforms.com

C3, Hungary; www.c3.hu

Canada Council for the Arts/Natural Sciences and Engineering Research Council New Media Initiative, Canada; www.canadacouncil.ca/cgi-bin/MsmGo.exe?grab_id=0&page_id=194&query=science&hiword=SCIENCES%20science%20

Creative Capital, USA; www.creative-capital.org

Creative Clusters; www.creativeclusters.com

De WAAG, The Society for Old and New Media, Netherlands; www.waag.org

Disonancias, Spain; www.disonancias.com/en

Ecotopia, Gulbenkian Foundation, Portugal; www.igc.gulbenkian.pt/node/view/117

Experimenta, Australia; www.experimenta.org

Eyebeam Atelier, USA; www.eyebeam.org

F.A.B.R.I.CATORS, Italy; www.fabricat.com/home.html

FACT – Foundation for Art and Creative Technology, UK; www.fact.co.uk

Fringe Gallery, USA; www.fringexhibitions.com

HASTAC – Humanities, Arts, Science, and Technology Advanced Collaboratory, Duke University, USA; www.hastac.org

Hexagram, Canada; www.hexagram.org

Interactive Institute, Sweden; w3.tii.se

InterCommunication Centre – ICC, Japan; www.ntticc.or.jp/index_e.html

IRCAM – Institute for Research and Coordination Acoustic/Music, France; www.ircam.fr

Kapelica Gallery, Slovenia; www.kapelica.org

Kontejner Art Center, Croatia; www.kontejner.org/home-english

Langlois Foundation, Canada; www.fondation-langlois.org/html/e/index.php

Leonardo – International Society for Arts, Science, and Technology, USA; www.leonardo.info
L'ORÉAL Art & Science Foundation; www.art-and-science.com
MARS – Media, Arts and Research Studies Lab, Germany; netzspannung.org/about/mars/?lang=e
MECAD – Media Centre of Art and Design, Spain; www.mecad.org/index_in.htm
Mindship International, Denmark; www.mindship.org
MIT Media Lab, USA; www.media.mit.edu
Mixed Reality Lab – MXR, Singapore; www.mixedrealitylab.org
NESTA – National Endowment for Science, Technology and the Arts, UK; www.nesta.org.uk
Observatory, The Foundation for the

Arts, Sciences and Technolog, Portugal; www.asa-art.com/facto/fct/en1.html
OLATS – The Leonardo Centre of Arts and Techno-sciences, France; www.olats.org
Rhizome, USA; www.rhizome.org
Science & the Arts, City University of New York, USA; web.gc.cuny.edu/sciart/index.htm
Smartlab, Digital Media Institute, University of East London, UK; www.smartlab.uk.com/1about/index.htm
Space Sciences Art Residencies, University of California at Berkeley, USA; cse.ssl.berkeley.edu/arts/news.html
STEIMteim, Netherlands; www.steim.org/steim
Symbiotica, Australia; www.symbiotica.uwa.edu.au

Tesla, Art/Science Interest Group, University College London, UK; www.cs.ucl.ac.uk/research/tesla
UNESCO Digital Arts Portal; digitalarts.lcc.gatech.edu/unesco
Wellcome Trust, Science Arts Programmes, UK; www.wellcome.ac.uk/Funding/Public-engagement/Grants/Arts-Awards/index.htm
Ylem, USA; www.ylem.org
ZKM – The Center for Art and Technology, Germany; www.zkm.de

Web Sites with Links to Artists and Other Resources
ArsTechnica; arstechnica.com/index.ars
Database of Virtual Art; www.virtualart.at
Hackaday; www.hackaday.com
Make Magazine; www.makezine.com

MARCEL – Multimedia Art Research Centres and Electronic Laboratories; www.mmmarcel.org
Media Art Net; mediaartnet.org/mediaartnet
Neural; www.neural.it
Noema; www.noemalab.org/index2.php
Ping Magazine; www.pingmag.jp
Res-qualia; www.res-qualia.net
Steve Wilson Art & Technology Web Links; userwww.sfsu.edu/~infoarts/links/wilson.artlinks2.html
Turbulence; www.turbulence.org/blog
We Make Money Not Art; www.we-make-money-not-art.com

SOURCES OF ILLUSTRATIONS

All images in the book are courtesy and copyright the artists; additional credits and acknowledgments are listed here. Page numbers relate to the pages on which the images (rather than their captions) appear.

half-title page: Kac. Black Box Gallery, Copenhagen; **opposite the contents page:** Hesse-Honegger. Photo Peter Schälchli; **6** Hall of Bulls. Courtesy Semitour, France; **7** Lozano-Hemmer. Installation at the Basque Museum of Contemporary Art, Artium, Vitoria-Gasteiz, Spain, 2002. Photo David Quintas; **9** Covers of *Leonardo*. Photo Sophia Wilson; **10** Auger. Support: Media Lab Europe; **11** Covers of *Ars Electronica* booklets. Courtesy Ars Electronica. 2005 cover illustration: based on a graphic by Daniel Lee. 2006 cover illustration: Tsuyoshi Ozawa, *Vegetable Weapon: Saury Fish Ball Hot Pot / Tokyo*, 2001, Courtesy Ota Fine Arts, Tokyo; **12** Leddy. Photo Norene Leddy. Artist, project lead: Norene Leddy. Tech leads: Andrew Milmoe and Ed Bringas. Community advisor, web director: Melissa Gira; **14** Alberti. Courtesy and copyright Research Library, The Getty Research Institute, Los Angeles, California (2007. PR.29); **15** Nairne. Image courtesy the Blocker History of Medicine Collections, Moody Medical Library, University of Texas Medical Branch, Galvaston, Texas, USA; **23** Willet. 'Collision', exhibition hosted by the University of Victoria, Canada; **24** Vanmechelen. Courtesy Lisson Gallery, London; **25** Ballengée. Photographed at Exit Art, New York, USA, in 2000. Courtesy Archibald Arts, New York, USA; **25** Borland. Courtesy Sean Kelly Gallery, New York, USA; **26** Ackroyd. Commissioned and presented by National Eisteddfod, Meifod, Wales; **26** Bulatov. Informational support: National Centre for Contemporary Arts,

Kaliningrad Branch, Russia. Consultations, co-chimering: Dr Professor K. Lukjanov, Dr J. Labas; **27** Czarnecki. Production: The Arts Catalyst. Funding: Creative Scotland Award; **27** Kac. Collection Instituto Valenciano de Arte Moderno (IVAM), Valencia, Spain; **30–31** Rockman. Collection JGS Inc.; **32** de Menezes. Work developed in the laboratory of Dr Ana Pombo, Imperial College, London, Hammersmith campus; **32** Chartier. Courtesy Platform Gallery, Seattle, Washington, USA; **33** de Menezes. Work developed in the laboratory of Professor Paul Brakefield, Leiden, Netherlands. Collection MEIAC, Badajoz, Spain; **34** Cooper. Courtesy Daneyal Mahmood Gallery, New York, USA, and Novamedia, Australia; **35** Quinn. Photo Stephen White. Courtesy Jay Jopling / White Cube, London; **36** Tissue Culture and Art Project, *Disembodied Cuisine*. Photo Axel Heise. Tissue Culture and Art Project is hosted by SymbioticA, School of Anatomy and Human Biology, University of Western Australia; **37** Prophet. Screen image Rob Saunders; **37** SymbioticA. Photo Phil Gamblen. 'Australian Culture Now' exhibition, Australian Centre for the Moving Image, Melbourne, 2004; **38** Ballengée. In scientific collaboration with Dr Stanley K. Sessions, Hartwick College, New York, USA. The Malformed Amphibian Project titles in collaboration with the poet KuyDelair, Université du Québec à Montréal (UQAM), Montreal, Canada. Scanner photograph of cleared and stained multi-limbed Pacific tree frog

created at the Alfred University, New York, USA. Unique digital chromogenic print on watercolour paper printed by Electric Works, San Francisco, USA. Courtesy the artist and Archibald Arts, New York, USA; **47** Wilson. Stephen Wilson. Photo courtesy SymbioticA; **47** Faculty from the Center for Biofilm Engineering and Montana State University School of Art. Copyright © 2002 MSU–Bozeman Bioglyphs Project: a collaboration co-created by members of the Montana State University–Bozeman School of Art and the Center for Biofilm Engineering, Manhattan College, New York, USA; **48** Kudla. Photo copyright © Neil Lukas, 2007; **48** Ross. Exhibition, Kapelica Gallery, Ljubljana, Slovenia; **51** Easterly. Photo Luke Hoverman; **52** Gracie. AI programming: Brian Lee Yung Rowe. Electronics: Gary Burns; **53** Masaoka. Photo Lori Eanes. Quotation from *A Mínima* magazine; **55** Beloff. Photo Anu Akkanen; **57** da Costa. Photo Susanna Frohman /San Jose Mercury News. Copyright 2006, San Jose Mercury News. All rights reserved; **58** Komar. Photo Alex Melamid. Copyright Asian Elephant Art and Conservation Project; **58** Wight. Commissioned by Cornerhouse, Manchester, UK. Funded by the National Endowment for Science, Technology and the Arts, UK, the Wellcome Trust and the Arts Council England; **59** Rinaldo. Photo Otto Saxinger, with retouching by Ken Rinaldo. Courtesy Ars Electronica and the artist; **59** Freeman. Support: the National Endowment for Science, Technology and the Arts, UK; **60** Gracie. Electronics: Gary Burns; **60** Birchfield. Photo David Birchfield; **62** O'Reilly. Photo Manuel Vason; **68** Ursitti. Photo Peter MacCallum. Video stills U8TV, from footage shot at an exhibition at YYZ

Artists' Outlet, Toronto, Canada; **68** Dunning. Copyright © Einstein's Brain Project 2006; **70–71** de Menezes. Work developed in the laboratory of the Oxford Centre for Functional MRI of the Brain, University of Oxford, UK, with the collaboration of Dr Patricia Figueiredo; **74** Domingues. University of Caxias do Sul, Brazil. Copyright © NTAV Lab 2006/2007. Support: CNPq (National Council for Research and Development), Brazil; **75** Warnell. Performed at the ICA, London. Photo Stephanie Nava. Performance presented by the Arts Catalyst, supported by the Centre for the History of Medicine, University of Warwick. Quotation from Ric Allsopp, 'Performing the Interior', paper presented at Endo-Ecto conference, ICA, London, 2006, copyright © 2006 Ric Allsopp; **76** Kunkel. See also www.oliverkunkel.com; **76** Décosterd. Photo Philippe Rahm; **76** Prophet. Support: Wysing Arts Centre, Cambridge, UK; Papworth Hospital NHS Foundation Trust, Cambridge, UK; the Leverhulme Trust; University of Westminster, London, UK; Department of Mechanical Engineering, University of Bath, UK; **78** Zucali. See also www.maschine-mensch.net. General sound design: David Gottschalk. Ars Electronica helpers: Gerald Priewasser (organization and coordination), Katharina Nussbaumer (programming); **78** gordon. Photo Brandon Porter; **78** Bruno. See also and www.unbehagen.com/wifism. Concept: Christophe Bruno. Programming Delphi: Valeriu Lacatusu. Programming PHP: Valeriu Lacatusu / Christophe Bruno. Hardware: Ignazio Mottola (bart-project. com) / Simon Dhenin (Ecole Nationale Supérieure de Création Industrielle, ENSCI) / Christophe Bruno /

Aurore Lafargeas; **78** Stelarc. Installation at Teknikunst, Meat Market, Melbourne. Photo Nina Sellars and Stelarc. Engineering: Adam Fiannaca. Sound design: Rainer Linz; **79** Elsenaar. Stills from a video recording by Josephine Jasperse; **80** Kreuh. Photo: Miha Fras. See also . Production: Forum Ljubljana, Slovenia; **80** Spelletich. Production support: Exploratorium, San Francisco, USA; **81** Hughes. Support: Hexagram Institute for Research/ Creation in Media Arts and Technologies, Montreal, Canada; **81** Schiphorst. Thecla Schiphorst & Susan Kozel. Photo: David Clifton. Whispers research group is an interdisciplinary group of artists, designers and technologists. Director, concept, design, interaction, system integration: Thecla Schiphorst. Performative environment design, jewelry design: Susan Kozel. Creative development consultant: Sang Mah. Software design and implementation: Robb Lovell. Hardware design and implementation: Jan Erkku. Garment design and construction: Gretchen Elsner. Software design and implementation: Norm Jaffe. Hardware engineer: Pablo Machcovsky. Electronics and hardware implementation: Diana Burgoyne. Sound design: Mark Brady. Production, experience coordination, video: Camille Baker. Electrical engineer: Calvin Chow. Web design: Adam Marston. Graphic design: Rodney Sanches; **81** Interactive Institute Smart Studio. Copyright © Interactive Institite. Photo Tobias Sjödin; **82** X Rokeby. Commissioned by the Institute of International Visual Arts (Iniva), London. Supported by the Moose Foundation for the Arts, London, and the Arts Council England; **84** Hodgkin. Courtesy Adamson Editions. Quotation from exhibition announcement, Photographic Gallery, London, USA, 2006; **89** Hill. Concept design, R & D production and management: Anna Hill. Auroral Synapse 'foxes fire' creative audio collaboration: Iarla O'Lionaird (Realworld Records). Spatial sound design consultancy: Martyn Ware and Illustrious. Interaction consultancy: Jason Bruges Studio. Video cameraman: Mark Szasy. Support: the Irish and Lapland Arts Council; **90** Henschke. Support: artist residency at the National Gallery of Australia, 2004. Realtime rendering programming: Ken Mok. Pinball cabinet construction: Lindon Davey-Milne; **91** Domnitch, (*top*). Photo: Wataru Kinoshita. (*bottom*) Photo Dmitry Gelfand; **92** Richards. Photo Patrick Stanbro; **95** Richards. Copyright © CARCC, 2008; **98** Hendricks. Courtesy Haunch of Venison, London; **100** Roloff. Installed at 101 California Street, San Francisco, USA. All works courtesy Gallery Paule Anglim, San Francisco, USA. Commissioned by Artsource Consulting, San Francisco, USA; **100–101** Rogers. Photo Scott Haefner, U.S.

Geological Survey; **102** Heimbecker. Funding: the Canada Council for the Arts, New Media Arts Creation program. Electronic and software systems designed in collaboration with Avatar, Quebec, Canada; **103** Polli. Scientific collaborator: Dr Glenn Van Knowe; **103** Bagnall. Photo Robyn Johnston 2007; **104** Peljhan. Photo Steve Dietl/ Projekt Atol Makrolab markIIex, Campalto Island Operations, Venice Lagoon, Biennale di Venezia, June 2003 – December 2003; **104** Meyer-Brandis. Support: Kunststiftung NRW, Düsseldorf, Germany; Geologischer Dienst NRW, Krefeld, Germany; **104** Osaka. Photo Kazumasa Sako; **105** Eliasson. Photo Jens Ziehe; **105** Nieman. Photo Julian Nieman; **105** Leiderman. Courtesy Galerie Elisabeth Kaufmann, Zürich, Switzerland, Galerija Gregor Podnar, Ljubljana, Slovenia, and Galerie Michel Rein, Paris. Photo Kazumasa Sako; **106** Nishijima. Photo: Nagasaki Prefectural Art Museum, Japan; **111** Demers. Photo Chris Herzfeld; **112–13** Artificiel group. Agence Stock Installation at the Musée d'Art Contemporain de Montréal, November, 2003. Photo Caroline Hayeur; **114** London Fieldworks. Photo Mark Pinder. Commissioned by ICA, London; **115** Klotz. Support: KITT Engineering, Enschede, Netherlands, and Michael van Schaik. See also http://www.led-art.nl; **116** Decker. Photo Mike Ensdorf; **118** De Marinis. Photo Roman März; **118** Rozin. Exhibited at the Israel Museum, Jerusalem. Photo Yosi Galanti; **119** Haque. Photo Eng Kiat Tan, Haque Design + Research; **120** Moises. David Moises. Photo Gregor Ecker. Courtesy Galerie Charim, Vienna; **120** Arduino, 2005. Photo Nicholas Zambetti; **121** Heaton. Photo Tom LeGoff. Courtesy Ronald Feldman Fine Arts, New York, USA. Makeup and hair: Tamah Krinsky; **122** Takafumi. List of collaborators available at rogiken.org/vr/index.php ?plugin=attach&refer=FrontPage&openf ile=kobito_siggraph2005.pdf; **122** Michiel van Overbeek. Photo Hennie van Ham. See also www.koffiekoek.nl. Email info@ koffiekoek.nl; **123** Nishijima. Photo Nagasaki Prefectural Art Museum, Japan; **123** Jordà. Photo Xavier Sibecas; **124** Stedman. From a performance with Kerry Segal at Contemporary Art Forum Kitchener and Area (CAFKA), Kitchener - Waterloo, Canada. Photo Elisabeth Feryn; **125** D'Andrea. Images courtesy Max Dean and *Border Crossings* magazine; **126** Time's Up. Photo Robert Zauner / Time's Up; **127** Nakano. Team Shadow (Soshi Tsujimura, Masako Fukushima, Masayuki Yamazaki, Daisuke Watanabe, Yoshinobu Nakano, Masayuki Sagano, Taku Shirazawa, Yasuhiro Yoshimura, Kenji Kawashima, Hitomi Komura, Haruka Ouwa); image produced by Image Processing Laboratory, Nara Institute of Science and Technology, Japan; **128** Stelarc. Performed at Cankarjev Dom,

Warehouse, Vhrnika, Slovenia, 19 May 2003. Photo Igor Skafar. Robot construction: f18, Hamburg, Germany; **129** Rinaldo. Photo John Marshall. Sponsored by the 2006 AV Festival in England at the Sunderland Museum and Winter Gardens; **130** Böck. Photo Silke Eberspächer; **135** Feingold. Photo Christina Lazaridi; **136** Sum. Photo RE/ACT Media Festival 2006; **139** Utterback. Photo Peter Harris © 2007; **142** Ho. Photo Wang We; **145** Sester. Photo Shawn Van Every. Support: Eyebeam, New York, USA, and Creative Capital Foundation, New York, USA. See also www.accessproject.net; **146** Böck. See p. 130; **148** Rokeby. Photo Don Lee/ David Rokeby; **149** Yanobe. Photo Seiji Toyonaga; **150** SSS – Sensors_Sonics_ Sights. Performed at Palais de Tokyo, Paris, 2004. Photo Marc Battier; **150** Quartet. Funded by the Wellcome Trust, the Arts Council England and the Australia Council for the Arts, with support from the ZKM Center for Art and Media, Karlsruhe, Germany. Graphic Image: Margie Medlin. Dancer: Carlee Mellow. Musician: Stevie Wishart. Motion control robot camera: Gerald Thompson/ Virtual character: Holger Deuter and Margie Medlin. List of collaborators available at www.quartet project.net/space/start; **152, 153** Rocamora. Photo John Chapman. Commissioned by Essexdance, Future Physical, Dance East and Arts Council England. Programmers: Chris Fayers and Joshua Portway. Images: John Chapman and Isabel Rocamora; **153** Troika Ranch. Photo Jon Harris. Dancers: Lucia Tong and Robert Clark. Visual reconstruction: Mark Coniglio; **154** Orth. Photo David Klugston. Copyright © Maggie Orth and International Fashion Machines, Inc., 2007; **155** Berzowska. Copyright © XS Labs 2005; **156** Anstey. Photo Squeaky Wheel; **157** Courchesne. Photo Thien Vu Dang; **157** Maebayashi. Photo Franz Wamhof © Edith Russ Site for Media Art, Oldenburg, Germany; **163** Leeson. Courtesy Paule Anglim Gallery, San Francisco, USA; **164** @c + Lia. Ars Electronica Festival, 2007. Photo Rubra; **165** Andrews. See also www. vispo.com/nio; **166** CODeDOC shows, 2003. Courtesy and copyright © Antoine Schmitt, John F. Simon Jr. Live version available at www.aec.at/de/festival2003/ programm/codedoc/schmitt/project. asp; **167** Reas. Courtesy BANK, Los Angeles, USA; Bitforms, New York, USA; **167** Shor. Courtesy Jewish Museum, New York, Berkeley Art Museum, CA, and the Orange County Museum of Art, Newport Beach, CA, USA; **168** Driessens. Photo Gert Jan van Rooij. In assignment of Leids Universitair Medisch Centrum (LUMC), Leiden, and Stichting Kunst en Openbare Ruimte (SKOR), Amsterdam, Netherlands; **170–71** McCormack. Photo Peter Lavery; **172** Brown. Support:

Andrew Snyder, Brent Goddard, Charles de Granvile; Research Council, University of Oklahoma, USA; College of Fine Art, College of Engineering, School of Art and School of Computer Science, all at University of Oklahoma, USA; **174** Coupe. Commissioned by Enter_ and Arts Council England. See also www.recollector. net; **176** Open Ended Group. Photo Tim Trumble. This work was created as part of 'motione', a project of Arizona State University, USA; **178** Shugrina. The 4th International Symposium on Non-Photorealistic Animation and Rendering, Annecy, France, June 2006 (NPAR 2006). Copyright © 2006 ACM (Association for Computing Machinery). Adapted by permission; **185** Lafia. Co-commissioned by the Whitney Museum of American Art, Artport, see http://artport.whitney. org, and Tate Online, see www.tate.org.uk/netart; **185** Ziegler. Photo Franz Wamhof; **186** Wachter. See also www.zone-interdite.net; **186** O'Rourke. Programming: Cesar Restrepo; **188–89** Teran. Photo Nina Toft / Atelier Nord; **190** Mikami. Support: Transmediale07/ Tesla, Berlin, Germany; **191** Schülke. Courtesy: Bitforms Gallery, New York, USA; **191** Goldberg. List of collaborators available athttp://demonstrate.berkeley.edu; **192** Kimura. Photos (*left*) Ayako Isomichi, (*right*) Noboru Matsuura; **193** Karatzas. Photos (*above*) Evan Karatzas, (*below*) John Palen. Project developed at Dynamic Media Institute, Boston, USA. RFID technology engineered by TagSense in Cambridge, MA, USA; **194** Günther. Photo Jose Betancourt and Ingo Günther; **196** Fry. Support: MIT (Massachusetts Institute of Technology) Media Laboratory, Aesthetics + Computation Group; **196** Jevbratt. Full details available at jevbratt.com/ 1_to_1/3/ migration; **197** Cox. Visualization by AVL-NCSA (Advanced Visualization Laboratory, National Center for Supercomputing Applications), Donna Cox, Robert Patterson, Stuart Levy, Matt Hall, Alex Betts, Lorne Leonard. Simulation by Brant Robertson, University of Chicago, USA; Lars Hernquist and T. J. Cox, Harvard University, USA; Volker Springel, Max-Planck Institut; Tiziana DiMatteo, CMU (Carnegie Mellon University). Planetarium show: Copyright © Denver Museum of Nature and Science and University of Illinois, NCSA; **198–99** Rubin. Photo David Allison; **199** Legrady. Software engineering, data storage and visualization: Rama Hoetzlein.

The nationalities listed after artists' names indicate the main locations where artists currently live and practise. Multiple nationalities are given where artists have recently practised in several countries or where more that one location has been listed in earlier documentation.